MEDIUM AND LARGE FORMAT PHOTOGRAPHY

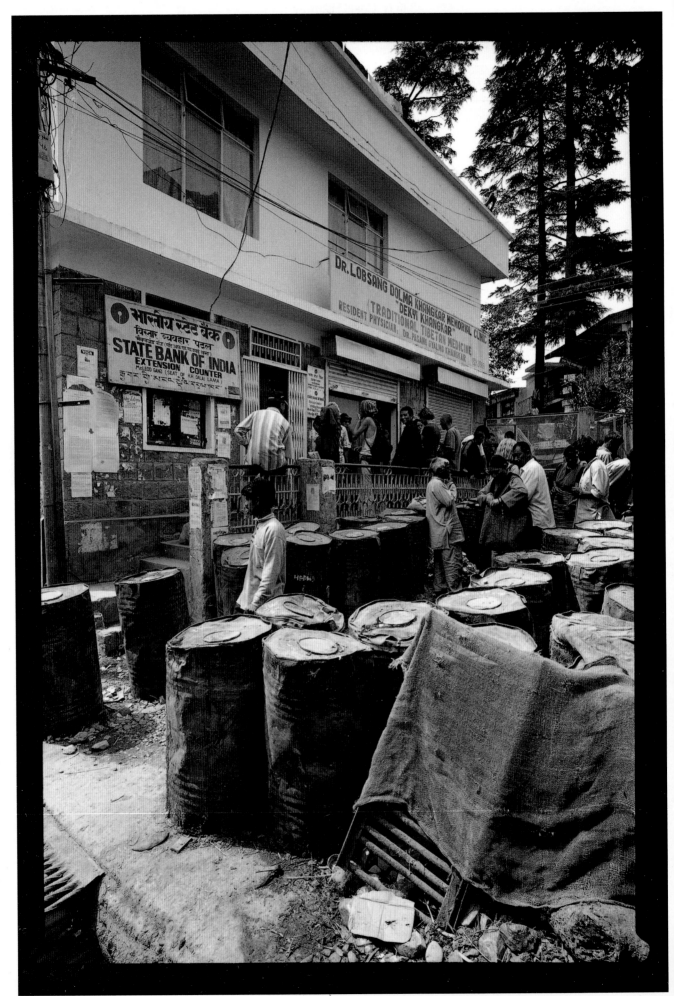

MEDIUM AND LARGE FORMAT PHOTOGRAPHY

moving beyond 35mm for better pictures

Roger Hicks and Frances Schultz

Amphoto Books
An imprint of Watson-Guptill Publications/New York

First published in the United States in 2001 by Amphoto Books,

an imprint of Watson-Guptill Publications, a division of

BPI Communications, Inc., 770 Broadway, New York, NY 10003

www.watsonguptill.com

First published in the UK in 2001 by David and Charles

Library of Congress Catalog Card Number: 00-110235

ISBN 0-8174-4557-9

Printed in China by Leefung-Asco

Publishing Manager Miranda Spicer

Commissioning Editor Anna Watson

Art Editor Diana Dummett

Desk Editor Freya Dangerfield

(page 2) BANK AND CLINIC, DHARAMSALA
*Many of the pictures in this book were shot with our Alpas, very simple
(though very expensive) scale-focus roll-film cameras. With their high-quality
lenses and good-sized negatives, they have produced some of our favorite
pictures. Roger took this with his 12 WA, fitted with a 38/4.5 Zeiss Biogon
and a 66x44mm back, on Ilford HP5 Plus – which is another product that
figures very large in this book.*

CONTENTS

Introduction & Acknowledgments

For the most part, becoming a better photographer is generally a question of enthusiasm, effort and practice. The only real expenditure is on materials, and perhaps in getting to places that inspire you to take better pictures.

It would, however, be foolish and irresponsible to pretend that equipment is irrelevant. Even where a new camera brings no real, inherent benefit, the mere decision to try something new can still spur the photographer on to trying harder. The bigger the change, the more likely this is to be the case; and the move from 35mm to roll film or sheet film is a pretty major step.

The trouble is, it is entirely possible to spend a small fortune (or even a large one) on new equipment, without any real benefit. In fact, the new purchase may even have the opposite effect to what was intended: it is hard to use, or you just don't get along with it, so you waste a lot of time fighting with the equipment, and your pictures actually deteriorate. This is where we hope this book will be of particular use.

The basic message is simple. Medium format (MF) and large format (LF) cameras are actually easier to use than 35mm. The bigger format is more forgiving at every stage: exposure, processing, printing. This is, after all, why 4x5in survived for so long in newspaper photography.

The difficult part lies in ridding yourself of your 35mm mind-set: taking lots of pictures and using only a few, trying to built a "universal" outfit with a lot of lenses, the whole received wisdom on exposure and development.

To a large extent, too, moving up is a matter of going back to basics. You may or may not choose to go back to basics on focus and exposure – if you want, you can buy auto-everything 645 cameras – but you have to go back to basics on what you want to photograph, and how you want to photograph it. If you are reading this book, the chances are that you can use your 35mm equipment without having to think too hard; you are so familiar with it that you just take the picture, without any great concerns about technique. Move up to MF or LF, and you have to start thinking again.

The potential rewards are, however, considerable. We think that this book contains some of our best work, and one of the reasons for this is the sheer technical quality that MF and LF make possible.

As ever, we have tried to indicate the least expensive route into each new area of photography, along with those areas where you have little alternative but to grit your teeth and spend the money. If you can afford to jump in with a somewhat greater investment than we would normally contemplate, then the very best of luck to you, but remember this: neither MF nor LF is likely to be anything near as expensive as you may think. We believe that once you have seen the results that even a cheap MF or LF camera can deliver, you will be all the more willing to find the money that you need for a better camera. Of course, this may be a good reason not to buy the book!

We should like to thank all the manufacturers who have lent us MF and LF cameras over the years, especially (in alphabetical order) Alpa, Contax, Gandolfi, Gran View, KJP, Linhof, Mamiya, NPC, Polaroid, Bob Rigby, Rollei, Toho and Walker. Among dealers, we should particularly like to thank Linhof and Professional (in London) and Robert White (in Poole) for the loan of equipment, and Silverprint (London) and The F Stops Here (Santa Barbara, California) for advice on LF. Kevin at Camerex (Exeter) and Bill Orford at Linhof and Professional help keep our cameras repaired and ready for action, and Camera Bellows, a division of Lee Filters, has supplied us with new bellows for many an old camera; we also use filters and hoods from the parent company.

In the darkroom, we would like to thank De Vere (large format enlargers), Fotospeed (chemistry), Nova (processing equipment), Paterson (enlargers and chemistry), RH Designs (timers and analysers) and RK Photographic (enlargers). Our 35mm and MF films are stored in Print-File sleeves and cleaned with Kinetronics brushes, while our prints are retouched with SpotPens.

Then there are the materials manufacturers, most especially Ilford (whose monochrome films we now use almost exclusively), Kodak (whose color films we now use almost exclusively), Polaroid (a strong argument in themselves for moving up to MF and LF), but also Bergger (specialty papers and film), Kentmere (specialty papers), Tetenal (color paper and chemistry), Fuji (film), Adorama (paper) and Silverprint (printing-out paper). Acknowledgments like this may seem a bit tedious, but by supporting companies who are genuinely helpful and enthusiastic, instead of the ones who are run by bean counters, you can help to ensure a flourishing photographic community.

Martin Morana of the Maltese Tourism Authority deserves special thanks for facilitating our shooting on that incredible island where, in a few square kilometers, there are surely more photographic opportunities than anywhere else on Earth of comparable size. If you can go there, do.

On a personal level, we should particularly like to thank Marie Muscat-King, several of whose pictures appear in this book (as they do in most of our books nowadays); Dr A. Neill Wright, doyen of the MPP Users' Club and inventor of both the 617 Longfellow and the 4x5in Fish (these references will become clear in the text); and Mike Gristwood, whose encyclopedic knowledge of photography is both legendary, and generously shared. On those rare occasions when he does not already know the answer, he can (almost) invariably dig out the leading papers on the subject, by the best authorities. But – the usual disclaimer – any errors in these pages are, of course, our own.

RWH
FES
Minnis Bay 2000

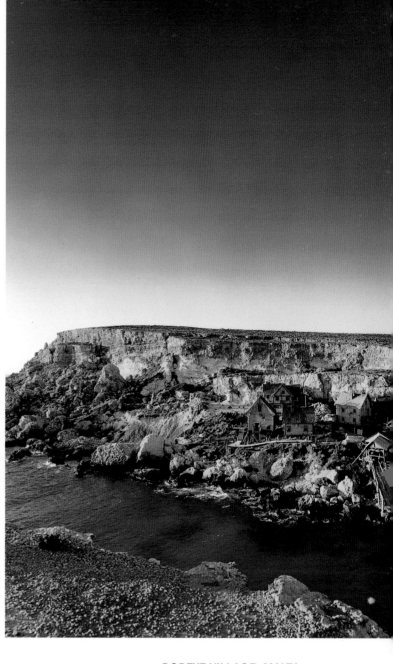

POPEYE VILLAGE, MALTA

The movie set for Popeye was not torn down: it remains as a permanent tourist attraction near Mellieha in Malta. The advantage of roll-film color negatives is that you can use reasonably fast films – this is 6x9cm Kodak Portra 400 VC – and not worry for an instant about grain or color saturation.
ALPA 12 S/WA, 58/5.6 SCHNEIDER SUPER ANGULON XL. (FES)

Chapter

1

WHY MOVE UP?

Most people who use 35mm have the same nagging question at the back of their minds: if they changed to a larger format, would they get better pictures? The answer, as so often in photography, is a firm, unequivocal "maybe."

Larger formats can deliver more detail, better tonality, and everything else that is generally described as "quality." Even the so-called 645 format, the smallest encountered on modern roll film, can decisively tip the balance in this respect, though for monochrome it may be more advisable to choose a larger roll-film format or even 4x5in cut film, as explained on pages 14 and 15. Go to the larger cut-film formats – 5x7in and above – and contact prints have a magic all their own.

But equally, 35mm is faster handling; is less likely to lead to problems with depth of field; allows more pictures to be taken in quick succession; is the only option if you want really long lenses; and delivers more than adequate quality for the majority of purposes.

In other words, a great deal depends on the sort of pictures you want to take, and on the use to which the pictures are to be put. Only you can decide whether you really would get a decisive advantage by moving up. We hope that this book will help you to make up your mind, but we would add this: like most photographers we know who use and enjoy using MF and LF, we also use 35mm. The choice is made on a day-to-day, job-by-job basis, but also on a longer cycle over which we seem to have little control. Sometimes Roger will have an LF "jag," shooting only 5x7in; at other times he will decide to take only his 35mm rangefinder cameras with him – Leica and Voigtländer. Frances may likewise use nothing but her Alpa 12 for a month, and then switch back to 35mm.

Anyone who has kept cats will recognize the syndrome: after the animals have been unable to get enough of one particular brand and flavor of cat food, they will suddenly shun it, only to go back to it a few weeks or months later. As a cat-keeping friend said, they normally go off it when it is the only sort you have in the house. We are the same with cameras and formats. If you turn out to be the same, don't worry about it. We firmly believe that it is a part of the creative process, though we do recognize that there are some people who are less fickle, and still highly creative. But what it all comes down to is that photography is supposed to be fun. If it isn't, why bother? This is, therefore, unashamedly a book about enjoying yourself.

▶ **INTERIOR, NOWROJEE'S, DHARAMSALA**
Six thousand feet up in the Himalayas, Frances shot this on 6x9cm Kodak Portra 400 VC, using a 35/4.5 Rodenstock Apo-Grandagon on her Alpa 12 S/WA. The speed of the film limits the maximum enlargement size, but 6x is still 13x20in or 34x50cm. Nowrojee's is the oldest shop on the northern subcontinent.

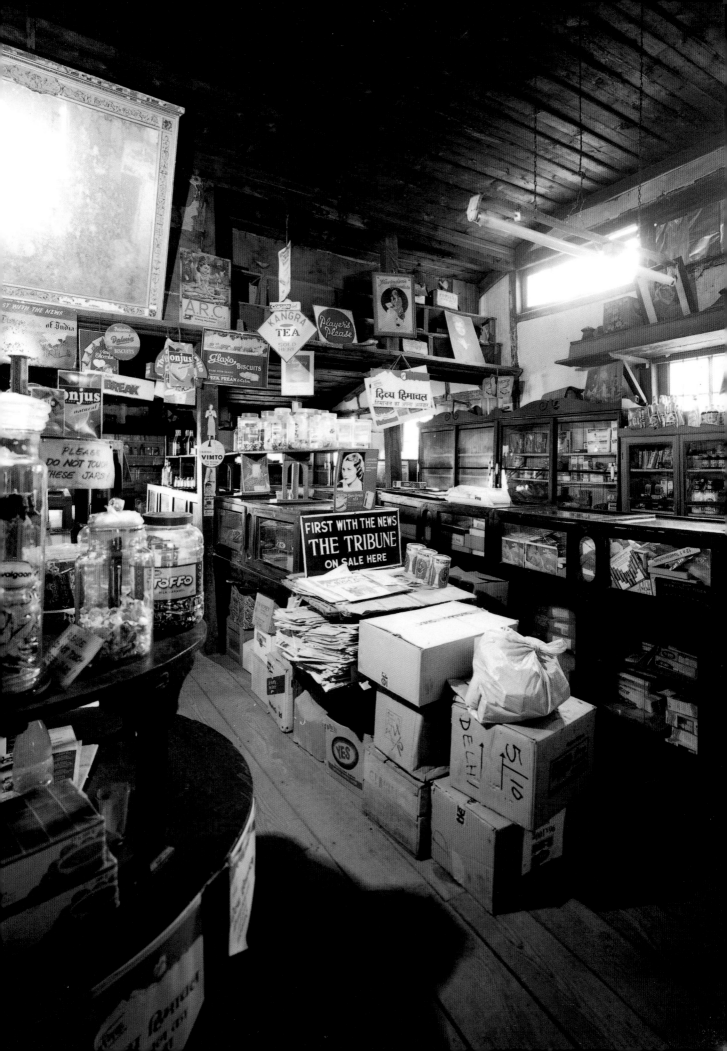

Medium format and large format

DRAG RACING, SELMA, ALABAMA
Although you can buy 35mm cameras with formats from 14x21mm (Tessina) to 24x60mm, the vast majority use the 24x36mm format with an area of 864sq mm.
LEICA M2, 90/2 SUMMICRON, FUJI RD ISO 100. (RWH)

Most people, when they think of moving up from 35mm, think of roll film, or what we have called "medium format" (MF). In general, this is probably the best choice. But for some kinds of photography, and some kinds of photographers, it may make more sense to go straight to large format (LF) – 4x5in and above.

Contrary to popular belief, new LF cameras are not significantly more expensive than MF, and if you are willing to buy used ones, they can be quite a lot cheaper. There is more about this on page 66. Nor is LF difficult or alarmingly expensive to use: there is more about costs throughout the book.

ACTUAL FILM SIZES

One of the easiest ways to understand the different options is to look at the actual area of film used for image recording. The 35mm frame is nominally 24x36mm, or 864sq mm. The nominal 645 size is typically around 56x42–3mm, just under three times the area of 35mm at about 2,350–2,400sq mm. The nominal 6x7cm size is again 56mm wide, but 68–72mm long: 3,800–4,000sq mm, or rather over four times the area of 35mm. And at 4x5in, the usable area is typically 95x120mm – 11,400sq mm, or more than thirteen times the size of 35mm.

Our belief – which we hope that we shall demonstrate to your satisfaction in this book – is that while roll film is a bigger, better version of 35mm, large format is a different order of creation. At 4x5in and above, many of the concerns of both 35mm and roll film have effectively ceased to exist: grain, resolution and sharpness can normally be taken for granted, leaving only the inconvenience of manipulation to be balanced against the superior quality.

BROKEN TREASURES
The smallest common cut-film formats are 4x5in (as here) and 9x12cm. The image area of 4x5in is approximately 11,400sq mm, or more than thirteen times the size of 35mm.
GANDOLFI VARIANT, 210/5.6 RODENSTOCK APO-SIRONAR, FUJI RDP 2. (FES)

CAMERA TYPES

In 35mm, there are comparatively few types of camera, the vast majority of which use the standard 24x36mm format. Most SLRs are pretty similar: the only real choice is between relatively simple manual focus cameras, such as the new Contaxes and old Nikkormats that we use, and multi-mode, ultra-automated and (to our taste) often bloated autofocus cameras. Then there are interchangeable-lens rangefinder cameras such as the Leica, the Voigtländer Bessa series and the Konica Hexar. After that, there are point-and-shoot compacts, and a few mavericks such as the Hasselblad/Fuji Xpan and a couple of swing-lens panoramic cameras.

In MF, the range is extraordinary: half a dozen or so "standard" formats, three panoramic formats, a choice of film sizes, and a choice of cuboid-style SLRs, "giant 35" SLRs, coupled-rangefinder cameras, autofocus, "baby" view cameras, panoramics . . . the list goes on. Each has its uses and its devotees; but unlike 35mm, where a Nikon user could reasonably easily switch to (say) Pentax or Canon, the different models, layouts and formats of the various MF cameras are likely to appeal to very different users.

In LF, there is an even more bewildering variety of formats and camera types. Also, there are so many manufacturers – about 30, at the time of writing, some producing just a handful of cameras a year – that buying an LF camera is more like buying a suit of clothes than a household appliance: your choice depends not only on your needs, but also on your personality, whether you prefer the classic brass and mahogany elegance of a Gandolfi or the aerospace high-tech of a Canham.

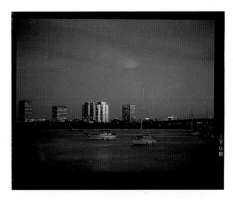

LONG BEACH HARBOR
Move up even to the smallest usual roll-film format, the 645 frame illustrated here, and you have about 2,400sq mm, almost three times the area of 35mm; the largest common format, 6x7cm, is bigger than 3,800sq mm, or rather over four times. *MAMIYA 645, 150/3.5 MAMIYA-SEKOR, KODAK EKTACHROME ER 64. (FES)*

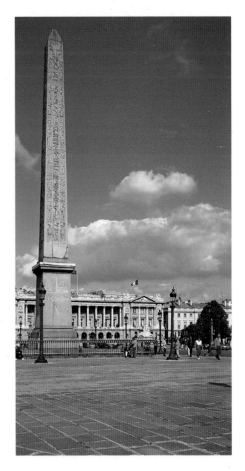

OBELISQUE DE LUQSOR, PARIS
Roll film also gives the option of seriously large panoramic formats: 6x12cm (as here), 6x17cm or 6x24cm. *TOHO FC-45A, 120/6.8 ANGULON, HORSEMAN 6x12CM BACK, FUJI RDP2. (RWH)*

WINE AND BRANCH
With modern improvements in film and lenses, the 6x7cm format is increasingly replacing 4x5in for many professional applications. *LINHOF TECHNIKARDAN, 210/5.6 RODENSTOCK APO-SIRONAR, FUJI RDP2. (FES)*

Simplicity and complexity

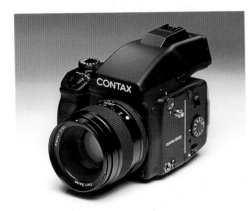

CONTAX 645

This is a simple camera because it automatically sets the film speed, focuses, sets the exposure, and winds on. It frees the photographer from technical considerations, allowing him or her to concentrate on the picture itself: on composition, and on the "decisive moment." It also allows the photographer to shoot (and select from) a good variety of images of one subject on one roll. This camera is too complicated because it has too many modes, buttons, knobs and things to go wrong: it is too easy to press the wrong button, or turn the wrong dial.

Different photographers have different definitions of "simplicity" and "complexity," or rather, they apply those definitions to different things. The captions below the pictures of the cameras should make the differences clear – and the arguments may sound like familiar battle lines, especially those that propose why each camera is complicated.

The truth is not only simple, but also unarguable. It is that you should choose the type of camera that will give you the best pictures. By all means take the advice of others – this is, presumably, one of the reasons you are reading this book – but equally, follow your own heart and head, and try to analyze what attracts you to (or repels you from) a particular camera.

If you are happy with a 35mm auto-everything camera, then by all means move up to an auto-everything MF camera, whether SLR (page 50) or direct vision (page 60). The increased area of the 645 image (almost all automated MF cameras are 645) will give detectably better results in color, and quite significantly better results in monochrome (page 14).

ALPA 12 WA

This is a simple camera because it has no unnecessary controls, and allows the photographer to set things up exactly as he or she wants, without having to worry about metering patterns or overriding film speeds or making exposure compensations. With an 8-on-120 back, it is a camera for the photographer who knows what he or she wants, and does not need to waste film finding out. This camera is too complicated because it is too easy to forget to set something, or double expose, or wind on without exposing, or accidentally fog the film, because there are no interlocks anywhere.

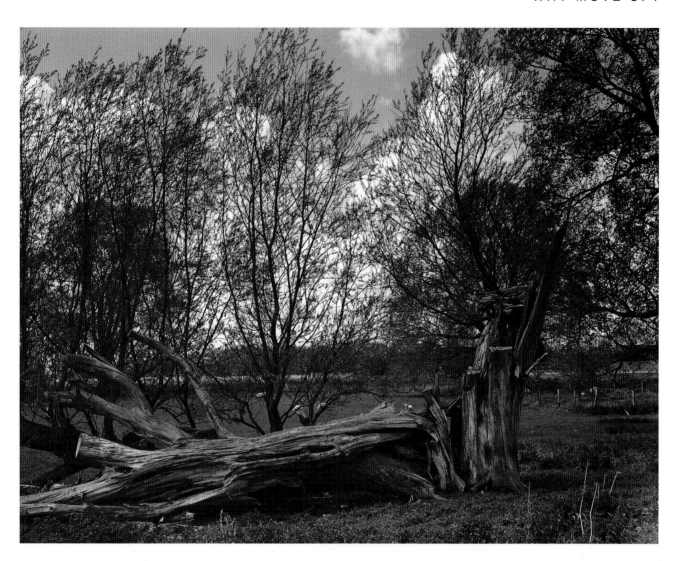

If, on the other hand, you want to take more control of the technical side of things, so that you know exactly where your point of focus and depth of field lie, and you don't want to have to fiddle with compensation dials and overrides when your opinion of the correct exposure doesn't agree with the camera's, you have an enormous choice of cameras in a wide variety of formats.

And if you currently use a 35mm auto-everything camera, but suspect that you could get better pictures if you took more control of the technical side of things yourself, console yourself with this thought: technique really isn't all that difficult to master. Before the advent of automation, countless superb pictures were taken by countless photographers, both amateur and professional, who were no more intelligent or deft than photographers today.

We have to confess that our own tastes run more to the view that a "simple" camera is one that doesn't pretend it knows more than we do. If we miss a picture because we made a mistake, that's one thing; but if we miss a picture because the camera behaved in an unexpected way – well, that's pretty infuriating.

TREE BY THE SIDE OF THE LITTLE STOUR, KENT

What matters in the long run is the picture: its composition, detail and tonality. This was shot on Ilford HP5 Plus using a completely manual camera, a 1970s Graflex XL (page 60) with an 80/2.8 Rodenstock lens and a 6x7cm back. It did not cost a fortune: we paid £300 (call it $500/€500) in 1998. It would just about be possible to get similar quality and tonality with 35mm, but it would require the best available lenses, the sharpest, finest-grained films, and far more care at every stage of the proceedings. In the course of a three-hour walk, carrying one camera each (Roger with the 10-on Graflex, and Frances with the 16-on Contax illustrated here), we shot five rolls of film between us. *Ilford Multigrade Warmtone, toned in Paterson selenium toner.*

Color and black and white

When it comes to choosing what sort of camera to buy, and what format, a great deal should depend on whether you shoot color or monochrome.

In color, grain and sharpness are the limiting factors. A good, sharp image on fine-grained film should be able to deliver a 7x enlargement with ease, so that even a 645 camera will give you a 12x16in/30x40cm enlargement without any problems. Because the image is a diffuse dye-cloud, rather than sharp silver grains, the half-tone effect is much less obvious in color than with conventional mono films.

In monochrome, tonality enters the equation. The smaller the degree of enlargement, the "creamier" the gradation, and the more closely the image approaches the sublime quality of a contact print. This is due largely to the half-tone effect, as described in the panel. As a rule of thumb, we reckon that a 5x or at most 6x enlargement is the limit at which you start to lose this "creaminess," though it varies with film, developer, technique and print viewing distance.

For optimum monochrome quality, therefore, 645 should not be enlarged beyond about 10x12in/25x30cm, though you can go a little further if you use the finest-grained films such as Ilford 100 Delta or Pan F Plus. Even 6x7cm should not go beyond 12x16in/30x40cm, subject again to the same qualifications. You can go bigger if you want, just as you can with 35mm, but you will lose the magic.

Remember, too, that sheer size is not necessarily an advantage in its own right: a smaller print can be a "magic window" into another reality, inviting the viewer in like Alice through the looking glass. Some prints "want" to be big, while others "want" to be small.

STAIRCASE OF RUINED HOTEL, GHAJN TUFFIEJA, MALTA

Where tonality is everything, as it is here, then 4x5in is all but essential if you want to go beyond about 12x16in/30x40cm, and the advantage of 4x5in over MF may well be visible even at smaller sizes: there is a wonderful tonality in an enlargement of just 2x.

TOHO FC45X, 110/5.6 SUPER SYMMAR ASPHERIC XL, ILFORD 100 DELTA, ILFORD MULTIGRADE WARMTONE, TONED IN SELENIUM. (RWH)

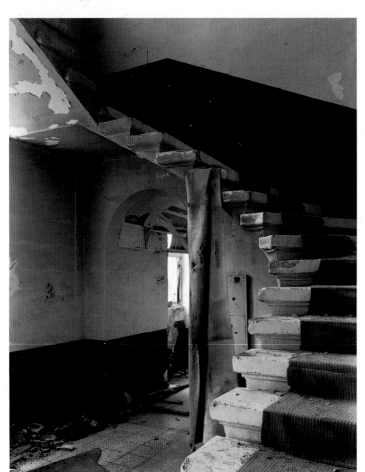

THE HALF-TONE EFFECT

Both squares are 17x enlargements from the same area of film, exposed identically. One shows a characteristic grain structure; the other doesn't, because the paper was rotated during the exposure. Obviously, the amount of light falling on both sheets of paper was identical. This is a crude but accurate demonstration of the half-tone effect. At small degrees of enlargement, the grain is invisible, and the tonality is "creamy." At bigger degrees of enlargement – even before we are aware of seeing the grain – the tonality starts to break up.

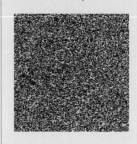

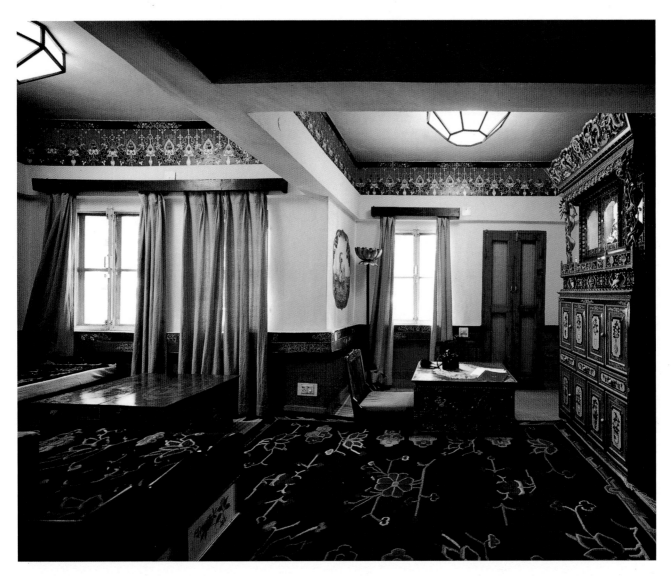

For monochrome prints bigger than about 12x16in/30x40cm, 4x5in starts to look very attractive: even a 16x20in/40x50cm enlargement is only about 4x, and a 12x16in/30x40cm enlargement is so far inside the "performance envelope" as to present only minimal challenges. You can stop worrying about technical quality, and concentrate on the picture.

For that matter, contact prints from still larger formats are even easier, and even more beautiful. One of our favorite pictures is a half-plate (4¾x6½in/ 121x165mm) contact print of the interior of a hardware shop. The shop belonged to a friend's grandfather in New York in the early years of the twentieth century, and the picture is a "magic window" in both space and time: the detail just goes on and on, even when you examine it with a magnifying glass. You can really feel that you are in that shop, smelling the kerosene and the furniture polish, the blackleaded stoves and the wooden floor.

INTERIOR, CHONOR HOUSE

Frances shot this interior of Chonor House (the best hotel in Dharamsala, seat of the Tibetan Government in Exile) with her Alpa 12 S/WA, using a 35/4.5 Rodenstock Apo-Grandagon on 6x9cm Kodak Portra 400VC, which stands enlargement to 12x16in/30x40cm with ease, or 16x20in/40x50cm at a pinch. For an 8x10in print, 645 would have been entirely adequate.

Formats and enlargements

DIFFRACTION LIMITS TO RESOLUTION

The theoretical limit of resolution (lp/mm) of any lens – the point at which contrast falls to zero – can be approximated pretty well by dividing the working aperture into 1500. If a more realistic contrast level is adopted, we should however divide the aperture into 1000 rather than 1500.

	f/5.6	f/11	f/22
Diffraction limit at zero contrast	275	140	70
Diffraction limit at 50% contrast	180	90	45

A common misapprehension is that larger formats can be regarded as scaled-up versions of 35mm, and enlarged to the same degree. Unfortunately, this is not the case. Bigger negatives (or transparencies) are likely to be less sharp, for three reasons. The bigger the format, the harder it is to maintain the resolution of the lens; the bigger the format, the harder it is to keep it flat; and it is usual to work at smaller apertures with larger formats, which means that the diffraction-limited resolution is necessarily lower, as shown in the panel.

With 35mm, film resolution and film location tend to be the limiting factors, and under ideal conditions (most particularly, with the camera on a tripod) a resolution of around 100 line pairs per millimeter (lp/mm) on the film is the best that can be expected, using the finest prime lenses: cheap zooms may struggle to deliver half that resolution. With MF, film and lens are pretty evenly matched, and 70 or 80lp/mm can be achieved relatively easily on the film, again assuming the use of a tripod, and careful focusing. With LF, a great deal depends on aperture, film location and film flatness. Although resolution well in excess of 80lp/mm is theoretically attainable, at least centrally, 60lp/mm is pretty good and 40lp/mm or less is not unknown.

These figures do not, however, tell the whole story. In the real world, the actual on-the-film resolution is likely to be lower than the maximum that can be achieved under ideal conditions, principally because of focusing errors (especially with autofocus) and camera shake. The larger the format, the less significant the quality losses are likely to be in the real world. With good quality 35mm, you can expect to drop from the 100lp/mm theoretical maximum to 50 or 60lp/mm; with MF, from 80lp/mm to maybe 40–50lp/mm; and with LF, where camera shake is rarely a problem, to around 40lp/mm at worst, unless you stop down too far.

SWINGS, BROADSTAIRS, KENT

Because of the shape of the film path, Linhof's purpose-built 6x12cm and (as here) 6x17cm panoramic cameras offer unusual film flatness despite the large format. If the film is wound back on itself (page 40) film flatness is inferior.
FUJI PROVIA. (RWH)

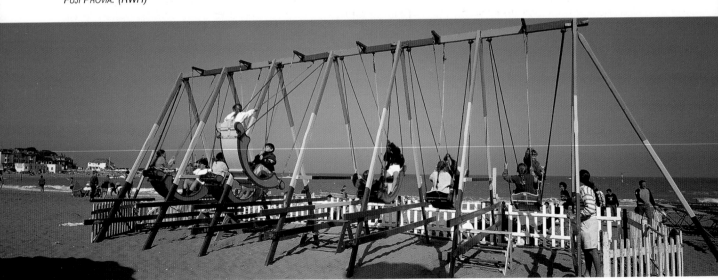

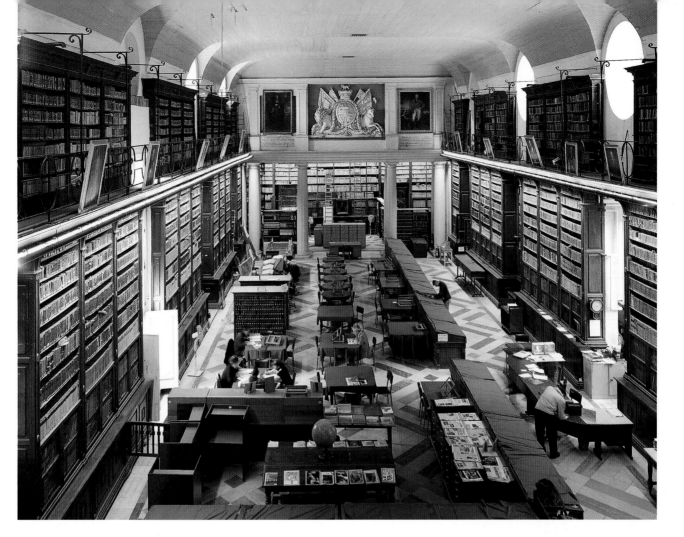

RESOLUTION ON THE PRINT

The figure we have long used as a general rule for a "sharp" print, based on the resolving ability of the human eye and a 25cm/10in viewing distance, is 8lp/mm *on the print*. Other estimates range from 5lp/mm ("acceptable") to 30lp/mm (contact-print sharpness).

If you use our rule of thumb, you can divide eight into the on-the-film resolution, and assuming a perfect enlarging lens, this will give you the maximum permissible degree of enlargement, as follows:

NATIONAL LIBRARY, MALTA
Somehow, a big transparency – this is 4x5in Kodak E100SW – seems better able to capture a big space; and with the latest super-sharp lenses (this is a 110/5.6 Super Symmar XL) the effective limits to resolution are set by film flatness. *Тоно FC45X. (RWH)*

	On film	With perfect enlarging lens	Enlargement sizes
35mm	50–100	6x to 12x	6x9in to 12x18in
			15x22cm to 30x45cm
645	40–80	5x to 10x	9x11in to 18x22in
			22x28cm to 42x56cm
6x7	40–80	5x to 10x	11x14in to 22x28in
			28x36cm to 56x72cm
4x5	32–64	4x to 8x	16x20in to 32x40in
			40x50cm to 80x100cm

Of course, enlarging lenses are not perfect, and there is also the half-tone effect to consider (page 14). But even 645 decisively tips the balance as compared with 35mm. At an 8x10in enlargement, 645 is likely to show a clear advantage over 35mm, and at 12x16in, the difference will normally be unmistakable.

Tripod or hand-held?

Although a tripod is essential for maximum possible sharpness in both MF and LF (and for 35mm, for that matter), it is perfectly possible for most people to shoot both MF and LF hand-held, provided they choose the right cameras.

STABILIZING 4x5in
The pressmen of old used to hold ⅒ second, ⅕ second, ½ second and even a full second this way. A useful trick for close-ups is to tie a piece of string to the front of the camera, with a clothespin at the far end at whatever your chosen, focused distance is. Clip the end of the string to the subject; walk back until the string is taut; tug smartly to remove the string; and shoot. . . . Frances actually shot this on quarter-plate Polaroid Polapan 100 at ⅛ second at f/4.5, with an NPC 195, held and focused conventionally. Despite her "benign essential tremor," sharpness is acceptable – which it would not be in an enlargement from 35mm at the same exposure.

SHUTTER SPEEDS AND HAND-HOLDING

With both MF and LF, you can normally hand-hold longer shutter speeds than would be possible with 35mm, simply because camera shake is magnified less when the negative is enlarged less. This in turn is why, in the days of Speed Graphics, pressmen could often get pictures without flash: shutter speeds of ⅒ second, ⅕ second and even longer were commonplace. When you consider that ⅕ second with a 135mm Schneider Xenar wide open at f/4.7 on Kodak Royal-X, ASA 1250, equates to about ⅟₆₀ second with a 35mm Leitz Summaron wide open at f/3.5 on Kodak Tri-X at EI 400, you can see why they did it and how they got away with it.

The usual tricks apply in all formats – relax as far as possible, start to exhale before you shoot, and don't stab at the shutter release – but there are specific recommendations for both MF and LF.

MEDIUM FORMAT

Camera shape can have a considerable effect on sharpness. The Alpa 12 can be fitted with exactly the same 38mm Zeiss Biogon as is fixed in the Hasselblad Superwide, but because of the shape of the Alpa, most people find it much easier to hold steady, and resolution can be 20 percent higher. Other "giant 35" cameras, such as the Mamiya 7, again give a sharpness bonus as compared with harder-to-hold cameras. With many cameras, fitting a side grip can significantly improve the sharpness of hand-held shots. Rollei and similar TLRs, with the camera on a short neck-strap at chest level, often allow quite long exposures to be hand-held with more success than seems reasonable: as long as ⅒ second. Reportedly, Junoesque ladies can even get away with ⅕ second on a fairly regular basis, provided they are not short of breath.

An MF SLR is rarely the best choice for hand-holding. Not only can there be an impressive delay between pressing the shutter release and taking the picture – as much as ⅒ second – but the big, heavy mirror moving around does nothing for sharpness. This is why a pre-release is so good: it closes the front shutter (on a leaf-shutter camera), stops down the diaphragm, raises the mirror, and opens the auxiliary shutter (if fitted). When you press the release, all that is left is for the shutter to fire, which it does, promptly, quietly, and with the minimum of vibration. Of course, you are left with little more than a crude box camera, with scale focusing and (at best) an accessory frame finder.

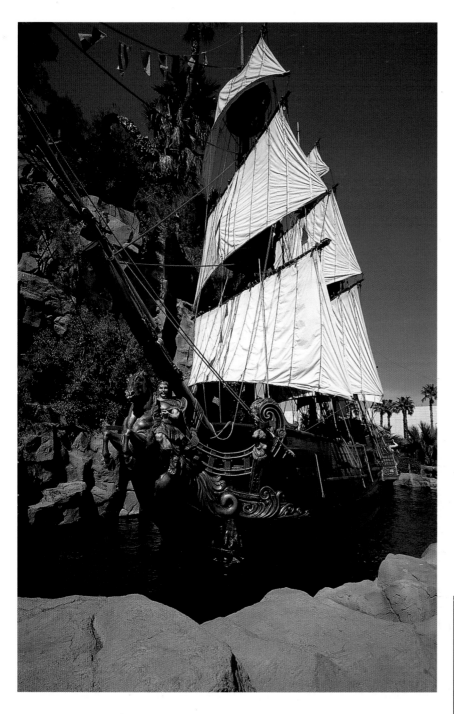

PIRATE SHIP, TREASURE ISLAND, LAS VEGAS

Extreme wide-angles are always easier to hold steady than longer lenses, and it would probably be possible to get an acceptable image at as little as ⅟₁₅ second with the 38/4.5 Zeiss Biogon (on 66x44mm) that was used for this shot: the Alpa 12 WA is also particularly easy to hold steady. On the other hand, ⅟₆₀ second provides a generous margin of safety. *Fuji Astia 100. (RWH)*

CHURCHYARD, SNAVE, KENT

Frances shot this with a view camera – a Walker Titan XL, fitted with the 110/5.6 Super Symmar XL – which pretty much precluded hand-holding. But a tripod will improve sharpness with any format. *Ilford FP4 Plus, printed on Multigrade Warmtone, toned in selenium.*

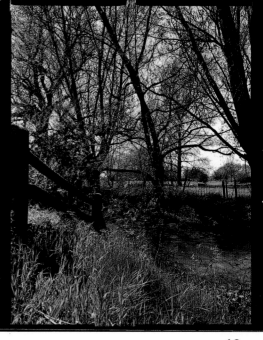

LARGE FORMAT

Press-type cameras such as the MPP can be hand-held for surprisingly long exposures, certainly ⅟₁₀ second and often longer, if they are held in the conventional way. The same is true of Polaroids and of such purpose-made cameras as the Gran View. Most LF cameras suitable for hand-holding are 4x5in, though 13x18cm/5x7in Linhof Super Technikas were made with rangefinders, and there is an 8x10in version of the Gran View.

For really long exposures – ½ second and even a full second – an old press trick was to balance the camera on the shoulder, framing by guesswork. If the photographer could lean against something at the same time, such as a wall or a lamp-post, still greater sharpness could be guaranteed.

Film choice

As compared with slower films, fast films allow faster shutter speeds or smaller apertures or both. But of course they are grainier and less sharp than slow films. Fast color slide films generally deliver inferior color; fast color negative films can be excessively grainy.

With 35mm, all of this matters. With MF it matters a lot less, except with slide films. In monochrome, unless you know that you are going to make big enlargements, even ISO 400 films such as Ilford HP5 Plus deliver more than enough quality. In color, ISO 100 slide films still deliver better color, but negative films start to look a good deal more attractive; Frances uses a lot of Kodak Portra 400 VC, a film we wouldn't dream of using in 35mm. With 6x9cm, her preferred format, grain just isn't a consideration at any reasonable degree of enlargement, or for reproduction, which is the destination of most of our pictures. Even with Ilford 3200 Delta, an 8x10in print off 6x7cm looks surprisingly similar to an 8x10in print off 35mm 100 Delta.

By the time we get to LF, we still use Ilford 100 Delta in 4x5in for its exquisite tonality, but we also use a good deal of Ilford FP4 Plus and Ortho Plus, especially for 5x7in and 8x10in where the final result is going to be a contact print on printing-out paper (POP, page 143). FP4 Plus and Ortho Plus can both deliver a very high maximum density and a fairly steep contrast curve, which is what you want with POP.

It is always a good idea to get to know a limited palette of films well, rather than fooling with whatever is cheapest or newest; but equally, it is worth trying something new from time to time, because there are genuine improvements. Sometimes these are not well signaled. Ilford's XP2 Super, for example, should really have been called XP3, and even if HP5 Plus might not be quite justified in being called HP6, it is still a vastly better film than plain HP5. Using a film because you know it and can get the best out of it is good; using a film out of habit, and damning all change as being for the worse, is clearly foolish. If you don't agree, ask yourself a simple question. Who needs these new-fangled dry gelatine plates, when wet collodion plates are so much sharper and have a wider exposure latitude?

SLATES
The sublime definition of the Zeiss lenses fitted to the Contax 645 – this is the 210mm Sonnar – cannot overcome the truth that depth of field is inherently smaller for long focal lengths. A faster film helps (this is Ilford HP5 Plus) but even then, you may have to compromise on hand-held shots. *(RWH)*

BUYING FILM

A perennial question from newcomers to LF, in particular, is "Where do you buy your film?" Because LF film is rarely seen in camera stores, and because

RECIPROCITY FAILURE
With small apertures and long shutter speeds, as are often used with LF, reciprocity failure can be a problem. If your MF or LF negatives are under-exposed, this may be why: it is worth checking the manufacturers' spec sheets, and it may be a good idea to switch to an emulsion with better reciprocity characteristics. On the other hand, most films are improving steadily in this regard: a revision to Ilford FP4 Plus in about 1999 made it a significantly more tolerant film.

few dealers advertise it, at least outside the United States, they imagine it is hard to get. It isn't. Any Ilford dealer can order any Ilford product and have it in a day or two, or there are many mail-order companies specializing in large format who can supply an extraordinary range of films in an unbelievable range of sizes.

Don't worry about any reluctance to sell to amateurs: if you know what you want, they will sell it to you. It is not a bad idea, though, to call the manufacturers and get their catalogs so that you do know exactly what you want before you try to order.

FRANCES

We were working on a book on Hollywood portraiture, using pictures from the Kobal Collection, and we decided to see if we could replicate the effects of the 1930s using vintage Hollywood-style equipment: an 8x10in camera (De Vere) and a long (21in/533mm f/7.5) uncoated lens, used at full aperture. After four experimental sheets of Ilford Delta 100, we learned how to get the effect we wanted.
(FES DIRECTING RWH)

Slowing down – and saving money

If you move up to a format larger than 35mm, you are likely to work more slowly, and to shoot fewer pictures, which costs less. Admittedly there are times when this is not an appropriate approach: most kinds of sports and action photography, quite a lot of reportage, and some kinds of nature photography, where you know that you will only use a fraction of the pictures you actually shoot. But there are many other types of photography where you can get much better pictures by taking your time, checking different viewpoints, composing with the utmost precision, and metering and exposing very carefully: architecture, landscape, still life, some kinds of portraiture. . . . A great deal depends on the subjects you want to shoot, and how you want to shoot them.

With 35mm, we typically use between one-tenth and one-quarter of the pictures we shoot. With MF, this rises to between one-quarter and one-half, and with LF it is between three out of four and nine out of ten. One of the most difficult things of all is to get out of the habit of taking a picture when you know

LAKE, YOSEMITE
The 35mm mentality can be hard to shift: shoot half a roll, and pick the pictures afterwards. But how many pictures do you really need or want to take of a scene like this? Better by far to take one or two, getting it right each time.
MAMIYA RB67, 127/3.8 MAMIYA-SEKOR, KODAK EPR. (RWH)

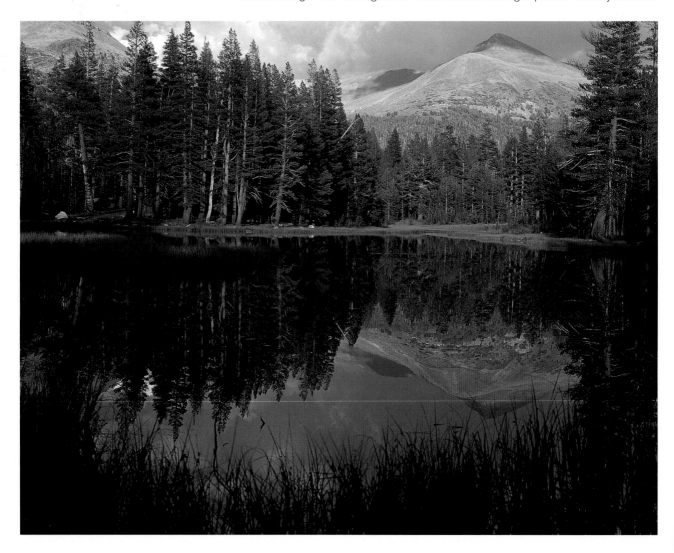

in your heart it won't work. With 35mm, the temptation is to take it anyway, on the off-chance it will work. How much film do you waste doing that?

Admittedly, it is possible to shoot almost as fast with MF as with 35mm, and (for example) in fashion and magazine work, this may be desirable. Even reloading need not be a problem: if you use 220 film (page 39), a Contax 645 gives you 32 pictures, and with 70mm (page 40) you typically get 50+ pictures even in the 6x7cm format. And you can always carry preloaded inserts to make loading still faster.

Equally truly, but rather less obviously, you can drastically improve the quality of your 35mm photography by using it like large format, always using a tripod, and taking your time. Shoot at the optimum aperture for the lens; focus carefully (and manually – all tests we have encountered to date show that careful manual focus is best, followed by autofocus, followed by sloppy or hurried manual focus); use slow, sharp films such as Ilford 100 Delta (Pan F Plus is finer grained, but not as sharp); and don't overexpose or overdevelop. Oh, and avoid zooms, except for a very few of the very best.

HIT RATE

Overall, we tend to shoot roughly the same number of rolls of 120 film in a day as we do 35mm. Given that Roger normally shoots 10-on and Frances shoots 8-on, we shoot about a quarter as many pictures, but allowing for the higher "hit rate" with MF, the number of *usable* pictures we get is similar. As 120 film is significantly cheaper than 35mm, this actually saves us money, and the film cost per final print is probably about the same.

With LF, we rarely shoot more than ten pictures in a day: typically, half a dozen would be a good day's work. A box of 25 sheets of 4x5in film costs maybe five or six times as much as a roll of 35mm, but a third of a box (eight sheets) represents about the same outlay as a couple of rolls of 35mm. As both MF and LF cameras can actually cost less to buy than 35mm, moving up really need not be expensive.

INQUISITOR'S PALACE, BIRGU, MALTA
In half a day's shooting in the Inquisitor's Palace, Roger exposed five sheets of 4x5in color film in his Toho FC45X with the 110/5.6 Super Symmar XL Aspheric. Even allowing for the additional expense of seven sheets of Polaroid, this equates to no more than the cost of a couple of rolls of 35mm slide film.
Kᴏᴅᴀᴋ *E100SW.*

Equipment costs

Most people are more afraid of the cost of the cameras, lenses and other ancillaries than of materials. Here, the news is even better.

A new, basic Rollei or Hasselblad SLR, complete with a standard 80mm lens and one back, costs about the same as a Nikon F5 with a couple of lenses, or a Leica M6 with one lens. A 4x5in Gandolfi Variant with a new 150mm lens is in the same ball park. Some cameras are cheaper; some are more expensive. But if you can contemplate a new, top-of-the-line 35mm SLR, you can contemplate a new MF or LF camera and lenses.

Lower your sights to the same cameras, used, or to something like a Mamiya RB67, and you can knock off a third for a current, near-mint camera, or half for a good user. You can buy a good, new entry-level 4x5in camera for the same sort of money.

Come down still further, to a discontinued but still excellent camera such as a Graflex XL (6x7cm) or an MPP Mk VII (4x5in) and you are looking at a fifth of the price of the new Rollei or Hasselblad. You are looking, in other words, at the price of a cheap-to-middling 35mm SLR.

Get lucky and you can buy a good, usable LF camera (MF is more difficult) for as little as one-tenth of the price of the new Rollei or Hasselblad: in other words, for the same sort of money as a half-decent 35mm compact.

Set your sights really low, and you can buy a new Russian Lyubitel TLR for the price of a few rolls of film. Or find one at a yard sale or flea market, for less than the price of a single roll of film. The definition of the three-glass lens may be nothing to write home about (though it may surprise you), but the tonality of the big 6x6cm neg will still beat even the most expensive 35mm camera at (say) 10x12in.

The same goes for enlargers. Yes, you can spend a fortune, and it may well be worth it; but between 1990 and 2000 we were actually given four or five medium format enlargers, two of them capable of accepting formats up to 6x9cm – and any camera club will normally turn up at least one member who is willing to sell an old enlarger for a pittance. Developing tanks don't cost a fortune, even new, and if you have a two-spiral 35mm tank it will normally take one 120/220 spiral. Most plastic spirals can be set for both 35mm and 120/220, so you may not need to spend anything on this. The only place it might be a good idea to splurge is on the best second-hand enlarger lens you can afford, but even this need not be a priority: our 105/5.6 three-glass Meopta, one of the cheapest enlarger lenses you can buy new, delivers superb results up to around 11x14in. The extra quality of our 95/4.5 six-glass Computar does not really begin to become apparent until around the same size.

Finally, tripods. The biggest, most expensive Linhof tripod you can buy costs rather more than a new Leica M6. But the tripods we use most for our MF and LF cameras were bought used, at camera fairs, for about the same price as a new Leica lens shade or filter, or to put it another way, for a good deal less than the price of ten rolls of black-and-white film.

► *LADIES*
▲ *CHURCHYARD, PRESTON-NEXT-WINGHAM*
Both of these pictures were taken with a Graflex XL, with an 80/2.8 Rodenstock Heligon, on Ilford HP5 Plus. As described on page 60, we bought this camera used – but we would suggest that it gives a bigger jump in quality than any change you could make in 35mm, even if you bought the finest cameras and lenses available, and spent many times the cost of the Graflex. The churchyard was printed on Ilford Warmtone, toned in selenium, and the "Ladies" on Ilford Cooltone, toned in gold. *(RWH)*

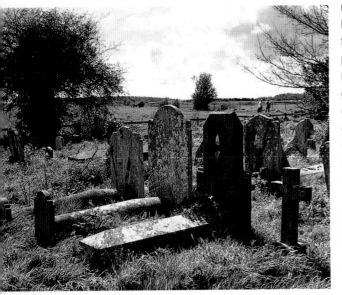

The commercial advantage

▶ **CHURCH OF ST THOMAS À BECKET, ROMNEY MARSH**
There is a school of photography that lovingly photographs ugliness in exquisite detail with MF and LF cameras. We prefer to apply the same techniques to beauty.
ALPA 12 S/WA, 58/5.6 SUPER ANGULON XL, KODAK PORTRA 400 VC. (FES)

At one time, there was no question: professionals didn't use 35mm. There are still areas where this is true today, but there is an ever greater willingness to accept 35mm, among the public at large and among those who commission photography. In many areas where large format long ruled supreme, such as the photography of jewelry, there is now a good deal of creative 35mm work. Even in wedding photography, where MF is still the norm, more and more people are opting for a reportage style using 35mm.

On the other hand, technically excellent photography is still in demand, often as an antidote to 35mm. When highly finished LF shots were the order of the day, the immediacy of 35mm could be a refreshing change; but when everyone is using 35mm, MF and LF become desirable novelties.

It is also true that many people are simply unaware of what MF and (especially) LF can do. When you show them they are awestruck. LF portraits, in particular, have qualities that cannot be duplicated with smaller formats – especially if you want soft-focus effects. LF and MF also excel in still lifes, and (because of the availability of movements) in architecture, car photography and many other fields where the control of apparent perspective is needed.

For fine art, too, there is no doubt that it is easier to make a technically excellent print from a larger format, and better prints should translate directly into larger sales. A truly fine mono print can be a thing of beauty in its own right, almost regardless of subject matter; and big negs make it easier to make fine prints.

Time and again, MF and LF pay for themselves on a simple comparison basis. People look at your MF and LF work; try to replicate it (or to have someone else replicate it) on 35mm; and fail. They then come back, cap in hand, to ask you to do the work. It is not that MF and LF cameras are difficult to use; it is simply that fewer people use them, or know how to use them.

It is true that LF is in decline among professionals, because MF lenses and (to an even greater extent) MF color films are now so incredibly good. On page 16 we looked at the way in which 35mm is limited by film quality, while LF is limited by film flatness and the need to use small apertures. In the 1950s, Linhof reckoned that 5x7in/13x18cm was the format where lens and color film were perfectly matched. By the late 1970s, it was 4x5in/9x12cm. Today it is arguably 6x7cm. Will it ever be 35mm? Probably not: film flatness, emulsion turbidity and the sheer amount of precision needed will probably mean that in this field at least, we have reached "the end of history."

There is, however, one more point to make. For certain kinds of stock (picture library) photography, 35mm has an unexpected advantage over larger formats. It is nothing to do with quality, and indeed, if you watch someone in a picture library, you will see that they always go through the LF first, then the MF, and then (somewhat cursorily) through the 35mm. But 35mm is quicker, cheaper and easier to scan; and if the library sells over the web, or via CD-ROMs or similar media, this matters. Thus does new technology deliver worse quality than old technology.

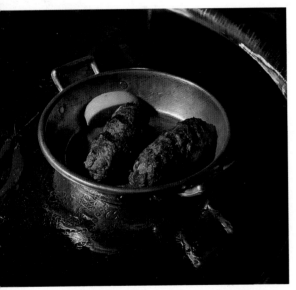

KEBABS
Until the last few years of the twentieth century, food photography was almost exclusively done with LF cameras, but nowadays modern film and good lenses allow more than adequate quality to be obtained with roll film. This was shot on daylight-type Fuji Provia and tungsten lighting, using a "baby" Linhof Technika with a 6x7cm back and a 135/8 Schneider Repro-Claron. *(RWH)*

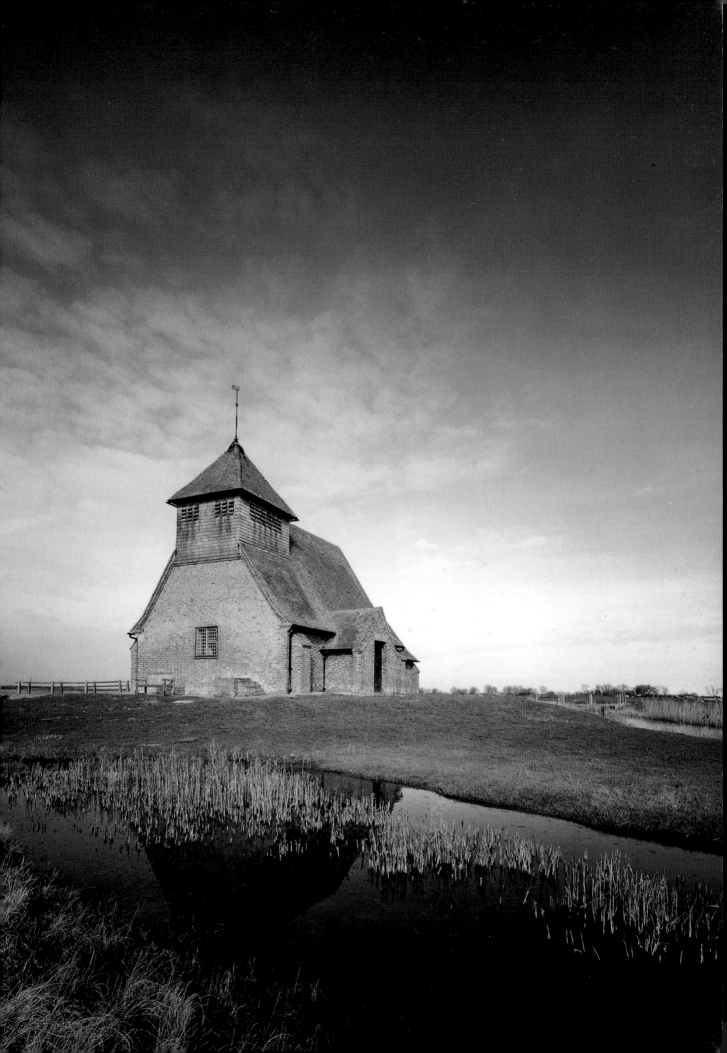

Polaroid cameras and film

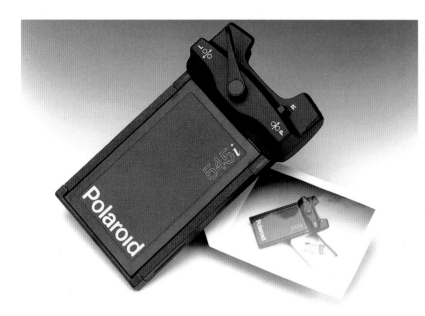

The Polaroid Corporation occupies a unique position in MF and LF, for two reasons. One is that the vast majority of MF and LF cameras can accept Polaroid backs, allowing you to check lighting, composition and exposure before you shoot your final picture. The other is that Polaroid materials themselves can be extraordinarily versatile.

POLAROID BACKS

Almost all LF cameras that will accept standard 4x5in cut-film holders will also accept a 4x5in single-sheet back. The other choices are the 4x5in pack-film back and the quarter-plate pack back (3¼x4¼in/83x108mm). The latter accepts (relatively) low-cost pack film, eight or ten

POLAROID 4x5in BACK

There are several models of 4x5in back: the 545i was current at the time of writing. As well as Polaroid film, these backs can be used with Kodak Readyload and Fuji Quickload wet-process films (page 72).

sheets to the pack. The film area is significantly smaller than 4x5in, and well offset, but can still give an excellent idea of exposure. Both pack backs may be too thick for the "gape" on some plain spring backs (page 85).

Most MF cameras with interchangeable roll-film backs will also accept a Polaroid back. Normally this will be masked down to the size of the film format in use (for example 6x7cm), though sometimes it may be bigger.

A few MF cameras, even some with interchangeable backs, will not accept a conventional Polaroid back: it is impossible, for one reason or another, to get

POLAROID SEPIA

There are several Polaroid Sepia images in this book. This one was shot hand-held, using an MPP Mk VII (page 74) with a 90mm Angulon (not Super Angulon). There is something about large format originals that is somehow completely different from an enlargement. *(RWH)*

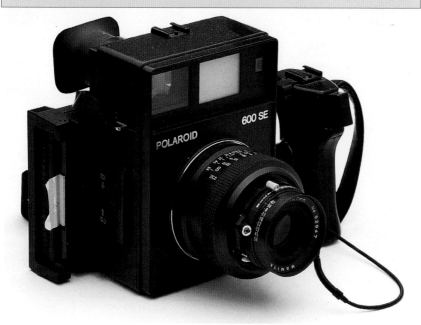

POLAROID 600 SE
Although it has been discontinued since the late 1990s, the 600 SE is still commonly encountered, and from time to time new cameras surface in dealers' store rooms. It was built by Mamiya for Polaroid, with interchangeable backs and interchangeable lenses (fixed on the 600 S).

the film close enough to the film gate. For these, it is possible to buy special Forscher Polaroid backs with fiber-optic transfer plates. However, they are expensive, and each time you remove them from the camera you lose a frame, so you really need a second camera body dedicated just to Polaroid – but even so unlikely a camera as the Pentax 67 can be made to take a Polaroid back.

PROFESSIONAL POLAROID CAMERAS

Because Dr. Land originally saw his Polaroid cameras as point-and-shoot toys for the affluent, Polaroid was a leader in exposure automation and not many purpose-built Polaroid cameras have given the user full control over aperture and shutter speed.

TIME AND TEMPERATURE
Polaroid peel-apart materials develop using exactly the same chemical processes as conventional materials, and time and temperature do make a difference. We carry a small thermometer with us, and time the development using a watch or timer. In cold weather, hold the film under your coat to keep it warm – but watch out for caustic "goo" oozing out at the edges.

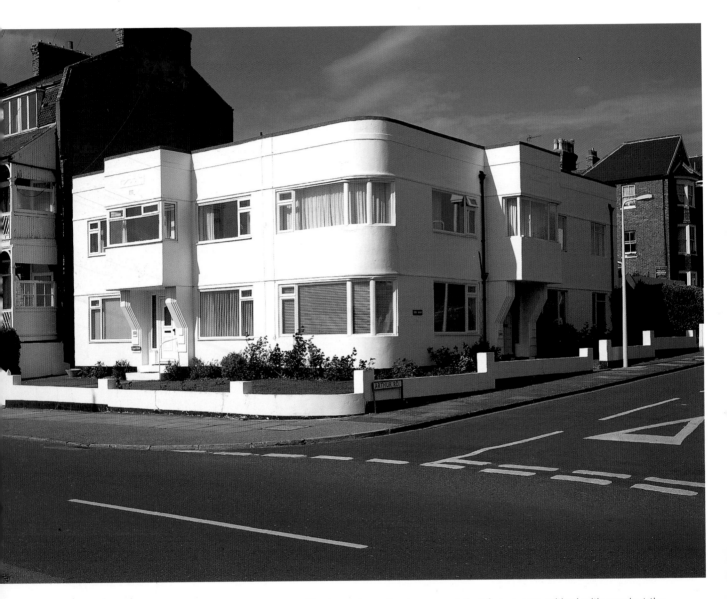

MODERNIST HOUSE

The official Polaroid backs for the 600 S/600 SE were all quarter-plate, but a specially adapted 545i back (still in production at NPC at the time of writing) is also available, allowing the use of Quickload and Readyload. This was shot on Fuji Provia 2; the image is slightly cropped, but it is still a good way to shoot hand-held large format transparencies. A roll-film adapter for the 600 SE was also made by Four Designs in the United States and may still be available. *(RWH)*

The large formats also meant that focus was critical with any but the slowest lenses, so Polaroid was perforce a leader in autofocus (and in creating very fast emulsions, so that slower lenses could be used, allowing more depth of field). A few early Polaroid cameras have coupled rangefinders and manual exposure settings, but they use film sizes that are no longer available; a few have been converted for use with later films.

PROFESSIONAL MATERIALS

"Professional" Polaroid materials still use the original peel-apart process, rather than the "integral" process. Although at first sight the films seem expensive, it is worth remembering that you are paying for both negative and print; for the convenience of being able to reshoot in a few seconds; and for

freedom from the labor of developing and printing. We often use Polaroid materials for quick, easy technical illustrations, for this very reason.

The standard materials for testing are Polapan 100 (black and white) and Polachrome 100 (color). The former is significantly cheaper, and with a little practice, a black-and-white Polaroid can tell you almost as much about exposure as a color Polaroid.

As well as just testing, though, you can also use both of these materials, and many others—including Polaroid Sepia, various ISO 400 and 800 materials, and even the legendary Polaroid 3000 (ISO speed!)—for origination. They can be scanned and run at 2x to 3x their original size without unacceptable loss of sharpness.

Then there is Polaroid Pos/Neg film, Type 55 P/N in 4x5in single sheet and Type 665 in quarter-plate packs. The negative is recoverable rather than instant – it must be cleared in a sodium sulphite solution, then washed – but it allows on-site processing of negatives, so you know what you have got, and it will stand any reasonable degree of enlargement, up to about 10x. A 5x enlargement off even the quarter-plate size is almost 20x16in.

"AMATEUR" CAMERAS AND MATERIALS

Although the lack of manual control and the slow development of the integral films limits their usefulness to the professional, it is worth remembering that images from these cameras can still be scanned electronically and will stand modest degrees of enlargement.

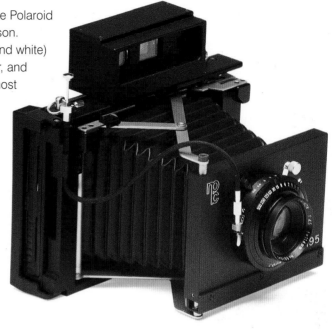

▲ NPC 195
This is probably the only "professional" Polaroid camera in production at the time of writing, having entered production in early 2000. NPC is a leading manufacturer of Polaroid backs and holders of the patents for fiber-optic transfer plates: the camera, with its fixed lens and noninterchangeable back, is an update of a much older Polaroid design, considerably stronger, and built to accept the standard quarter-plate (3¼x4¼in/ 83x108mm) film pack size. A folding, coupled rangefinder camera, it is wonderfully light and compact but will still stand up to serious professional use.

◄ "INTEGRAL" POLAROID FILMS
The possibilities for physical manipulation of the developing image, via pressure from a smooth-tipped stylus, have been explored by numerous artists over the years. The classic film for this is SX-70, but it is possible with a number of other integral films.

Equipment rental

An option that is surprisingly rarely explored by amateurs is equipment rental. This can be an excellent way of seeing whether MF or LF is for you at all; or if a particular system suits you; or whether, once you have already taken the plunge, some other lens or piece of equipment is as much use as you hope.

Many leading MF cameras, and a fair range of LF cameras and lenses, may be rented from professional dealers. Some manufacturers, too, offer rental deals whereby, if you decide to buy the camera, the rental fee is refunded. Usually these are temporary promotions, but (for instance) both Gandolfi and Walker normally keep cameras for rent. And many dealers can be persuaded to rent out used cameras on the same sort of basis, or (if they know you) to lend you the camera for nothing for a day or two.

The manufacturers' deals are typically for about a week, while the dealers' commercial rentals are by the day. On the other hand, a full week's commercial rental typically costs the same as only three days, and often for the price of a single day's rental you can rent equipment over a weekend, from about Friday afternoon to Monday morning (the exact times vary by dealer).

Even if you live a long way from a professional dealer, you may be able to get a similar deal, factoring in the cost of UPS or another courier service; it is worth checking.

While the equipment is in your possession, you are responsible for it, but many photographic insurance policies allow you to specify a "float" of equipment on loan or rental. Normally you will be required to leave a deposit equal to the value of the equipment rented, or a credit card slip with the requisite "open to buy," or (rarely) equipment of the same value as what you rent.

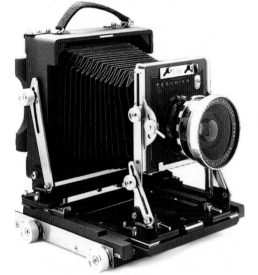

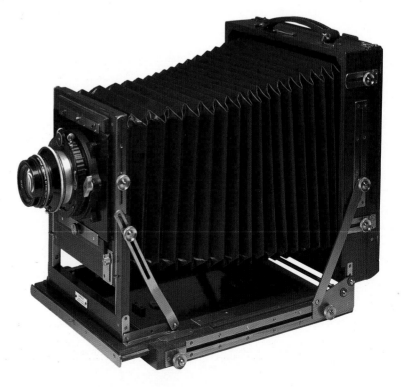

▲ *WALKER TITAN 4x5*
▶ *GANDOLFI PRECISION 8x10*
Both of these cameras can be rented from the manufacturers, though the availability of lenses may be a matter for negotiation, and what they have in at the time. Alternatively, you can try out lenses from other sources at the same time. Here, the Walker is fitted with an old 121/8 Super Angulon in a curious mount, and the Gandolfi with a 14in (356mm) f/9 process lens mounted in front of a big old Compound shutter. When you rent a camera, if you don't rent a lens with it, remember to request a panel with the right-sized hole.

BEFORE YOU RENT

Before you rent the equipment, find out as much about it as you can – from brochures, or from handling it in the shop – and make sure that you have any ancillary equipment you need: tripod, exposure meter, film holders, and so forth. Of course, all of these can also be rented. LF films can be tray-developed, while many developing tanks are dual-format 35mm/120.

It rarely makes sense to have the film commercially processed and printed, as the cost of using a pro lab is very high, and only a good-sized print from a pro lab (or a good "shamateur" lab) will show you any advantages over 35mm. Unless you can do this stage yourself, you may be better advised to shoot color transparency. Not only will this give you a feeling for how the camera handles and the sort of results it can deliver, but if you have a scanner (page 146) with a transparency hood, you will find that a decent-sized transparency can give surprisingly good results when scanned and printed.

MINNIS BAY STORES

This is an 8x10in shot, using a borrowed Gandolfi and the 110/5.6 Super Symmar XL Aspheric, shooting on Ilford HP5 Plus: the long exposure (about a minute, from memory) meant some loss of both speed and contrast as a result of reciprocity failure. For about a fifth of the price of this lens, though, you should be able to find a used 121/8 like the one on the Walker, with the same coverage, albeit with a slightly smaller angle of view and a stop slower. The same shop, shot with that lens, appears in an earlier book of ours. *(RWH)*

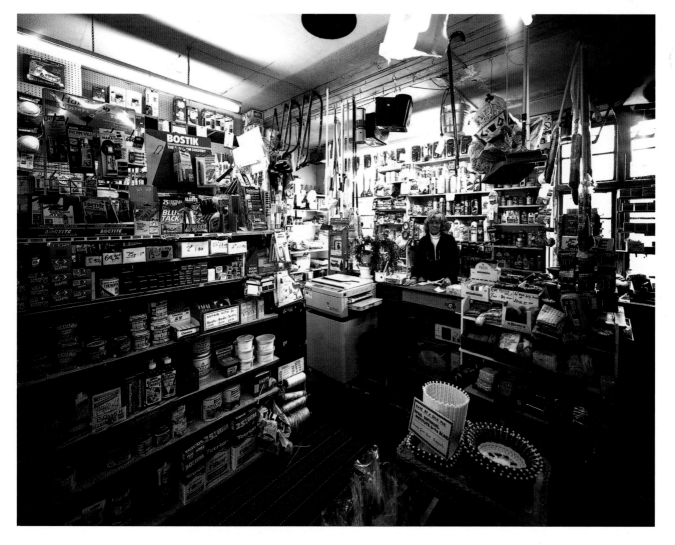

TORNADO DAMAGE, SELMA, ALABAMA
It can be very hard to explain what you like about a picture, but Roger particularly admires this picture by Frances for a number of reasons. At first sight, it is no more than a record shot, uncompromisingly four-square. But the endless detail, even in the shadows, would make even a dull record shot interesting, and compositionally, the jumble of lines suits the subject matter well: the trees that are still standing contrast well with those that are fallen or broken. The toning (Ilford Warmtone in selenium) is extremely effective, and including the processing artefacts from the Polaroid Type 55 P/N used to take the picture creates an intriguing frame.

Overall, the effect is reminiscent of some of the photographs of Civil War battlefields, where the trees were felled and splintered by gunfire rather than by natural causes. Whatever its appeal may be, there is a timelessness about the image, part of which is due to the technical quality that was obtained from a very modest 4x5in set-up, a Cadet monorail with a 1950s Kodak Ektar 203/7.7 Tessar-type lens. Similar gradation and sharpness would simply not be obtainable at all with 35mm, and could barely be attained with MF.

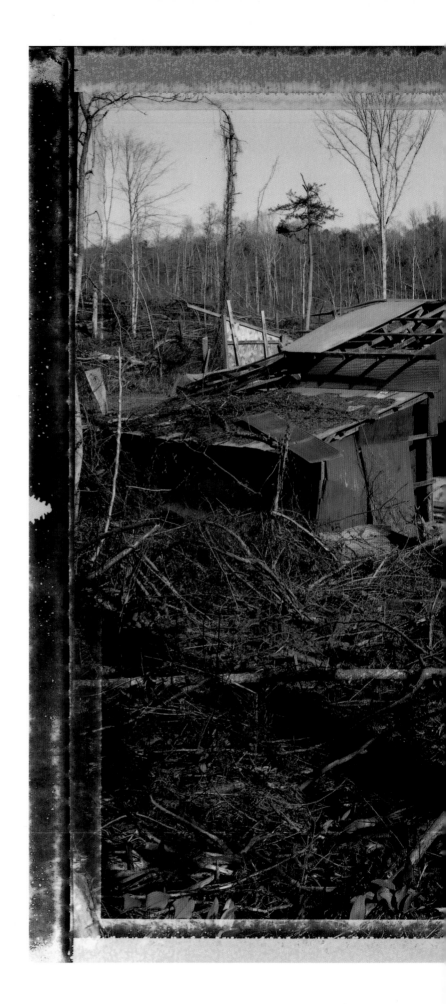

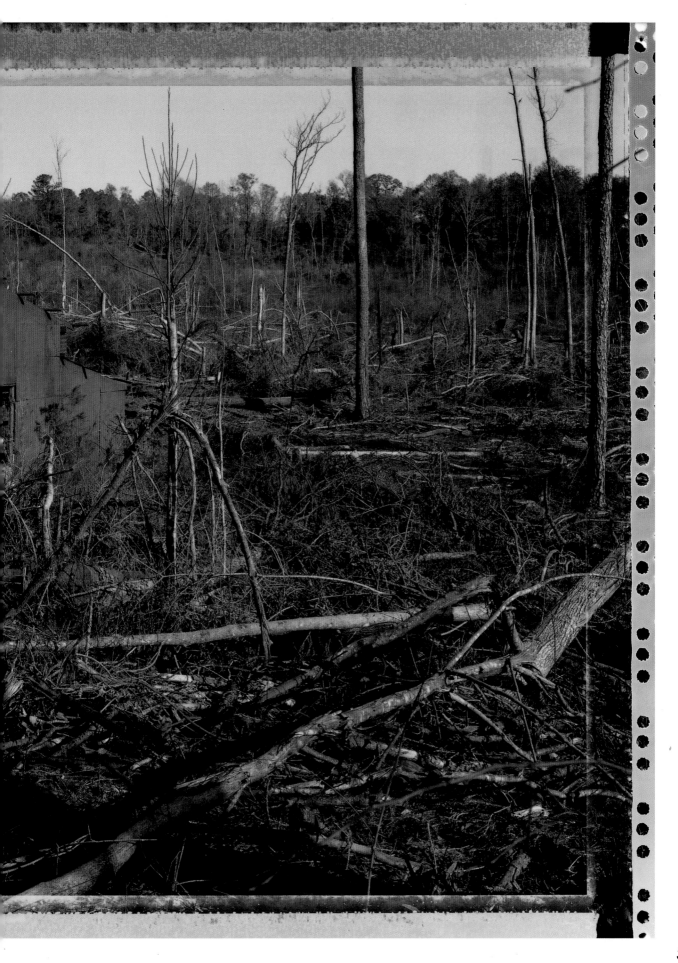

Chapter
2
ROLL FILM

Very few people choose their cameras entirely rationally, and we do not exclude ourselves from this reproach. The three biggest traps are simple acquisitiveness; outdated preconceptions; and following the herd. None can be overcome entirely, but if we can bring ourselves to recognize them for what they are, we will have a better chance of choosing the right camera.

Acquisitiveness No one is immune to this. A new camera is announced, and (of course) everyone focuses on its good points: its superb lenses, its ease of use, the extent of the system it fits into. Only later do we become aware of its drawbacks: the autofocus is capricious, it eats batteries, and the promised shift lens never actually appears.

Read equipment reviews carefully, because they are often written carefully; they have to be a balancing act between not offending the manufacturer, who may well advertise in the magazine, and not misleading the reader, who should have every right to read an honest report. And always handle equipment before you buy it (at a good dealer's, or a show) to make sure it suits you.

Outdated preconceptions Many photographers stay with the prejudices that were popular when they started photography. To take three common examples: It's true that early RC paper had an unpleasant bloom to it; that early VC materials had a limited range of grades, and poor maximum densities; and that in the 1950s, the Voigtländer Apo Lanthar was visibly superior to just about anything else, though it had a smaller circle of coverage than its competitors. But if the prints are under glass, modern RC and fiber papers can be indistinguishable; Multigrade arguably overtook graded papers for quality in the 1980s; and while the Apo-Lanthar was the best lens of its era and is still a remarkably good lens today, the best modern lenses are sharper, contrastier, better corrected, and have more coverage.

Herd instinct Generations of professional photographers have bought a particular system because they used it at college, or because their "gaffer" had it when they were an assistant. Amateurs and professionals alike will buy a camera because it is used by someone whose work they admire. People who would be better served by direct vision cameras (page 60) buy SLRs because "everyone knows" that SLRs are more versatile. And plenty buy MF because they believe (entirely mistakenly) that LF will be too expensive to buy, too complicated to use, and too expensive to run.

Despite all this, it is true that roll film is likely to suit more people, for more applications, than large format; and so it makes sense to devote a chapter to choosing first a film size, then a format, and then a camera.

▶ *KOREAN-AMERICAN FRIENDSHIP BELL, SAN PEDRO, CALIFORNIA*
We started using Alpas more or less by accident: we saw the original prototypes at *photokina* 1996, and borrowed two of the earliest to be made, in December 1998. At first, we were unsure how much we would use them: scale focusing, no interlocks, wide-angle lenses only.... Then we saw the results, and we were hooked. Today, Frances uses a 12 S/WA, with shift, while Roger uses a 12 WA, without. Roger shot this with his Alpa, and the 38/4.5 Biogon on 66x44mm Fuji Astia.

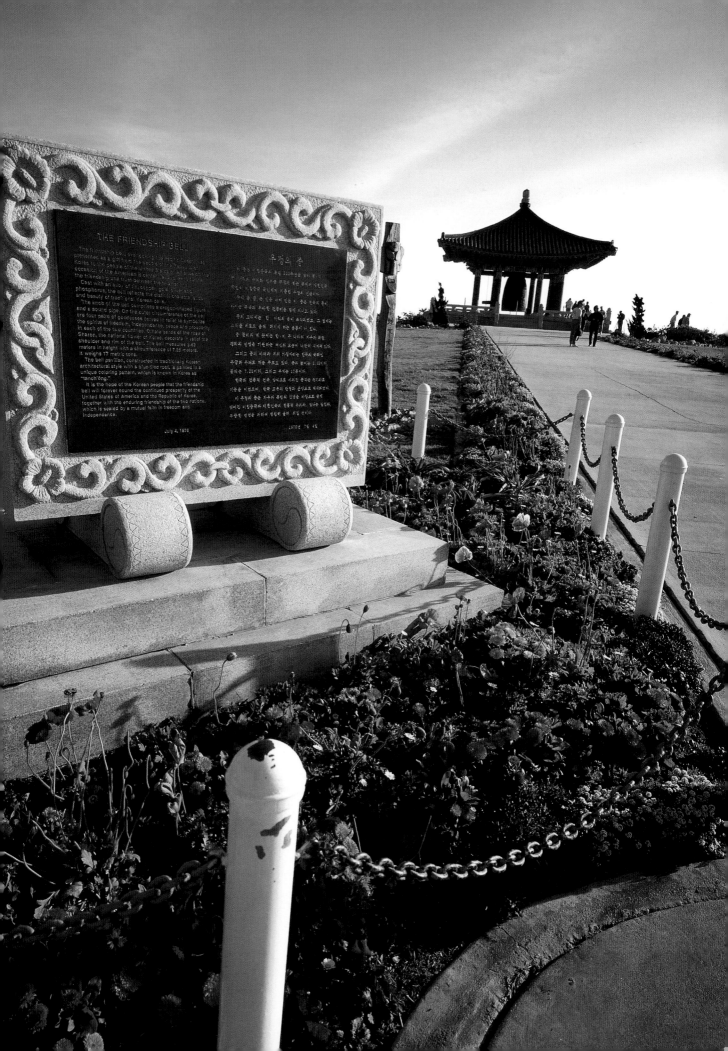

Roll-film sizes

The most popular roll-film size is 120, which is 62mm (about 2½in) wide and approximately 810mm (32in) long. The film is supplied on one spool, and wound onto another: the empty feed spool then becomes the take-up spool for the next roll. Each exposure is normally up to 58mm wide (typically 56mm) but there are many different formats, according to the length. The most common are 56x42mm approximately (645, 15-on or 16-on), 56x56mm approximately (6x6cm nominal, 12-on), 56x68–72mm (6x7cm nominal, 10-on) and 56x82–8mm (8-on), though there are others as described on pages 42 to 49.

In the past, 120 has also been known as No 20, BS (British Standard) 20, and B2. The opaque backing paper is marked for 8-on (6x9cm nominal), 12-on (6x6cm nominal) and 16-on (645 nominal), though almost all modern cameras rely on automatic counting after a "start" arrow has been lined up with a mark inside the back.

The great advantages of 120 are wide availability; an enormous range of emulsions (if an emulsion is coated at all in MF, it is likely to be coated in 120, with the exception of a few copying films); a handy number of exposures per roll for most applications; and the option of using the film in a vast range of cameras made from about 1902 onward.

A Fuji innovation in the late 1990s, to ease loading, was the provision of a hole at the end of the 120 paper leader, and a knob or button inside the

WALL AND CORBELED HUT, NEAR MELLIEHA, MALTA
The original 8-on-120 format can be an aesthetic choice rather than merely a technical one. Although we have a wide range of backs for our Alpas (66x44mm, 6x7cm, 6x8cm, 6x9cm), Frances simply prefers 6x9cm, often (as here) with a 35/4.5 Apo Grandagon.
ILFORD HP5 PLUS, PRINTED ON ILFORD MULTIGRADE COOLTONE, TONED IN TETENAL GOLD TONER.

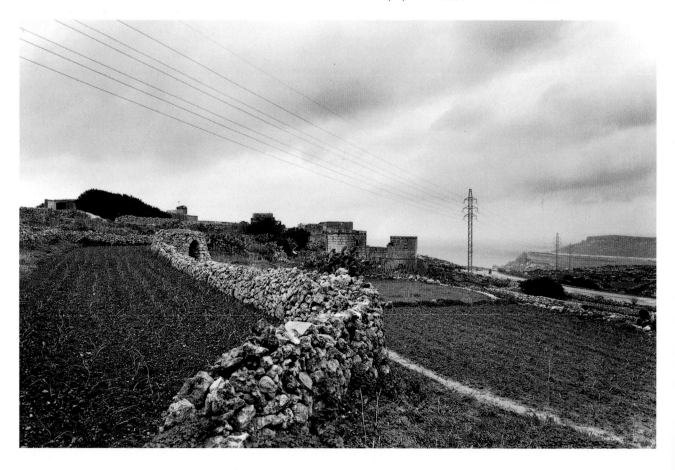

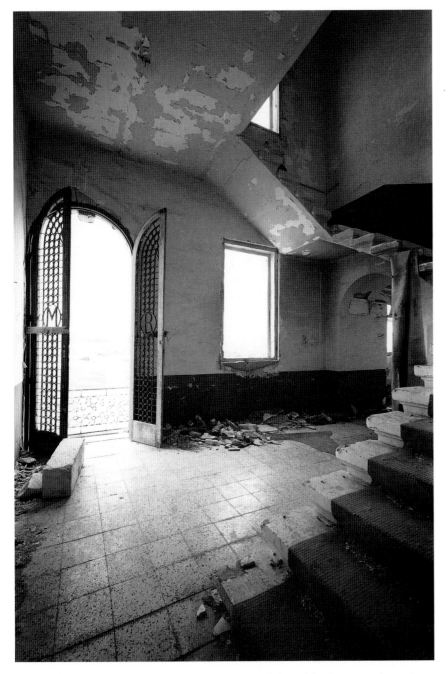

INTERIOR OF LOBBY, RUINED HOTEL
In this book there are several pictures of this building at Ghajn Tuffieja in Malta, which fascinated us. Here, Frances used her favorite Alpa combination again: 35/4.5 Apo Grandagon on 6x9cm Ilford HP5 Plus, but cropped slightly on the long dimension, using an area roughly equal to a nominal 6x8cm. You can always crop a bigger format: gluing bits onto a smaller format is much more difficult.
PRINTED ON ILFORD MULTIGRADE WARMTONE, UNTONED.

take-up spool slot. This is useful, but not essential, and both new-style and old-style films and spools are cross-compatible.

There has been a half-120, which gives 8-on for 15-on, 6-on for 12-on, 5-on for 10-on and 4-on for 8-on (and for that matter 3-on for 6-on and 2-on for 4-on), but it has rarely been seen outside Japan.

DOUBLED-UP 120: 220

The 220 size is twice the length of 120, but fits onto the same-sized spool by the simple expedient of dispensing with the backing paper. Instead, there are black paper leaders and trailers. Obviously, films cannot be advanced via the old "red window" system, so the "start arrow" system (opposite) is the only possibility. Less obviously, some cameras and backs have repositionable pressure plates to compensate for the difference in thickness; a very few have self-adjusting pressure plates; and many are designed for use with either 120

ALPA WITH 70MM BACK
Alpas accept a variety of backs, including
several based on Linhof. They have them
modified to fit the Alpa, and offer a variety
of formats including Linhof's own 6x7cm
and Alpa's 44x66mm.

"SET" IN FILM
This is a Mamiya back, but it is no better
and no worse than any other using the
same sort of film path. Leave the film in
the back overnight, and the next time you
wind on, you will wind on a kink in the
film. As long as you wind on and shoot
reasonably quickly – no more than a few
minutes, or at most an hour or two,
between shots – "set" should not be a
problem. You may, however, decide to
sacrifice (or repeat) the first frame after
winding on, especially if you are shooting
at full aperture or with a wide-angle lens.

(normal) or 220 (rarer), but not both. On the used market, backs for 220
normally sell at quite a discount against 120.

Relatively few emulsions are coated in 220, and it is often cheaper to buy
two rolls of 120 rather than one roll of 220.

LOADING 120
"Always load and unload in subdued light" say the manufacturers' instructions, and with good
reason. They should also add, "Make sure the film is tightly wound off." A modest amount of
light-strike, normally confined to the negative rebate, is by no means unusual, especially if
you allow the slightest degree of unwinding once you have removed the film from the camera.

THE LOST CAUSE: 70MM

The 70mm format is like giant 35mm, with perforations down the sides, and it
is loaded in giant cassettes (page 136) – though cassette-to-cassette loading,
rather than rewinding, is the norm. The standard load is 15ft (4.6m) which
gives rather over 50 exposures in the 6x7cm format. Again, backs tend to
be very modestly priced on the used market.

Very few emulsions are available in this format, but those that are coated
are excellent. Most are to special order only, with the exception of a few
duplicating emulsions.

BARELY SURVIVING: 127

The old 127 format (also known as BS1, No 27, A8 and VP, from "Vest Pocket")
is a miniature version of 120, just 46mm wide. Like 120, it is paper-backed,
and like 120, it supports 8-on (645 nominal), 12-on (4x4cm nominal) and 16-on
(3x4cm nominal) formats. Availability of monochrome is limited; color is rare,
and may cease to be available altogether.

CHECK ROLL-FILM BACKS CAREFULLY
Most professional MF cameras, though far from all, offer interchangeable
roll-film backs, and there are numerous backs that can be fitted onto 4x5in
cameras (page 84). Backs for 120 are far and away the most usual, but if you
have a particular need or desire for 220 or 70mm, check that they are available
from the manufacturer whose products you fancy. When you buy a camera
with interchangeable backs, and it comes with one or more backs, check
carefully what film they take.

Also check the format – 6x6cm, 6x7cm, 6x9cm – and if you are
really suspicious, especially at camera fairs, run a scrap 120 film through the
back, marking each frame, to make sure that the outer shell of the back and its
removable inner mechanism are compatible.

In younger and less wary days, we were sold a Graphic back with a
6x9cm (8-on-120) film gate and a 6x7cm (10-on-120) film advance, and
a 620 Graflex-fit back that we thought was 120 and Graphic-fit.

OBSOLETE FILM SIZES

The most common cameras for an obsolete size are probably for 620 film, which is like 120 but on a narrower spool: if you have any old 620 spools, you can respool 120 onto 620, but it is not as easy as it sounds. This size is also known as BS3, Z20 and No 62.

The 828 size (aka 888, 88 and "Bantam," BS0) gives eight exposures on imperforate 35mm and is long extinct. BS4, better known as 116 or just plain 16, resembles a giant 120, 70mm wide, while BS5 (616, Z16) presumably bore the same relationship to 116 as 620 did to 120, ie a smaller spool. No 10 was 6-on 3x4cm nominal; No 29 was 6-on 2x3in nominal; No 18 or 118 was 6-on quarter-plate (3¼x4¼in) nominal; No 22 or 122 was 6-on postcard, 3½x5½in nominal; and No 30 or 130 was 6-on, 2⅞x4⅞in nominal. Metric equivalents are not given as these films are quite obsolete. A very few obsolete film sizes are, however, available (at a price, and in monochrome only) from a firm called Films For Classics.

SHARLENE
For fashion and similar photography, the Contax 645 has two advantages. First, it is very fast-handling. Second, it gives a choice of 16-on-120 or 32-on-220, the latter with the flattest film in the business thanks to a vacuum back.
210mm Sonnar, Ilford HP5 Plus, printed on Ilford Multigrade Warmtone, untoned.
(Marie Muscat-King)

The small formats: 645 and 66x44

Originally, the format that is today known as 645 was obtained by halving the 8-on-120 format to give 16-on-120. As late as the 1950s, some cameras had removable masks (now often lost) or swing-in flaps, along with two red windows in the back, one for 12-on, the other for 16-on.

The actual dimensions are typically 43x56mm, though the short side may be as little as 41mm. It is normally 15-on-120 with most modern cameras, to give more room between images, though a few cameras (including the Contax 645) are 16-on. On 220, it can be 30-on, 31-on or 32-on.

A great advantage of the 645 format is that it enlarges very well indeed onto most standard paper sizes with minimal wastage. It fits just about perfectly onto 12x16in/30x40cm paper (a 7.1x enlargement is 30.5x39.8cm). Losses are under 5 percent for 8x10in and 16x20in (20x25cm and 40x50cm), and under 10 percent for A4 and A3.

It is very much a "super 35mm" format, tipping the balance quite decisively on quality (especially in color) without sacrificing too much in speed of handling, lens choice and so forth. An increasing number of 645 cameras offer all the features of modern full-auto 35mm, including autofocus and even automatic film-speed reading, via a barcode on the backing paper of the 120 film.

SHARLENE
From the same session as the picture on page 41, this shot by Marie Muscat-King emphasizes the way in which the most technically advanced 645 cameras are very much "super 35mm" in concept – though like us, she preferred to switch off the autofocus, and focus manually.
210MM SONNAR, ILFORD HP5 PLUS, PRINTED ON ILFORD MULTIGRADE WARMTONE, PARTIALLY SEPIA TONED IN SULPHIDE.

> ### 645 BACKS FOR 6X6 CAMERAS
> The obvious way of making a 645 back for a 6x6cm camera means that a prism is required for one orientation or the other, but late Rollei 6x6 SLRs have a particularly ingenious back where the insert can be fitted in either orientation, "portrait" or "landscape," allowing use of the waist-level finder. Hasselblad also makes (or made) a vertical-orientation 645 back that was simply 12-on, masked at the sides, instead of the 16-on 645 that could only be used 'landscape'.

This is an excellent format for color, at least to 12x16in/30x40cm or thereabouts, though for optimum quality in monochrome, anything more than 10x12in/25x30cm (6x) should be approached with caution because of the half-tone effect (page 14). For many commercial applications (including weddings) there is no real need to go any bigger than 645, though for very high quality advertising or fine-art photography this format is marginal and 6x7cm or 6x8cm may in fact be preferable.

Both SLRs and direct vision cameras are made in 645, in autofocus and manual focus. The only real drawback to 645 SLRs is that an eye-level viewing prism is needed, as the viewfinder cannot easily be used with the camera tipped on its side: reversing backs are not used with this small a format, as they would bring the camera up to the size of 6x6cm or beyond. The prism inevitably adds bulk, weight and expense, so 645 cameras are not necessarily any lighter than 6x6cm. With direct vision cameras, this is of course no problem.

66X44MM

At the time of writing, 66x44 was unique to Alpa. It was conceived to take maximum advantage of the 80mm image circle of the 38/4.5 Zeiss Biogon, as also used on the 6x6cm Hasselblad. But 66x44 normally needs to be cropped far less than 56x56, so although it is smaller in absolute terms, more of the image can be used on the important A4 format, at a smaller enlargement: 4.8x instead of 5.3x. The actual format is masked down from 6x7cm and is 10-on: at first sight wasteful, but offering wonderfully wide handling margins on the negatives.

MANCHESTER

The 38/4.5 Biogon on 66x44mm is almost exactly equivalent to 21mm on 35mm, and is Roger's standard lens on the Alpa. Built-in spirit levels, one visible in the viewfinder, make it much easier to level the camera, even hand-held, than is possible with 35mm.

ILFORD HP5 PLUS, PRINTED ON ILFORD MULTIGRADE WARMTONE, TONED IN PATERSON SELENIUM TONER.

The old standard: 6x6cm

The main reason for the existence of the 6x6cm format – more accurately called 2¼in square, actually about 56x56mm – is the reflex camera. With a reflex, obviously, a square format makes a waist-level finder much easier: there is no question of "portrait" or "landscape" orientations, and no need for a prism or reversing back.

Most cameras using the format are 12-on-120, though a few old Zeiss folders were 11-on-120 to allow for inconsistencies resulting from automatic (rather than red-window) film-advance. There have also been plenty of 12-on-620 cameras in this format, and a few 70mm cameras. Many manufacturers also offer 220 backs or dual 120/220 backs.

If the photographer remains in control at all times, the great advantage of the 6x6cm format is that the image can be mentally cropped in the viewfinder, and then printed as originally visualized. In particular, the bottom centimeter or

GURU RINPOCHE

This statue of Guru Rinpoche (in Tibetan, the "Precious Teacher," or in Sanskrit, Padmasambhava, the "Lotus Born") is in a cave beside Tso.Pema (Rewalsar). This is one of the sites that is particularly sacred to the man who brought Buddhism to Tibet in the eighth century CE. *HASSELBLAD 500C, 80/2.8 PLANAR, KODAK ER 64, LIT WITH MULTIBLITZ CT-45. (RWH)*

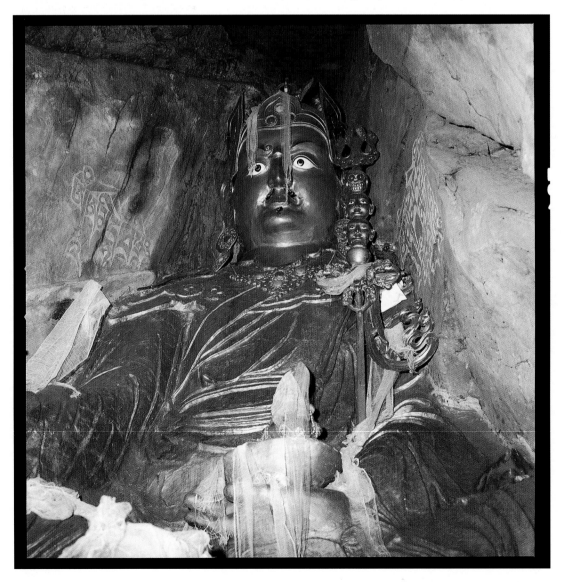

so of the image can be cropped out to provide a degree of "rising front" for horizontal images.

On the other hand, the format has the faults of its qualities. Because it is almost invariably cropped – very few photographers shoot good, square pictures, on a regular basis – the effective film area is about the same as for 645, but you only get 12-on instead of 15-on. If the photographer relinquishes control, as for example when submitting a transparency for publication, the way is open for a purblind art director or designer to make the worst possible crop.

The camera which originally popularized the format was arguably the Rollei TLR, with its raft of imitators from the late 1920s onwards. The original 1928 Rollei used the 6-on 117 format, now long gone, though apparently many were modified to accept 620. Rollei TLRs from the 1950s onwards remain remarkably usable today – earlier models with uncoated lenses are best avoided, except for special effects – but the late 1940s also saw the arrival of an even more enduring design, the Hasselblad SLR. The original 1600F and its slightly more reliable successor the 1000F ("F" for focal plane shutter) gave way in due course to the 500C ("C" for Compur) which was still in production, albeit in improved and renamed form, half a century later.

The enduring popularity of the Hasselblad is a result of its simplicity, small size, light weight, and very high quality. Other 6x6cm SLRs have their own merits, but effectively ride on its coat-tails. Rather more of a puzzle is the popularity of 6x6cm direct vision cameras, where a rectangular format (645, 6x7 or 6x9) has clear advantages. And there really is very little advantage in using a 6x6cm roll-film back on a 4x5in camera, which is why used backs in this format generally trade at quite a discount to 6x7cm and 6x9cm.

Basically, the arguments for and against 6x6cm are identical to the arguments for and against 645, and which you choose is a matter of personal preference and philosophy. Our own prejudice is in favor of 645, simply because we do have to let transparencies out of our control from time to time, but if you can retain full control of cropping there is a good deal to be said for the simplicity of a 6x6 SLR or even TLR. Quality can be superb: a friend of ours once shot a 48-sheet poster on a Minolta Autocord TLR.

CHAM FESTIVAL, TSO.PEMA
To a considerable extent, the camera you use determines the way that you compose the images. This picture can be cropped in a number of ways, but they all entail losses of content that are (in Roger's view) more important than compositional gain.
HASSELBLAD 500C, 80/2.8 PLANAR, KODAK ER 64.

The bigger formats: 6x7/6x8/6x9cm

Although 6x7cm is incomparably the most popular of these three formats, they all have their advantages. As with 645, reflexes need a prism or a revolving/reversing back, and the bigger the format, the bulkier and more expensive this makes the camera: with direct vision cameras, this is a much less important consideration.

6x9cm/2¼x3¼in

Historically, the largest format came first. It was originally conceived as an amateur snapshot film capable of giving small, but acceptable, contact prints. As 8-on, it accompanied the launch of 120 in 1902 or so; very few 16-on-220 or 6x9cm on 70mm backs have ever been made.

The actual image size varies quite widely, with the standard set pretty much at 56x84mm (2:3, the same as 35mm), but a few are as short as 82mm or even 80mm, and a few others are as long as 88mm, which is about the most you can get onto the film if you use the backing paper numbering and line up the numbers very carefully indeed. There is actually enough film for 8-on 56x90mm, but as far as we know, this has never been done.

Today, 6x9cm is more commonly encountered in roll-film backs for 4x5in and "baby view" cameras than in purpose-built 6x9cm cameras, though a few do exist: in the past, there were even 6x9cm reflexes. But unless you want to do panoramic shots or are photographing tall buildings, 6x9cm has few obvious advantages over the smaller sizes. Reloading can become uncomfortably frequent, especially if you are bracketing.

STALAGMITE, GHAR DALAM, MALTA
According to the tenets of camera-club composition, horizontal compositions are more restful and enduring than vertical ones. There is a good deal of truth in this – and a longer, thinner 2:3 format (6x9cm) can have more impact than the stumpier 6x7cm format as a result. Also, the bigger format reduces the impact of the grain of the Ilford Delta 3200 that allowed a reasonably short exposure. *ALPA 12 S/WA, 35/4.5 APO-GRANDAGON, ILFORD MULTIGRADE WARMTONE, TONED IN PATERSON SELENIUM TONER. (FES)*

6x7cm/2¼x2¾in

The origins of the 6x7cm format arguably lie before World War II, when the National Graflex offered 10-on-120, though the format seems to have been around 56x63mm. After the war, Simmon Omega brought out the 9-on-120 format at around 56x68mm – a common size ever since – and Linhof went for 10-on with 56x72mm, the longest "6x7" around. The 6x7cm format in all its manifestations is probably the most common size for roll-film backs for LF cameras, as well as being popular for purpose-built 6x7cm cameras.

MISION SAN ANTONIO, CALIFORNIA
We have mixed feelings about texture screens, superimposed frames and the like, but we rather like this example from The FX Files. If you want to use such things, your choice of format may be governed by the size of the mask that is available. An advantage of the Alpa is that it can accept a wide range of backs from 645 to 6x9cm.
35/4.5 Apo-Grandagon, Ilford HP5 Plus, Ilford Multigrade Warmtone, untoned.
(FES)

6x8cm/2¼x3in

The 6x8cm format seems to have been introduced by Fuji with their big studio reflexes, though Mamiya then brought out a 56x75mm back for the established RB67. These are the only common cameras to use the size, though Alpas can accept Mamiya 6x8 backs. There have not been any 6x8cm roll-film backs for 4x5in cameras, possibly because of the availability of Linhof's 10-on 56x72mm format. Both 6x8cm and the large (Linhof) 6x7cm enlarge very well onto A4/A3, and pretty well onto standard paper sizes, while the smaller 6x7 sizes (56x68mm) go very well onto standard paper sizes and pretty well onto A4/A3.

CHOOSING A FORMAT

Since the late 1980s or so, color films have become so good that 6x7cm, and to a lesser extent 6x8cm, have replaced 4x5in for many professional applications, though it may still be desirable to go to 4x5in or bigger when you need the very highest quality color for reproduction in glossy magazines, or for big monochrome blow-ups, 12x16in/30x40cm and beyond.

Panoramic RF formats

In theory, there is no limit to how far you can "stretch" 120 formats. In the 1970s, the late Colin Glanfield had widened MPP 6x9cm backs from their original 56x88mm to around 56x95mm, and in due course a number of "6x12" cameras and roll-film backs began to appear from major manufacturers, typically 56x112mm but sometimes as big as 56x120mm. These were of course doubled-up 6x6cm, giving 6-on-120 (and rarely, 12-on-220). The advantage of 6x12cm is that a back for this format can be fitted straight onto most 4x5in cameras, and the resulting image can be enlarged using a 4x5in or 9x12cm enlarger. There have also been several complete 6x12cm cameras, from Horseman, Linhof and Art Panoram.

The logical next size up is 6x17cm, or tripled-up 6x6cm, typically around 56x170mm, 4-on-120 (or conceivably, 8-on-220). This gives a wonderfully impressive great strip of film, over four-fifths the area of 4x5in, which can be enlarged in a 5x7in, 13x18cm or half-plate enlarger. Dr A. Neill Wright even worked out a way of building his own 6x17cm cameras, using two old roll-film folders, a specially made lens cone, and a 90/8 Super Angulon in a focusing mount (Appendix II). Proprietary 6x17cm cameras have appeared from Fuji, Linhof, Gilde and Art Panoram: and the Gilde can also be masked down for smaller formats.

There has even been a 6x24cm format, 3-on-120, though the Art Panoram in which it is used is a rather crude camera and an 8x10in enlarger is needed. Although we have used both 6x12cm and 6x17cm, and although they are fun, they are to a considerable extent "freak" formats. A double-page A3 (about

AKROPOLIS

A 6x12cm back – this was taken with a Horseman – can be fitted to many 4x5in cameras (in this case, an MPP with a 150/4.5 Apo-Lanthar). The aim of the shot was to conceal as far as possible the urban sprawl of modern Athens by using a strong foreground.
Fuji Astia 100. (RWH)

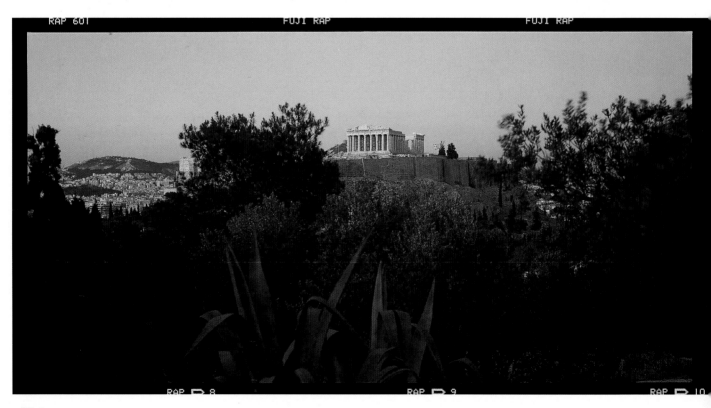

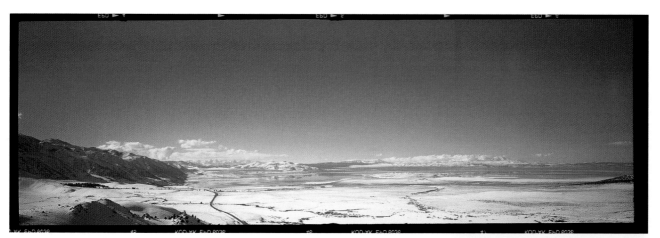

▲ SNOW SCENE
This hand-held 6x17cm shot was taken with the Longfellow camera described in Appendix II. The composition could be better, but there is a certain fascination in seeing so much context.
KODAK EPD 200. (RWH)

► SWINGS, BROADSTAIRS
Linhof's magisterial 617 allows an astonishing range of hand-held pictures, but having to reload every four shots can be tedious if you get carried away or if you want to bracket. As with most 6x17 cameras, there is no "idiot proofing": double exposures and missed exposures are all too easy.
FUJI PROVIA 100. (RWH)

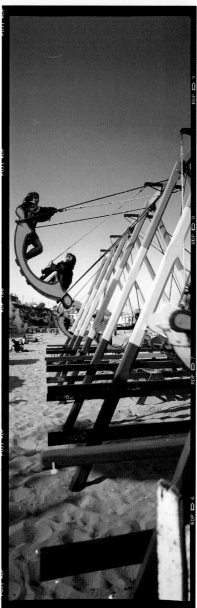

8x10in) spread is the same 7.6x enlargement, whether you use 6x9cm or 6x12cm. If you run 6x12 full width across an A3 double-page spread in a magazine, it is 210x420mm on the 297x420mm spread – an 87mm (3½in) gap underneath, with a 3.75x enlargement – and 6x17 is 140x420mm, rather under half the depth of the spread, albeit with only a 2.5x enlargement.

> **THE IDEAL FORMAT?**
> The 1:2 ratio of 6x12cm can be uncomfortably stubby for a panoramic format, but equally, the 1:3 of 6x17cm can be uncomfortably long. We have found that 1:2.5 is generally a happier compromise, which means chopping off the ends of 6x17cm or cropping 6x12cm to 45x112mm. Perhaps surprisingly, at the time of writing no one had tried a 5-on-120 format of 56x140mm with a 1:2.5 "ideal format," though this may be because they reckon that if you have to use a 5x7in enlarger anyway, you might as well have a longer image.

Compositionally, the normal advice with these very long formats is to have two (or more) centers of interest, well separated, though there is also something to be said for a single center of interest and plenty of context.

For panoramic color, it probably makes more sense to crop 6x9cm or even 6x7cm, as a 12x20in/30x50cm print is still only 7x off the Linhof 56x72mm format. In monochrome, there is more to be said for 6x12cm, where 12x20in/30x50cm is only 4.5x. The 6x17cm format is best reserved for impressing clients with huge original transparencies, or for those rare individuals whose personal vision requires them to work in this way.

SLR design philosophies

NEW YORK SKYLINE

A 150mm lens on a 645 (this was a Mamiya) equates roughly to a 90mm on a 35mm and a 200mm on a 6x7cm. The longer the lens you need, the smaller the format that it is convenient to use. KODAK *ER ISO 64. (FES)*

The popularity of the MF SLR is arguably the result of two fairly disparate causes. One is the sheer genius of the original Hasselblad SLR design of the late 1940s, which was so far and away the most useful MF camera of its era – compact, rigid, handy, with first-class interchangeable lenses – that it changed the course of professional photography. The other is the popularity of the 35mm SLR. Because so many photographers today are brought up, so to speak, on the 35mm SLR, they imagine that in roll film the SLR must again be the automatic choice.

This second assertion bears a little examination. The 35mm SLR is probably the most popular camera for serious amateurs and professionals. This is because it can tackle just about any sphere of photography, from macro to portraiture to reportage to landscape to sports and action. In some areas, especially macro, or photography with very long tele lenses, it is unparalleled. But this is not the same as saying that it is the best camera for every single application. To stick with the 35mm examples with which most photographers are most familiar, the continued survival (and indeed renaissance) of rangefinder cameras bears witness to their advantages for reportage, travel and landscape.

MF SLRs, on the other hand, are niche cameras, more like rangefinder 35mm cameras. They make no great claims to universality, and a particular brand is likely to show much greater strengths and weaknesses than is usual in 35mm, where the leading brands are pretty much interchangeable with one

FAIRGROUND

There is a certain kind of reportage-style photography – shallow depth of field, cropped edges, blur – which can be done more successfully with a fast lens on a 645 (here, 80/1.9 on a Mamiya) than with a 35mm, principally because depth of field is shallower. AGFACHROME *R100S. (FES)*

another. For example, if you want to use long lenses on a 6x7cm camera, then the Pentax 67 is a particularly good choice, while if you do a lot of close-up work, you will generally do better with a bellows-type camera such as the Mamiya RB67 or Fuji 680. Or again, if you do mostly studio work, you are less likely to be worried about weight and bulk than you would if most of your photography is done on location: if you have to carry your cameras far, then either a 645 or a Hasselblad will probably suit you better. It is an interesting thought that cameras from the 1930s, 1940s and 1950s are almost invariably smaller and lighter than their modern counterparts, partly because they are less complicated, but also because fewer people went everywhere by motor car in those days.

Two great divides to this day, however, are the provision (or otherwise) of interchangeable backs, and leaf shutters versus focal-plane.

PIONEER
With a longer-than-standard lens – this was a 127/3.8 on a Mamiya RB67 – you can minimize the "falling over backward" effect that you get when you tilt the camera; however, a shift lens or a "baby" view camera is still a better solution in most cases.
KODAK ER 64. (RWH)

INTERCHANGEABLE BACKS

The vast majority of MF cameras today provide interchangeable backs. These have at least three major advantages. They are very useful if you want to shoot both black and white and color, or if (for example) you want to use both a fast film and a slow film. They are all but essential if you want to check exposure and lighting with a Polaroid back. And if you are working with an assistant, he or she can hand you a freshly loaded back when the film runs out – though for this application, interchangeable inserts are at least as useful, rather more compact, and a lot cheaper.

The importance of interchangeable backs can, however, be overestimated. As far as we are concerned, Polaroids are the biggest single argument for interchangeable backs. But Polaroids are expensive and can slow you down, if you have to keep changing backs, and they are really of most use when you are shooting color transparency films in the studio: with color negative or monochrome, they do not tell you all that much about exposure, and on

location, except with the more contemplative forms of photography such as landscape, they are of limited usefulness.

The other arguments in favor of interchangeable backs are even less compelling. When it comes to shooting both color and black and white, we increasingly find that we can take better pictures if we concentrate on either black and white or color, rather than switching between the two. If there really is a shot which cries out for color when we have mono in the camera, or vice versa, it will generally wait until we have finished the roll: there are not that many pictures on a roll of 120, after all. And as we are normally working independently, without an assistant, we have to stop and reload sometime, anyway. Extra backs are heavy, bulky and expensive: it may very well be that you can live without them.

SHUTTERS

ST JOHN'S IN THE WILDERNESS
If you have to carry your camera any great distance, there is a good deal to be said for smaller, lighter cameras such as the Mamiya 645 used for this picture.
MAMIYA-SEKOR 35/3.5, KODAK ER. (FES)

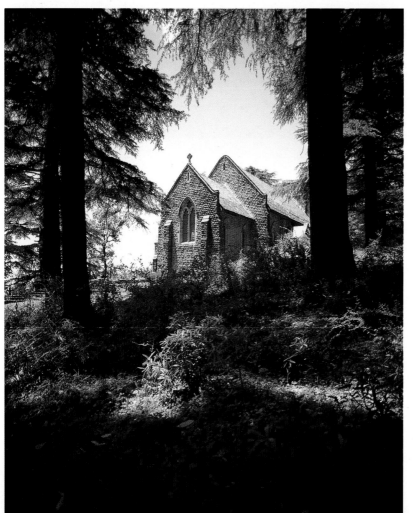

The argument in favor of a leaf shutter (LS) is simple: it synchronizes at a higher speed than a focal-plane (FP) shutter. In the studio, a higher synch speed will remove the risk of "ghost" images from ambient light, though quite honestly, anything above $\frac{1}{30}$ second should be adequate for this. On location, for fill-in flash, it can mean the difference between being able to use the flash, or not. If your ambient-light exposure is $\frac{1}{250}$ second at f/11, and your synch speed is $\frac{1}{30}$ second (not unknown with some FP shutters), you would have to stop down to f/32. Even if you can do this – and many lenses don't stop down this far – you may not want the concomitant diffraction limitations to resolution (page 16), and indeed you may even prefer to go to $\frac{1}{500}$ second at f/8 to throw the background out of focus.

On the other hand, if you don't use flash, why pay for a shutter in every single lens you buy, and why put up with a relatively limited shutter speed range? Few leaf shutters exceed $\frac{1}{500}$ second, and even a marked $\frac{1}{500}$ is often closer to $\frac{1}{350}$ or so anyway. With an FP shutter, you can have $\frac{1}{1000}$ second or even higher, and you are not faced with the choice of restricting the speed of the lens to feed it through a small shutter, or using a bigger, heavier and more expensive shutter, quite possibly with a lower top speed even than $\frac{1}{500}$ second.

There is also the point that all focal-plane shutters are not created equal. The Contax 645 offers a $\frac{1}{4000}$ second top speed and flash synch at $\frac{1}{250}$ second; but some of the older "giant 35mm" designs have a maximum flash synch speed of $\frac{1}{10}$ second.

ASPENS, ARIZONA
Mamiya's RB67 may be long in the tooth, and slower handling than some, but its versatility is unrivaled: bellows focusing persuaded Roger to switch from the Hasselblad, and while the rotating back adds weight, it is very quick to use.
50/4.5 Mamiya-Sekor, Kodak ER 64

WORLD TRADE CENTER, NEW YORK
Mamiya's "baby," the 645, is a cuboid-style SLR with an FP shutter, available in various levels of sophistication. The least expensive is an excellent entry-level camera, if you don't need leaf-shutter lenses or Polaroid backs.
35/3.5 Mamiya-Sekor, Kodak ER 64. (FES)

CUBOID AND "GIANT 35"

Most MF SLRs today are based around a roughly cuboid body with a lens mount at one end and a fitting for interchangeable roll-film and Polaroid backs at the other. There are, however, a few – the Pentax 67 is the best known – that resemble giant 35mm SLRs.

Which you prefer is very much a matter of personal choice, and of what you want to photograph, but you should not make the mistake of assuming that because you are used to a 35mm SLR, a scaled-up 120 version will be easier to use than a cuboid. With the Pentax, for example, many people will find the automation of the 645 a great deal easier to live with, despite its unfamiliar shape, though equally, there are plenty who swear by the bigger image of the 67.

If you need a Polaroid back, the "giant 35" style is bad news because you need one with an expensive fiber-optic transfer plate, and you need to dedicate a body to Polaroid because you lose a frame every time you remove and replace the back, which is a pretty slow process anyway, and (of course) you have to wind off the conventional film before you can switch backs.

On the other hand, the big Pentax (in particular) is very fast handling and offers a better range of long, fast lenses – the latter being a decisive argument if these are what you need.

SLR viewfinders

With 35mm, the pentaprism is so popular that it is actually fixed on many cameras, and even where it is removable, the vast majority of photographers never use anything else. With roll film, it is disputable whether the pentaprism or the "waist-level" finder (actually chest-level, of course) is more popular, and the choice of other finders is wider than one might expect.

WAIST-LEVEL FINDERS

Until the advent of the pentaprism, these were the only choice, and they remain very popular to this day. Unless the camera is square format, you need either a revolving back or a prism.

All conventional waist-level finders incorporate a flip-up magnifier for critical focusing: many allow interchangeable magnifiers to compensate for individual eyesight. On Rollei TLRs, the waist-level finders have an opening panel in the front of the hood, and a peep-sight in the back, in order to convert the finder into a frame or sports finder; however, as far as we are aware, this has not been extended to SLRs.

GOLDEN GATE BRIDGE
Many people find that a waist-level finder makes composition easier, because the image is more isolated and easier to contemplate for its own sake.
MAMIYA RB67, 127/3.8 MAMIYA-SEKOR, KODAK EPR 64. (RWH)

"STOVEPIPE" FINDERS

These consist of a rigid, tapering tube with an eyepiece (which may have dioptric adjustment) at the top. They normally allow higher magnifications than plain, folding waist-level finders, but they are a lot bulkier, so they are more use in the studio than in the field. Some incorporate through-lens meters.

PRISMS

These fulfil the same function as on a 35mm SLR, allowing right-way-up, right-way-round viewing. They are of course big; they are not cheap; and if they are true prisms, rather than mirror systems, they are also heavy. To save weight, bulk and cost, some trim quite a bit off the edge of the field of view, too: the Pentax 67 is notorious for this, though equally, many like this feature as it provides a margin of safety.

Unless you use a square-format camera, or one with a revolving back, a prism is all but essential: trying to use a waist-level finder with the camera tipped on its side is altogether too much like hard work.

Some prisms contain the entire metering system of a camera, while others complement

the electronics built into the camera. The degree of cross-coupling varies widely, but with modern cameras, all communications (including film speed setting) are made electronically, and full viewfinder information and automation are the norm. A few old-fashioned prisms incorporate uncoupled meters.

DIRECT VISION FINDERS

There are two reasons for fitting a direct vision finder to an MF SLR. One is if you want to use the camera to follow action, but do not want the bulk or expense of a prism. Trying to follow a moving subject with a waist-level finder is something that some master easily, but many find extremely difficult; the subject, of course, moves in opposite directions in real life and on the focusing screen: if it is left to right in real life, it is right to left on the screen.

The other reason can be even more compelling. With roll-film SLRs, there is a considerable degree of "temporal parallax" – as much as $\frac{1}{10}$ second – between pressing the shutter release and taking the picture. A "pre-release" cuts this to $\frac{1}{60}$ second or less, as the mirror is already out of the way, the auxiliary shutter open, and the in-lens shutter cocked and ready to fire. Of course, once the mirror is up, you have no way of focusing: you have a scale-focusing box camera.

INTERCHANGEABLE SCREENS

The arguments for and against interchangeable screens in MF cameras are much the same as they are for 35mm cameras. Some people are perfectly happy with a single, standard, "universal" screen; others find that another screen suits their particular style of working; and yet others work with a range of screens. And, as with 35mm, "aftermarket" screens are also available, usually for improved brightness. These can be particularly useful with older cameras, where they are often the only alternative to old, dull screens. Even if the screen is not obviously user-changeable, a newer, brighter screen can often be installed quickly and easily by a competent repairer or by a brave and dextrous user.

ST PATRICK'S, NEW YORK
For quick shots, as on New York's bustling streets, a prism is hard to beat. *MAMIYA 645, 35/3.5 MAMIYA-SEKOR, KODAK EPR 64. (FES)*

BROKEN LAMP, BRAGANZA
A prism finder, as fitted to the Mamiya 645 used to take this picture, can of course be used for considered shots every bit as easily as a waist-level finder; and it makes the camera a lot easier to tip on its side.
80/1.9 MAMIYA-SEKOR, KODAK ER 64. (FES)

The manufacturers

Among MF SLRs, there are seven big names: in alphabetical order, Bronica, Contax, Hasselblad, Mamiya, Pentax and Rolleiflex. Although model changes are relatively infrequent in MF as compared with 35mm, there is little sense in giving a blow-by-blow account of the different models, as they can and will change. It is a better idea to look at the design philosophies they have demonstrated over the years.

BRONICA

Bronica's devotion to the cuboid shape goes way back to the late 1950s, with a 6x6cm camera. They currently make 645, 6x6cm and 6x7cm models, all with focal-plane shutters and fully interchangeable backs, including Polaroid. The 67 is particularly compact, but requires a prism if it is to be tipped on its side. Slightly old-fashioned in their absence of automation, they are widely used by both professionals and amateurs.

Many of their earlier cameras, which somewhat resemble Hasselblads, remain in use to this day. They have excellent lenses but are a little clunky, and if they break, repairs may be a problem – though of course their modern cameras are as reparable as anyone's.

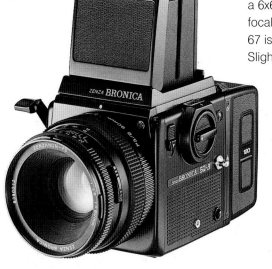

▲ BRONICA SQ-B
The 6x6cm Bronicas (SQ-Ai and SQ-B) are the backbone of the system, and are excellent workmanlike cameras.
(COURTESY BRONICA)

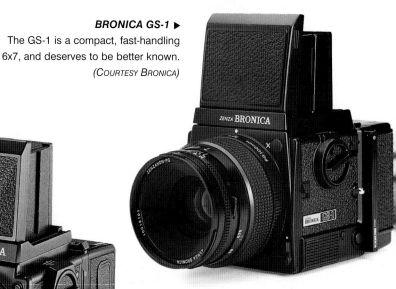

BRONICA GS-1 ▶
The GS-1 is a compact, fast-handling 6x7, and deserves to be better known.
(COURTESY BRONICA)

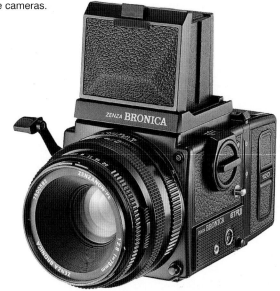

◀ BRONICA ETR-Si
For many, a major attraction of the 645 ETR-Si is a full range of leaf-shuttered lenses.
(COURTESY BRONICA)

CONTAX

The new kid on the block, the Contax 645 appeared at *photokina* 1998 with lots of automation (including autofocus, electric film advance and multiple exposure modes), superb Zeiss lenses and fully interchangeable backs with the option of interchangeable inserts as well. The control layout is similar to 35mm Contax cameras. The Contax 645 is arguably the closest of all MF SLRs to a modern, fully auto 35mm SLR in handling and features.

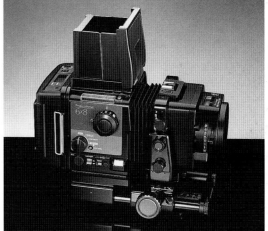

CONTAX 645
The first-ever MF camera to bear the Contax name. One of the attractions of the 645 for reactionaries is that when you switch off all the automation you are left with an excellent manual camera.

FUJI

A big name, and a big camera, but not a big seller, at least in the MF SLR market. Fuji's GX 680 is massive, with bellows focusing and useful movements on the front standard, and a revolving back. It is also very highly automated. In the studio, it is wonderful. On location, both the size and the rather stiff price tell against it. Backs are fully interchangeable, with a variety of sizes from 6x8cm downwards, plus Polaroid.

HASSELBLAD

Widely regarded as the ultimate 6x6cm SLR, not least because of its Zeiss lenses, the basic Hasselblad design is relatively little changed from the 500C (Compur shutter) in 1957. The first Hasselblad SLR, the 1600F (focal-plane shutter), appeared in 1948; the later 1000F was more reliable. As well as the C-series, there are also current models with focal-plane shutters, and various levels of metering. All are 6x6cm only, though 645 and Polaroid backs are available.

Older 500C series cameras remain extremely usable to this day, and may be integrated with current bodies and lenses. Roger bought a second-hand 500C in about 1980, and sold it to a friend in about 1985. The friend has been using it professionally ever since. This camera is now about 40 years old!

FUJI GX 680 II
Built for supermen, the sheer heft of the GX 680 is intimidating, but once it is on the camera stand, it is a pleasure to use. (COURTESY FUJI)

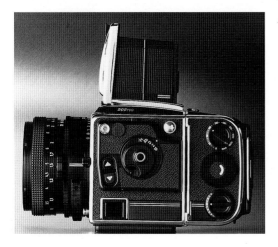

HASSELBLAD
The resemblance between the high-tech 205FCC and the original 500C is clear, and there is a very high degree of interchangeability over more than four decades of Hasselblads. (COURTESY HASSELBLAD)

MAMIYA

Mamiya make two types of 6x7cm camera, the all-mechanical RB67 and the more electronic RZ67, as well as both manual-focus and autofocus 645 cameras; but no 6x6cm. The RB and RZ, with their bellows focusing and fully interchangeable backs (including Polaroid), are widely used professional work-horses: indeed, older cameras may have been worked almost to death, and well worn examples should be examined carefully. Revolving backs remove the need for a prism, but add bulk and weight. On the basic RB, shutter cocking and film wind are independent.

The 645s are more popular in the amateur market, though they are also widely used professionally for applications ranging from weddings to aerial photography. Some have interchangeable inserts rather than backs.

▲ MAMIYA 645 Pro TL
This camera offers 35mm-like convenience in a 645 package.

◄ MAMIYA RB67
This is one of the great professional workhorses.

PENTAX

Pentax make two very different styles of camera, the "giant 35" 67 and the cuboid 645, the latter both autofocus and manual focus. There is no 6x6cm. Pentaxes traditionally offer a wider-than-usual assortment of lenses, with the 67 particularly strong on long, surprisingly fast lenses. Early 67s were not as reliable as later ones, even when they were new, and do not improve with keeping. Most Pentaxes require Forscher Probacks (page 29) if you want to use Polaroids. The prism on the 6x7cm trims off quite a lot around the edge of the field of view, in order to keep size and weight to a minimum.

▲ PENTAX 645N
The way in which 645 cameras are to a considerable extent "pumped-up" 35mm is well illustrated by this 645N.
(COURTESY PENTAX)

◄ PENTAX 67II
The surprise update of the elderly Big Pentax took account of suggestions that had been gathered over the decades, and made for an even easier-to-use camera.
(COURTESY PENTAX)

ROLLEIFLEX

Whether you regard the Hasselblad or the modern electronic Rolleis as the ultimate 6x6cm SLRs will depend on your taste for automation. Both feature manual-focus German-made Zeiss lenses, but the Rolleis were designed from the outset for auto-film advance and auto-exposure, including the best auto-bracketing in the business. They also have very fast leaf shutters. Backs are fully interchangeable, including a 645 back that can be run "portrait" or "landscape" (the Hasselblad's is landscape only).

The old bellows-focus Rollei SL66, with limited front tilt, retains its admirers to this day.

OTHER MANUFACTURERS

Most of the remaining manufacturers of SLRs are East European, though there are also a few makers who have fallen by the wayside. The 6x6cm Russian/Ukrainian Zenit 80 and Kiev 88 are often known as Hasselbladskis, from their resemblance to the Hasselblad 1000F. They are not famed for their smoothness or reliability, though a few distributors all but rebuild them before sale, making a very much better camera: Kiev USA is one of the most respected.

There are also Ukrainian "giant 35" cameras, the Kiev 60 and 645 (a masked-down 60), which are subject to the same caveats. Quality control on lenses for these and the Hasselbladskis varies widely, though the best are very good and some are so good that people buy the cameras just to use them: the fish-eye in particular.

The Exakta is another "giant 35," made in the former East Germany, but availability seems to be on-again, off-again and there are persistent doubts about film spacing. Lenses range from first-class Schneider to very dubious Eastern European.

Among those makers who have gone before (or who are at least resting), there are Kowa, Corfield, Agi (Aeronautical and General Instruments), Pilot, Primarflex and others. Kowas were made into the 1970s and perhaps beyond: they are surprisingly good cuboid 6x6cm SLRs with good lenses but noninterchangeable backs, and if they break, they may well be irreparable. All obsolete MF SLRs, except Kowa, are primarily of interest to collectors rather than users.

ROLLEI 6001 PROFESSIONAL
A fascinating camera, the Rollei 6001 manages to wear its technology lightly: it is surprisingly easy to use.

KOWA/SIX
This camera belonged to Frances's late father, and remains a surprisingly usable camera to this day, with switchable 120/220 pressure plate and a range of good lenses.

Direct vision cameras

We bought this camera primarily to use with Ilford Delta 3200 – the 80/2.8 lens was the big attraction – but we have come to appreciate it more and more for all films.

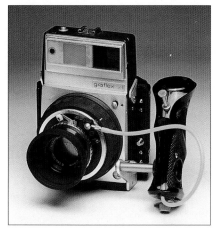

IN CAMERA

The heavy drapes, the imposing thrones for the judges, the stool for the accused: everything in the Palace of the Inquisitors in Birgu in Malta was designed to inspire fear. Frances put her Alpa 12 S/WA on a tripod to shoot this on Ilford HP5 Plus.
35/4.5 Apo-Grandagon, printed on Multigrade Warmtone, toned in selenium.

We have used the term "direct vision" because it encompasses rangefinder, autofocus and scale-focus cameras. Direct vision cameras are normally much more compact than SLRs, and when it comes to wide-angles, they normally deliver much better performance because the lens design does not have to have the extra back focus needed to clear the flipping mirror.

Few rangefinder MF cameras remain in production, though Fuji has over the years offered a bewildering variety of 6x9cm, 6x7cm and 645 cameras, mostly with fixed lenses: some of their early "giant Leicas" had interchangeable lenses. Mamiya very sensibly went to 6x7cm for the Mamiya 7 – the square format of the Mamiya 6 seems curious – and among out-of-production cameras that are still reasonably modern, it is certainly worth looking out for the following:

Plaubel 67 The Japanese incarnation of this *doppel-klapp* folding camera had either a fixed 80mm Nikkor or a fixed 55mm Nikkor. The front is connected to the back by X-shaped struts, like its German predecessor that is illustrated on page 65.

Linhof 220 Despite its name, it used 120 film. The 95mm lens is fixed, and the camera is bulky but very fast handling with an excellent rangefinder.

Graflex XL These American-built cameras have interchangeable lenses with multiple bright-line frames in the viewfinder, and interchangeable (but noncoupled) roll-film and Polaroid backs. The rangefinder is excellent, while the lenses vary from good to the best you can get (including f/2.8 Zeiss Planars).

Simmon Omega/Koni-Omega/Omega The original Simmon Omega is spectacularly ugly and very bulky, but surprisingly usable. Later Japanese-built Koni-Omegas (by Konica) and plain Omegas have better lenses. The interchangeable backs are strange but fast handling; as far as we know, there never was a Polaroid back.

Mamiya Press These have interchangeable lenses and backs, though later lenses are much better than earlier ones. The (uncoupled) backs are particularly interesting as they are multi-format (645 to 6x9cm).

ROLL-FILM FOLDERS

Old folding RF-MF cameras are rarely a good buy today: even if the struts were rigid when the camera was built (and many weren't), they are unlikely to have improved with age, and the lenses were mostly unimpressive. This is true even of the legendary Zeiss Super Ikontas, which we have found to be wildly overrated.

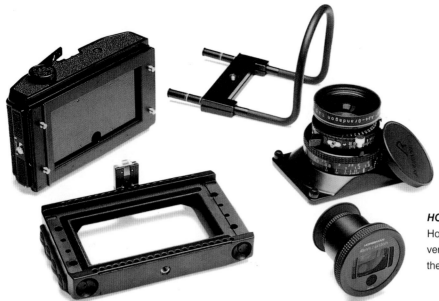

HORSEMAN 6x12cm
Horseman's 6x12cm uses an adapted
version of their back for 4x5in cameras:
the modular construction is clearly visible.

AUTOFOCUS

Fuji is the leader in autofocus 645 "giant compacts," which deliver very much
better results than 35mm, assuming you want to blow your compact shots up
to 8x10in and beyond. They have a certain charm, but we must confess that
we have never had a burning desire to own one.

SCALE-FOCUS CAMERAS

Some scale-focus cameras are based on 4x5in systems, such as Cambo and
Sinar, while others are *sui generis* such as the Hasselblad Superwide, the
Corfield WA67, Silvestri, Horseman and Alpa. All have
separate film wind and shutter cocking, and are at
their best with extreme wide-angle lenses, at which
point a very great deal depends on precision of
manufacture. The only ones we have used extensively
are Alpas, which are second to none in quality of
construction and results, though the WA67 (recently
discontinued) also impressed us very much. Scale
focusing, together with intelligent use of the depth-of-
field scale, is more than adequate for lenses up to
about 58mm on MF.

PANORAMIC CAMERAS

From ultra-wides to panoramics is not a very great
step, though paradoxically, we have often found that
extreme wide-angle lenses (such as the 35mm f/4.5
Apo-Grandagon on 6x12cm) do not deliver the best
panoramas: 110mm or even 150mm on 6x12cm can
be a lot more effective. Cambo, Sinar, Silvestri and
Horseman can all be used with 6x12cm backs, and
the Linhof 6x12 is designed exclusively for this format.

Another option for panoramas is 6x17cm, which is
available "off the shelf" from Fuji and Linhof, both with
interchangeable lenses, or (at considerably less cost)
as a home-made camera as described on page 154.

THANGKA PAINTER
Roger uses his Alpa 12 WA for reportage
as well as for landscapes, architecture
and more: the stunning quality of the
38/4.5 Biogon on the 66x44mm format is
what endears the camera to him. This
was shot on Fuji Astia.

Other roll-film cameras

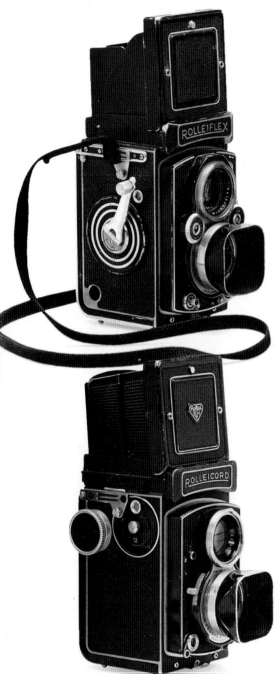

As well as SLRs and direct vision cameras, there are two other important types: the twin-lens reflex (TLR) and the "baby" view camera.

TWIN-LENS REFLEXES

The TLR is effectively two cameras, one atop the other. The lower camera is a box camera, and the other one, on top, is a single-lens reflex. Both lenses can be mounted on a single panel and focused together, so very accurate focusing and entirely adequate composition (subject to parallax) are possible. Better still, the camera can be made very rigid and precise, and extremely strong. This was why the TLR was so popular for so long, from the end of the 1920s (when it was popularized by Rolleiflex) to the 1960s and indeed beyond (when it was increasingly supplanted by the more versatile SLR).

The TLR offers continuous viewing, extremely quiet operation and (for those who like them) almost instinctive handling, though there are a few people who simply cannot get on with them: Roger is one, though Frances has never really tried. Parallax compensation, typically down to about 1m (3ft), is accomplished via a moving mask (or moving bars) on the upper focusing screen, or sometimes by tilting the upper camera automatically inside the housing. For still closer distances, matched pairs of lenses are available, the one for the upper lens having a built-in parallax compensation wedge. Mamiya's "Paramender" sits between the camera and the tripod, and with a quick winding action raises the taking lens to the position of the viewing lens, a useful feature on a camera that can focus very close by reason of its bellows construction.

TLRs were particularly popular for reportage, travel and portraiture – though the fixed lenses, usually 80mm, meant that they were more suitable for half-length or full-length portraits than for head-and-shoulders. A few models, notably Mamiya's C-series, offered interchangeable lenses, though the penalty was separate shutter cocking and film wind. Where a manufacturer offered both 'Flex and 'Cord models (as in Rolleiflex/Rolleicord, MPP Microflex/Microcord), the 'Flex normally offered coupled film wind/shutter cocking, the 'Cord, separate. The very rare Rollei Wide and Tele Rollei have fixed lenses and deliver stunning quality but are so prized by collectors that they are no longer really in the realms of "user" cameras.

An unusual feature of Rolleis, since 1937, has been automatic film counting with automatic start. The leader is fed through a pair of rollers, which detect the bump when the film itself starts and zero the counter at that point. Rolleis also have focusing hoods that are convertible to frame finders, sometimes with a mirror to allow (somewhat inconvenient) focusing on the ground glass, at eye level, through another aperture below the viewfinder peep-hole.

"BABY" VIEW CAMERAS

There is no particular reason why a roll-film camera should not be built along the same lines as a 4x5in camera. The best known (and best) are probably the

▲ ▲ ROLLEI TLRs
The 'Flex above has lever wind with coupled film wind/shutter cocking, while the 'Cord has knob wind (though still with automatic film spacing) and separate shutter cocking. 'Flexes were available with and without meters.

"baby" Linhofs, which were normally made as Super Technikas: "Super" implies a coupled rangefinder/viewfinder that can be used when all movements are set at zero. We used these for years, until we realized that we almost never used them hand-held. At that point we had a Technika 70 modified, with the rangefinder/viewfinder and all the couplings removed, which made it a great deal lighter and allowed us to have a trapdoor fitted in the top for extra rise.

With modern films and lenses, a 6x7cm or 6x9cm "baby" can deliver exquisite quality. On the other hand, the savings in weight and bulk, as compared with 4x5in, are not always all that great, and vary from maker to maker: our Toho FC45X 4x5in camera is smaller and lighter than the 6x9cm Cambo 23 we used to have, and wooden "babies" can be surprisingly bulky. Also, because "babies" sell in far smaller numbers than 4x5in, they are often more expensive.

HONFLEUR, NORMANDY

This was taken with one of our earlier "baby" Linhofs, a Super Technika IV, using a (Linhof-selected) Schneider Xenar 100/3.5. The lens we use now, a Schneider Apo-Symmar 100/5.6, is contrastier, sharper, and allows more movement – especially with the modified camera.
FUJI PROVIA 100. (RWH)

"BABY" LINHOF

This is the modified Technika 70 referred to in the text: not pretty, but extremely useful, and about a quarter of the price of a new Technika V even after allowing for the cost of the camera and the labour of conversion (by Bill Orford, who was asked to keep costs to a minimum).

Using very old cameras

▶ PLAUBEL MAKINA OUTFIT

The rangefinder Plaubel Makina was made from the 1930s to the early 1960s, unfortunately with the 100/2.9 Anticomar as a standard lens the whole time. Later coated versions, as on this camera from about 1960, are not too bad, and the fact that the rangefinder is out on many examples is to blame for much of the softness. The camera itself was beautifully made and highly functional, and a later Japanese camera of the same name, built on the same lines but with a fixed 80/2.8 Nikkor, is highly sought after to this day.

Even if you do not choose to use an antique camera as your only MF camera – as a rule, we prefer more modern equipment – it is still fascinating to be able to run a few films through the cameras of the past.

Some inspire new respect for the photographers of yore, and the problems they had to endure: tiny, squinty viewfinders, red-window film advance, flat, soft lenses, no interlocks to avoid double exposures or blanks, and so forth.

Others make one wish that someone would make something similar today, a little bit more up to date, with modern lenses and film holders. Many old cameras are far more compact than their modern counterparts, and provide useful features such as a rising front, interchangeable 6x9cm backs (and of course ground glass focusing), and the option of hand-held use.

Any camera that accepts 120 film can still be used, or you can respool 120 onto 620, or even buy old film sizes from Films For Classics. The main things to look out for are bellows without pinholes, shutters that don't stick, and reasonable rigidity. Many old roll-film folders were not very rigid to begin with, and they will not have improved with keeping. If you have a particularly sloppy example, be realistic in your expectations – but remember that another fruitful source of unsharpness is lenses that have been stripped and reassembled wrongly – in particular this applies to front-cell focusing lenses with multi-start threads.

As a general rule, most old lenses (especially from the 1950s and earlier) had less contrast than modern lenses when they were new, and may well have lost a little more contrast over the years, typically as a result of lubricants from the shutter and diaphragm distilling onto the glass. The resultant veiling flare – an overall flare, not the clear-cut flare patches you get from reflections of the diaphragm – will normally promote a blue cast out of doors, as well as reducing overall contrast.

Having old lenses stripped, cleaned and reassembled is rarely cost effective, and there is a limit to which the wise photographer will carry out such disassembly himself (or herself). On the other hand, it is often entirely possible to remove the cells from the shutter (mark them before you do, to make sure that they go back to exactly the same position); clean them, preferably with Opti-Clean; and finally to reassemble them. It may also be possible to substitute newer lenses for older ones, though this is quite likely to spoil scale or rangefinder focusing.

COMBAT GRAPHIC

On the grounds of price alone, this rare 70mm "giant Leica" is likely to be of more interest to collectors than to would-be users, but it is a surprisingly easy camera to use. It was kindly loaned by Paul-Henry van Hasbroeck.

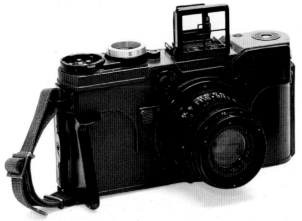

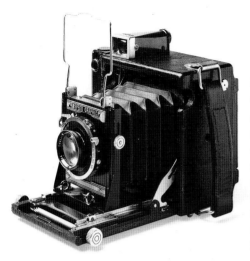

"BABY" SPEED GRAPHIC

"Speed" Graphics have focal-plane shutters; plain Graphics can only be used with shuttered lenses. The "Baby" or "23" can sometimes be found with a roll-film back, though many (like this one) take only small-format cut film. Fitting new lenses is easy, though, and the rangefinder can even be made to couple. This was kindly loaned by David Bebbington.

▼ EARLY PLAUBEL MAKINA

The *doppel-klapp* construction allows the camera to collapse to the size of a paperback book, but (as with most folding cameras) wear and tear take their toll. This camera dates from about 1935; Makinas were very popular at one time as "miniature" press cameras.

OPTI-CLEAN

This is a pretty miraculous product, originally designed for the electronics industry. It comes in a little bottle, like nail polish. You paint it on; wait for it to dry; then peel it off. If it is used in accordance with the instructions, it is very easy to use, and it is safe for both coated and uncoated lenses. Unfortunately, even though it is made in the United States, it is not available for photographic use in that country.

▼ SEA FRONT, MINNIS BAY

Frances shot this with the 1930s Plaubel Makina illustrated: if one were going to use it more seriously, one would need to renew some of the velvet light-trapping (and probably tape over the space for the dark slide in the back), and realign the rangefinder, ground glass and film back.
ILFORD 100 DELTA, PRINTED ON ILFORD MULTIGRADE COOLTONE, TONED IN TETENAL GOLD TONER.

LARGE FORMAT

The popular perception is that large format cameras are big, expensive and complicated. Well, one out of three isn't too bad. Most of them are indeed fairly big and heavy, though our lightest full-featured 4x5in monorail actually weighs less than some of the current generation of big 35mm auto-everything SLRs.

As for expense, not many new 4x5in cameras cost as much as a top-of-the-line Nikon or Canon 35mm; most are in the same class as a medium-to-good 35mm SLR; and a few are comparable in price with the cheapest sort of 35mm SLR that most serious photographers would want to consider. On the used market, prices start in the same range as a modest autofocus compact: for the price of a decent zoom 35mm compact, you can often find a complete outfit, quite possibly with more than one lens.

When it comes to complication, they could hardly be simpler. There are more steps to using LF cameras than there are to using 35mm or MF, and it is quite possible to forget to carry out one of those steps, in which case you may not get a picture; but each step is very simple indeed, and after working with a checklist for a while (see panel), operating an LF camera becomes second nature. Before we go on to look at the cameras, however, it makes sense to look first at the features that are common to most LF cameras, regardless of type, and then at the formats and film handling.

▶ **SOPHIE MUSCAT-KING**
LF portraiture is quite demanding – keeping the subject in focus is not the least of the difficulties – but the tonality that LF can give makes it worth persevering. Even old, low-cost cameras and lenses are adequate: this was shot with an MPP Mk VII and a 1950s-era Symmar 210/5.6.
ILFORD 100 DELTA. (RWH)

OPERATING SEQUENCE FOR LF CAMERAS
1 Open shutter.
2 Focus and compose on ground glass.
3 Adjust movements (page 68) and check focus.
4 Set aperture and shutter speed.
5 Close and cock shutter.
6 Insert film holder.
7 Withdraw film sheath.
8 Take picture.
9 Replace film sheath, black side out (page 76).
10 (Optional) Remove film holder, open shutter, check picture.

Camera movements

▼ BRISTOL, NEAR CASTLE GREEN.
MPP Mk VII, Zeiss Tessar 150/6.3, Ilford FP4. (RWH)

Camera movements tend to scare the novice silly, but they are very easy to understand as long as you look at them methodically. They fall into two groups: shifts, and swings or tilts. Shifts move the front and back of the camera parallel to one another, while swings and tilts throw the lens panel and the film out of parallel.

SHIFTS

Vertical shift or rise is the easiest shift to understand. It works in exactly the same way as a shift lens on a 35mm camera. Instead of tilting the camera, you keep the front and back parallel with the subject, and move the lens upward. This moves the image upward, bringing in more of the top of the subject (usually a building) and cutting out some of the foreground. This avoids the "falling over backward" effect that you get when you tilt the camera. Instead of raising the front, you can also lower the back (at least on some cameras) and this has the same effect.

The other shifts are downward vertical shift (fall), and left and right shift (cross). You use fall when you are looking down on a subject – especially useful in still lifes, though also handy when you are looking down a flight of stairs – and you use cross when you want an apparently head-on picture of a subject but cannot shoot from the desired position. With cross, you can choose an apparent viewpoint in the middle of a busy road, or shoot around an inconvenient obstacle. You can even shoot a mirror without appearing in it, as the drawing at left shows.

SWINGS AND TILTS

The use of swings and tilts is easy to understand when you think about focusing. Something that is near the camera requires more bellows extension; something that is further away requires less. If the near subject is on one side of the picture, and the far subject is on the other side, you use the swing to have more bellows extension on one side of the camera than the other. If you are photographing a receding plane, such as a table top, you use the tilt (horizontal swing) to hold it in focus from front to back.

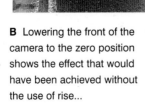

A A fairly typical, if unremarkable, use of movements enables a tall building to be photographed without any "falling over backward" effect, more or less head-on.

B Lowering the front of the camera to the zero position shows the effect that would have been achieved without the use of rise...

C ...and centering the cross movement shows that the photographer could shoot from the curb, rather than the middle of the road.

Front swings and tilts affect focus, but not image shape, while rear swings and tilts affect both focus and image shape. It is not hard to see how the latter works. Imagine a slide projected head-on to a wall, then projected at an angle. If it is projected at an angle, the shape changes: you get "keystoning," with the further part wider than the nearer part.

CATHEDRAL GATE, CANTERBURY
Linhof Technikardan, 90/6.8 Angulon. (RWH)
A The 90mm Angulon (not Super Angulon) nominally covers only 4x5in...
B ...but in practice, especially if there is no detail in the corner of the image, quite a bit of rise is possible, especially at f/32...
C ...though eventually, the lens simply runs out of coverage, and the corners of the image go dark.

THE SCHEIMPFLUG RULE
This is an easy way of checking how much swing or tilt you need. When the subject plane, the lens panel plane, and the image plane all meet at a single line, then everything in the subject plane will be in focus in the image plane.

▼ BOOKSHELF
Cambo 6x9cm Monorail, 150/4.5 Apo-Lanthar. (RWH)

A At full aperture, without any swing, only a few of these books are in focus...

INDIRECT MOVEMENTS
These are obtained by using two swings or two tilts together to get extra movement. Here, you can see how you can get extra rise by using both the front tilt and rear tilt together, keeping the two standards parallel with the subject but angling the base of the camera.

B ...but with swing, all can be brought into focus without stopping down, a classic illustration of the Scheimpflug Rule.

Focusing and depth of field

MINAS DE COBRE, SANTOS DOMINGOS, PORTUGAL

In a shot like this, where front-to-back sharpness is important, you may do better to use roll film. The big drawback to fast film and a small aperture with a larger format is that the image may be too dim to check focus fully. Going to roll film does not mean abandoning movements: this was shot with a "baby" Linhof (page 63) or you could put a roll-film back on a 4x5in camera.
SCHNEIDER XENAR 105/3.5, ILFORD 100 DELTA. (RWH)

If you are not employing any movements, then focusing is simply a matter of making sure that the image looks sharp on the ground glass. People get very excited about what sort of magnifier you should use, but it really does not matter very much: a fancy aspheric magnifier is nice, but a cheap plastic loupe is still a great deal better than nothing, and works perfectly adequately. As long as you have reasonable close-up vision (with glasses if necessary), you can even focus without a magnifier most of the time: when the image looks most contrasty, it is sharpest (which is pretty much how many autofocus systems work).

Without movements, you do not even need a focusing cloth: a simple hood is normally adequate (page 74). If you want to judge depth of field, or to use movements, or if your eyesight is not good enough in the close range, then it is wisest to use a focusing cloth and a magnifier. Once again, you can use any power of magnifier that you like, though a tilting magnifier is useful: as you get nearer to the edges of the focusing screen, you need to angle the magnifier inward more and more, especially with wide-angle lenses.

Although most LF users tend to err on the side of caution when they stop down for depth of field, it is still a good idea to stop down no further than strictly necessary. With modern lenses, optimum definition is often obtained at f/16 or even f/11, and stopping down further will result in less sharpness as diffraction limits become ever more important.

EXTENSION

Bellows extension may be given numerically – for example, as 500mm or 20in – or as "double extension" and "triple extension." The latter terms take as their base line the focal length of a "standard" lens, equal in length to the negative diagonal. For a 4x5in camera, this is 150mm/6in, so 'double extension' is 300mm/12in and "triple extension" is 450mm/18in.

A "double-extension" camera can focus down to life size with the standard lens, and a "triple-extension" camera to twice life size. Often more important, however, is how a camera can handle a longer-than-standard lens. Clearly, a double-extension 4x5in camera with a 300mm lens can only focus at infinity: a triple-extension camera can focus to half life size with the same lens.

GANDOLFI/CORFIELD LOUPE
The body of this loupe is moulded from a flexible plastic, so it can be angled at the corners of the ground glass. The actual optic is the close-up lens from a Mamiya RB67 viewfinder, which is available in various strengths to suit individuals' eyesight.

▼ ▶ A USEFUL FOCUSING TRICK

Especially in the studio, a barcode makes a wonderful focusing target. The fine black-and-white lines from any barcode snap in and out of focus with a clarity that has to be seen to be believed: we typically use the codes on film boxes. For still lifes, you can place two or three (or more) barcodes at appropriate places on the subject, holding them in place with Blu-Tack or something similar if necessary. Just remember to remove them before you take the final picture! We have even used barcodes for focusing 8x10in portraits, as below. The enlargement of the barcode (right) shows the kind of resolution you can expect, even from a century-old lens at full aperture.

DE VERE 8x10IN, 21IN (533MM) F/8 ROSS, ILFORD 100 DELTA. (FES)

DAVE BARBER
Selective focus with LF creates quite different effects from selective focus with 35mm: the quality of the out-of-focus image is different. This was shot on 4x5in Polaroid Polapan 100 with an old 210/5.6 Schneider Symmar at full aperture.

LINHOF TECHNIKARDAN. (RWH)

Film holders and camera backs

Almost all modern cameras accept standardized double cut-film holders (DCFHs). The critical measurements are the width (so that they fit snugly from side to side), the distance from the end to the locating ridge (so that they lock in across the long dimension) and the register, so that the position of the film matches the position of the ground glass. The thickness can (and does) vary quite widely, and some cameras cannot accept unusually thick film holders. If your film holders match the dimensions given in the box, they are likely to be fully standardized: variations of a millimeter or so (or even 1/16in) are commonplace.

▲ READYLOADS AND QUICKLOADS

These are preloaded sheets of film, each in its own lightproof flexible envelope, that can be used with their own dedicated backs or with Polaroid single-sheet backs. A limited range of emulsions is available, and prices are (unsurprisingly) around 50 percent higher than for conventionally packed sheet film – but the convenience is wonderful.

FILM HOLDER DIMENSIONS

	4x5in/9x12cm	5x7in/13x18cm and half-plate	8x10in/18x24cm
Width	120mm/4-¹¹⁄₁₆in	149mm/5-¹⁵⁄₁₆in	235mm/9³⁄₁₆in
End to locating ridge	140m/5½in	193mm/7⅝in	275mm/10¹³⁄₁₆in

Because conventional film holders are heavy, bulky things, there have been a number of attempts to make smaller, lighter holders. The best known are (Kodak) Readyload, (Fuji) Quickload, Polaroid Type 55 P/N (page 30) and Mido. Then there are a number of obsolete and obsolescent film holders.

MIDO THIN CUT-FILM HOLDER

The Thin Cut-film Holder resembles a two-sided, reloadable Readyload/Quickload, and fits in a special adaptor of its own. At the time of writing, continued availability was uncertain.

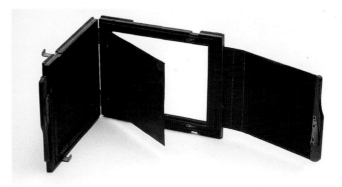

GRAFMATICS

These were made from about 1951 to maybe the 1970s, but fit most modern, standardized cameras (they are too thick for some). They look like thick DCFHs and hold six sheets of 4x5in film in a rapid-change magazine: a "baby" (2¼x3¼in) version was also made. The septums should all be present – the unscrupulous often attempt to sell incomplete Grafmatics – and the holders must be treated gently or they will jam. If the Grafmatic operates (page 77), do not attempt to straighten slightly bent corners in the septum, as this will probably cause jamming. It is not clear whether these bends are a design feature or the result of wear and tear. We are fond of Grafmatics and own nine.

▲ BOOK-FORM DARK SLIDE
Wooden "book-form" dark slides were normally individually matched to the cameras for which they were made. If you have the right holders for your camera, you can often use cut film and a sheet of Formica or something similar as a backing.

MIDO CONVENTIONAL HOLDER
The other kind of Mido holder is like a slimmed-down standard DCFH, and is supplied with a sort of clam-shell spacer to bring it out to the same register as a standard DCFH; only one spacer is needed for any number of Mido holders. Again, at the time of writing, continued availability was uncertain.

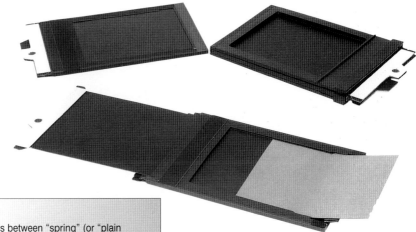

SPRING AND INTERNATIONAL BACKS
An important distinction, even among standardized backs, is between "spring" (or "plain spring") and "international" (or "Graflok"). Spring backs are permanently attached, while international or Graflok backs have a removable ground-glass frame and sliding locks to hold thick roll-film holders or Polaroid backs in place. Unless you have the latter kind, or unless your spring back has an unusually wide "gape," you will be limited in the type of roll-film holders you can use (page 85) and the choice of Polaroid backs (page 28).

◀ SINGLE METAL DARK SLIDES
These were semi-standardized, especially in the 9x12cm format, and are generally interchangeable. They were made both for film and for plates. The one in the foreground is a plate holder with film-holder adaptor: load the film into the adaptor, then load the adaptor like a plate. Adaptors are hard to find nowadays: they are no longer made new, though once they were available in all popular sizes.

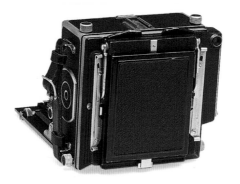

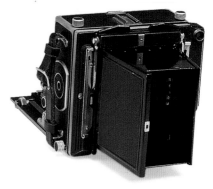

The back of this old MPP Mk VII is fairly typical of international backs, though it also has a removable, collapsible focusing hood, here seen closed.

The focusing hood springs open, somewhat like the focusing hoods on some MF SLRS, for quick, easy checking of composition; though getting a magnifier onto the ground glass isn't easy.

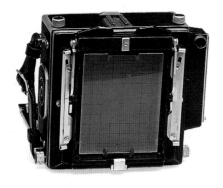

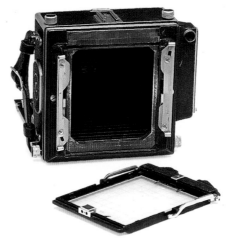

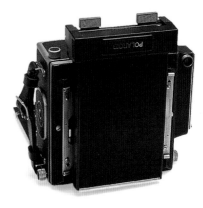

With the focusing hood removed, the ground glass and the Graflok bars are easily seen.

By pushing in on the springs of the ground glass, and sliding the frame parallel with the long dimension, the ground glass and its frame can be removed.

This thick Polaroid 4x5in pack back will fit under some ground glasses, but with others, the Graflok bars must be used, as here.

CHECKING REGISTER

Although the register of film holders is standardized, the register of cameras can vary, especially if the ground glass has been replaced. The original standardized register for plate cameras was almost certainly ³⁄₁₆in (0.188in/4.76mm), but believe it or not, different manufacturers have different views on what it should be today. Many use 4.85mm (0.191in), though after allowing for film curvature, 4.65mm (0.180in) would almost certainly be a better bet.

If the plane of focus of your negatives is consistently closer than it should be, then you need to pack out the ground glass a little; if it is consistently further away, you need to move the ground glass closer to the lens. Some cameras have adjustment screws: others rely on paper or metal shims to give the correct distance. Check precise focus with a sheet of newspaper or something similar at 45 degrees to the line of sight.

▼ REVOLVING BACK
On some cameras, the back actually revolves to allow portrait and landscape orientations of the film:this is an MPP Mk VIII with an MPP roll-film back. The Graflok bars are semi-concealed; they are worked by the big ridged sliders on either side of the center.

REVERSING BACK
The back on this 8x10in De Vere can be removed; rotated 90 degrees, to switch from portrait to landscape (or vice versa); and then replaced. This is called a reversing back.

REDUCING BACK
Any camera with a reversing back can be fitted with backs for smaller sizes: this is called (logically enough) a reducing back. Here, our 8x10in De Vere monorail is fitted with a 5x7in reducing back.

SPLIT DARK SLIDES
It is entirely possible to get two good-sized (2x5in/5x12cm) panoramic pictures on a single sheet of 4x5in film. The trick is to use a second film sheath (dark slide) that has been sawn in half for much of the long dimension. Compose on the upper or lower half of the ground glass; insert the film holder; pull the sheath (dark slide); insert the half-sheath, to block the unused side; expose; remove the half-sheath; and insert the full sheath. This was one of Roger's first experiments with the technique, using his MPP Mk VII and Apo-Lanthar on Fuji Provia.

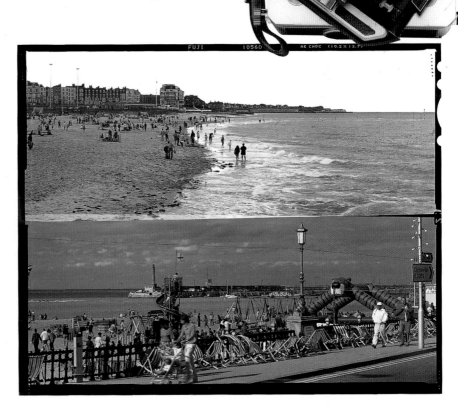

Loading film holders and Grafmatics

Loading film holders of any kind requires some practice, but it can soon become almost second nature. The most important thing to remember is that when the film is held with the short side uppermost, the notches should be on the right. If they are, then the emulsion side is toward you. This holds good for all formats. Different films have different notch patterns, which are normally reproduced on the outside of the film box.

Loading a Grafmatic is similar to loading a dark slide except that there are six septums. Note how the cut-out in each septum faces inward in the holder, and how there may be a slight curve to the septum beside the cut-out. Use of the lock "A" is optional. Again, use a brush or compressed air to clean the septums.

Treat a Grafmatic gently, and it will last forever. Get brutal with it, slam-banging the slides, and it will bend and jam. Apart from this, the main thing to remember is that the lens *must* be closed whenever you change films in a Grafmatic, and between exposures you *must* push the dark slide in, or the films can fog through the cut-outs in the septums.

LOADING A CONVENTIONAL FILM HOLDER

1 Remove the sheath from the film holder.

2 Tap the holder smartly to remove dust...

3 ...or use a brush...

4 ...or compressed air. Partially reinsert the sheath, with the white side out.

5 In the dark, insert the film, guiding with the fingertips. Check that the film is secure, with a fingernail. Note the location of the notches.

6 Close the sheath, making sure the lower door is shut.

7 Use the L-shaped locks to secure the sheaths.

8 Mark the date, and the type of film loaded.

LOADING A GRAFMATIC

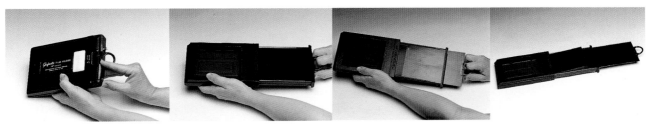

1 Turn the lock A to "free" (red dot covered – under the thumb) and the counter to 1 (under the finger – if it is on "X" it will be locked solid).

2 Holding the chrome lock "B" with the thumb as shown, pull out the main drawer.

3 Release the chrome lock "B" and pull out the dark slide.

4 The six septums will now spring up and can be removed.

5 The cut-outs in the septums are oriented like this in the holder, but it is easier to turn them around to load them. Rather than sliding the film all the way in from the end, bow it slightly; slip one edge under the long side of the septum; slip the other edge under the other long side (whereupon it will snap flat); and push it the rest of the way.

6 Press the loaded septums down.

7 Slide the dark slide and drawer home.

8 Set the counter to 1 and set lock "A" (red dot exposed). Mark the panel with the film type and date, as for a normal holder.

USING A GRAFMATIC

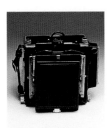

1 Put the Grafmatic in the camera, with the lens closed.

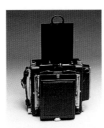

2 Set lock "A" to open, and pull out the captive dark slide.

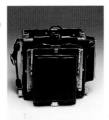

3 Push it in again. The "Film Exposed" dot is now uncovered.

4 The "Film Exposed" dot has a sliding cover, here retracted. Make the exposure now.

5 Grasp the dark slide and the chrome lock "B," and pull out, all the way. The exposed septum falls to the back of the Grafmatic. Push the drawer back in.

6 The counter will advance by one and the red dot will disappear. Set lock "A" closed (optional) and remove the Grafmatic. After six shots, the counter will be at "X" and the Grafmatic will lock solid.

4x5in/9x12cm

▶ DRAPER'S MILL

The white-painted sweeps were off the mill for restoration, all carefully numbered, in Roman numerals, for replacement. These and the bright grindstone contrasted with the shadowy interior: reduced development made it easier to capture the long tonal range, and 4x5in made it easier to capture the textures.

TOHO FC45X, 110/5.6 SUPER SYMMAR XL, ILFORD FP4 PLUS PRINTED ON ILFORD MULTIGRADE WARMTONE, TONED IN FOTOSPEED SELENIUM TONER. (RWH)

GROUND-GLASS BACK

In the days when this MPP back was made, 9x12cm was still a popular size among British pressmen, and indeed, MPP offered an adaptor to allow the use of single metal dark slides in this format (page 73); but the significantly smaller size of 9x12cm, as compared with the full-screen 4x5in, is obvious.

Overwhelmingly the most popular cut-film size is 4x5in, which has to a very great extent displaced its old European rival, 9x12cm (3.5x4.7in), even in France, the origin and bastion of metrication. Modern, standardized film holders for both sizes have the same external dimensions, and the ground glass of modern 4x5in/9x12cm cameras is often marked for both sizes. Of course, the internal dimensions are different, so 4x5in is too big for a 9x12cm holder, and 9x12cm will fall out of 4x5in holders.

As recently as the early 1950s, 4x5in was still regarded with some suspicion: "real" photographers preferred larger negatives, preferably contact printed; and in color, at least for advertising, same-size photomechanical reproduction seems to have been the norm.

By the 1960s, the standard for most advertising and high-end commercial photography was 4x5in – or 5x4in, as older British photographers still say – though larger formats were still common for high-budget advertising. This remained the situation until the last decade or so of the century, when, as already mentioned, roll film started to make ever greater inroads into professional photography.

As a result of their long popularity, there are immense numbers of 4x5 cameras on the market, both new and used. There are monorails (page 86), technical cameras (page 89), press cameras (page 89), wooden field cameras (page 88), and a variety of specialty cameras including aerial cameras.

Again because of the professional appeal of the format, the choice of films in 4x5in is greater than for any other cut-film format (including 9x12cm). What is more, there are plenty of tanks for developing 4x5in film: larger formats have to be developed in trays or drums, or on hangers in deep tanks. As an additional consideration, 4x5in film is (unsurprisingly) about half the price of half-plate (4¾x6½in/121x165mm), 5x7in or 13x18cm, and about a quarter of the price of 8x10in.

Although enlargers for half-plate, 5x7in and 13x18cm are not much bigger than for 4x5in, and may even cost much the same, they are quite a lot less common. Enlargers for 8x10in are vast, and either cost a fortune or are given away because the owner needs the space.

One more advantage of the 4x5 format is that the majority of modern cameras can accept roll-film holders, either by removing the ground glass or by slipping a holder under the ground glass (page 85).

At 4x5in or 9x12cm, the half-tone effect (page 14) is pretty much a thing of the past. You can even use ISO 400 films without worrying too much, unless you want very big enlargements. And, of course, you can use "old technology" films with impunity: Bergger's BPF 200 is a good example of a film that many like because it can be developed in almost anything, without having its performance wrecked by the fad of the month.

For most photographers seeking to move up into large format, 4x5in is the best choice, at least for a first camera. Of course, this doesn't mean it is the best choice for everyone, as we shall see in the next few pages.

5x7in/13x18cm/half-plate

▶ PULPIT

The churches of Romney Marsh are a never-ending source of pictures: this is at Old Romney. Roger determined exposure with a spot reading of the shadows on the spines of the books, but failed to allow quite enough extra exposure for the extension. The bigger the format, the more this is a problem: with 8x10in, a large head portrait can be two-thirds life size.

Gandolfi Variant 5x7in, 210/5.6 Rodenstock Apo-Sironar-N, Ilford FP4 Plus, printed on Ilford Multigrade Warmtone, toned in selenium.

GANDOLFI VARIANT

The Variant accepts complete, interchangeable rear standards for 4x5in, 5x7in and 8x10in, and is probably Roger's favorite 5x7in camera. For the first few years, Variants were made of black-painted MDF, but consumer demand led to a switch to "real tree": more expensive, but lighter and prettier. Unlike the traditional Precision, which uses Gandolfi's own backs, Variants are normally made with Cambo backs.

The great advantage of this group of sizes is that they make far more impressive contact prints than 4x5in, without the bulk and expense of 8x10in. They are also a very pleasing shape, much more aesthetically agreeable than the stubby 4x5in and 8x10in formats. Properly matted and framed, they have a unique charm, and this is arguably Roger's favorite format. We have a Gandolfi Variant 5x7, a Linhof Technika V 13x18cm, and a half-plate back for our De Vere 8x10in monorail.

Standardized film holders for all three formats have the same external dimensions, and can be used interchangeably in the same cameras. The actual film sizes are 5x7in (127x178mm), 13x18cm (5.1x7.1in), and 4¾x6½in (121x165mm) – note that half-plate is *not* half of whole plate, which is 6½x8½in (165x216mm). Although the external dimensions of the holders are the same for the three formats, the films are not interchangeable in the same holder.

The funny thing is that everyone thinks that these formats are more popular somewhere else: Britons regard them as European and American formats, Europeans as British and American, and Americans as European and British.

The smaller size of 5x7in as against 8x10in can be particularly important when it comes to lenses: a 210mm lens (standard on 5x7in) is often a good deal cheaper than 300mm (standard on 8x10in) and if you want a long lens for portraits, 300mm for 5x7in is a great deal cheaper and easier to find than 450mm for 8x10in. For enlargements, 5x7 offers very little advantage over 4x5in, but 5x7in enlargers are (once again) more frequently encountered, more affordable and less huge than 8x10in, though very few remain in current production.

The great disadvantage of these sizes, however, is that relatively few films are available, as compared with 4x5in. To complicate matters further, some films may only be available in certain sizes in any given market. Several color films are listed only in half-plate (4¾x6½in), and in the UK, Ilford sells only 5x7in, while 13x18cm is the only possibility if you want to use Ilford films on the continent. On the other hand, specialty suppliers sometimes stock "foreign" sizes, or can be persuaded to if the demand is high enough.

Although there are far fewer 5x7in cameras around than 4x5in, there are still several in current production. When this format turns up on the used market, the cameras are sometimes surprisingly cheap, especially if they are described as "half-plate," which many people mistakenly believe to be completely obsolete. Most are "woodies," though there are also monorails and Linhof Technikas in this size.

An option well worth considering is buying an old whole-plate camera and fitting a modern, standardized 5x7in back. Because whole-plate film is unobtainable, the cameras are often very cheap, and the expense of a back can be justified. Sometimes you can find used ones – in 1999 we paid £25 ($40) for a De Vere 5x7in reducing back for 8x10in, which could fairly easily have been adapted to many other cameras – or you can buy a new one from Cambo, in which case (once again) you will have to make some sort of adaptor, or you can go to Gandolfi, who will make a new back, in any format that will fit, for any Gandolfi camera ever made, or (at a slightly higher price) for any other camera.

Other cut-film formats

The largest common formats, and certainly the largest for which standardized film holders are half-way affordable, are 8x10in and 18x24cm. Once again, holders for the two formats share common outside dimensions, and ground glasses are often marked for both formats. The 18x24cm (7.1x9.4in) format is a considerably more pleasing shape, but even fewer films are available than in 8x10in, so we often crop 8x10in to 7x10in/18x25cm.

By this size, contact prints are the rule, though 8x10in enlargers are (slightly) more common than one might expect. They are often surprisingly cheap when they are encountered, too: very few people want to make enlargements from 8x10in negatives, and of those who do, even fewer have room for giant enlargers.

Film availability is pretty good, but film cost is frankly alarming: predictably, around four times as high as for 4x5in, and twice as high as 5x7in. Black-and-white, color transparency and color negative are all available.

4x10IN

A recent semi-standardized format is 4x10in, effectively a half-width 8x10in film holder for panoramas. Only a few black-and-white emulsions have ever been cut to this size, though obviously, cutting down 8x10in is not difficult and the shape of the format (1:2.5) is what we regard as ideal for panoramas.

THE VERY LARGE FORMATS

Move up from 8x10in to 11x14in, and you are at the limit for standardized film holders. The holders themselves are terrifyingly expensive – the same sort of price as a good, mid-range compact, or a cheap 35mm SLR, for just one holder – and film availability is poor: very few emulsions, at very high prices. We used to have 11x14in cameras, but sold them because the cameras were so big and heavy, film and holders cost so much, and we had so few lenses that would cover the format. This is the largest size that we have ever heard of, for enlargers, and we have only heard of about half a dozen, in 20 years.

These objections apply *a fortiori* to the other very large formats, with the added complication that the holders are at best semi-standardized and are often matched to a particular camera. A bewildering variety of formats is available, including – but not limited to – 10x12in (once a popular size, though standardized holders were never available), 8x20in, 12x20in, 14x17in, 12x16in, 16x20in and even 20x24in. Merely handling the very largest film sizes – loading the holders and developing the film – can be challenging in the extreme.

A few photographers deliver stunning contact prints from the few black-and-white films that are cut in these sizes (Bergger in France is the leading supplier), but from personal experience we would argue that you need to be absolutely and totally convinced that there is no other way to take pictures before you spend the money needed to buy the cameras, holders, lenses, film and even contact printing frames in these formats. Try everything else first!

ROGER
This 8x10in portrait was taken using the De Vere monorail and 21in (533mm) f/8 Ross lens (with Thornton Pickard shutter) shown on page 93. It was then contact printed with a Textureffects texture screen, of a pattern devised by William Mortensen.
ILFORD 100 DELTA. (FES)

THE "BABY" FORMATS

There are three small formats that fit (once again) in holders with standardized external dimensions, namely 6.5x9cm (2.6x3.5in), 2¼x3¼in (57x83mm), and 2½x3½in (63.5x90mm); we are not sure whether 6.5x9cm and 2½x3½in films are fully interchangeable in the same holders. They offer little advantage over 6x9cm roll film, unless you want to try individual development. Many cameras for these formats can be used with roll-film holders, usually with a Graflok-type fitting (page 74), though the "baby" Linhof has its own unique fitting.

QUARTER-PLATE AND WHOLE PLATE

Quarter-plate (3¼x4¼in/83x108mm) was at one time very popular, but film availability today is limited to a few black and white emulsions, and declining at that. This is a pity, as there are some lovely cameras in this size, and film holders were fully standardized.

Whole plate (6½x8½in/165x216mm) has suffered an astonishing eclipse, from being one of the most popular sizes right up into the 1950s and even 1960s, to being completely unavailable today. As already mentioned on page 80, a useful trick is to fit old whole-plate cameras with new 5x7in backs.

Roll-film backs

Fairly obviously, a 4x5in camera can accept a roll-film holder for any film size up to around 6x12cm. Although 6x12cm backs are very expensive, a 4x5in camera with a 6x9cm or 6x7cm roll-film back can be a very economical route into medium format, even if you never use 4x5in.

The main advantage of the larger format is when you want just a tiny bit more effective rise on the long dimension than you can get on 6x7cm: the taller format will give you this. "Binding" of bellows, especially with wide-angles, is often a problem, so you need bag bellows, or unusually flexible pleated bellows.

If the client gets to see original transparencies, the extra size of 6x12cm is somewhat more impressive, and there is once again the argument about extra rise, as with 6x9cm versus 6x7cm. Some photographers use only 6x12cm roll film, rather than smaller formats, for these very reasons. On the other hand, 6x12cm backs are typically 50 to 100 percent more expensive than 6x9cm, reloading is inconveniently frequent, and, as already noted on page 49, the extra size is often cropped anyway.

▼ 6x17CM BACK
This home-made 6x17cm back, built along the same lines as the "Longfellow" camera in Appendix II, works with wide-angle lenses even on a 4x5in camera because the 4x5in aperture is in the middle of the light path, not at the back.
(COURTESY DR A. NEILL WRIGHT)

RUIN, THE PELOPPONESE
Even though 6x12cm backs cost a lot more than 6x7cm or 6x9cm, they can be fitted onto a 4x5in camera to make a relatively cheap 6x12, as compared with buying a purpose-made 6x12cm camera.
MPP MK VII, VOIGTLÄNDER 150/4.5 APO-LANTHAR, HORSEMAN 6x12CM BACK, KODAK EKTACHROME 100. (RWH)

Although 6x6cm backs are available, the film area is inconveniently small (especially after cropping), and on the used market, prices are invariably low.

 At the time of writing, only one manufacturer (Sinar) offered a multi-format back, which was so staggeringly expensive that most people would find it cheaper and easier to buy two or even three separate backs, one for each format.

FITTING ROLL-FILM BACKS

Most roll-film backs for 4x5in cameras are fitted using the sliding Graflok bars at the sides of the back, after removing the ground glass. This allows backs of any thickness to be used, with a short film path. A few plain spring backs have a very wide "gape" and will accept conventional roll-film backs, though you have to be careful to avoid marking the ground glass when you insert and remove the back: felt sticky pads covering the highest point(s) of the backs are probably best.

 Plain spring backs with a nonremovable ground-glass frame will not accept conventional roll-film backs, so the only option in most cases is slip-in backs, also known as "there and back again" backs. These have both the feed spool and the take-up spool at one end. The film runs all the way to the end of the holder, along the front, and then back again, along the back. Although these have two great advantages – in addition to the fact that you can use them in just about any camera, the film feed path does not kink the film before the film gate – they can also suffer from reduced film flatness and marginal light-trapping, especially on the first frame.

GAPE
Different backs have different degrees of "gape," that is, the space under the ground glass. This Cadet, here seen without Graflok bars, is fairly typical: anything less than about 1in (25mm) thick can be slipped under the glass. A few have a smaller gape, and are hard pressed to swallow even half an inch (12mm), while a few others have a wider gape and can take even a two-inch-thick (50mm) roll-film back.

CAMBO AND GRAPHIC BACKS
The Cambo back, half-inserted in the camera (a Cadet, this time with optional Graflok bars fitted) can be pushed under the ground glass of most 4x5in cameras: there is no need to remove the back and use the Graflok bars (page 74). Cambo backs are made in 6x7cm, 6x9cm and 6x12cm. The fatter Graflex back (long discontinued) is typical of the sort of back that can only be fixed with the ground glass removed, unless the camera has an unusually wide "gape."

Monorails

CADET

One of the least expensive 4x5in monorails ever built, the Cadet is wonderfully simple and unintimidating, but still retains full movements front and back. The 168mm Dagor on this camera is something of a cult lens.

The monorail has been the standard professional choice for studio work since the early 1950s, and remains the most versatile form of LF camera to this day. As well as 4x5in/9x12cm, there are "baby" monorails (6x9cm), these are 5x7in/13x18cm/half-plate, whole plate (for which no film is available nowadays – page 83), and 8x10in.

Many have interchangeable standards so that you can use the same front end with a variety of rear ends in different formats. To do this, you often need different bellows: the alternative is a "reducing back," which consists of (for example) a 4x5in back in a large surround, so that it can be dropped into an 8x10in camera (page 75). For extreme extension, some allow the use of a middle standard with two sets of bellows, one from front to middle and one from middle to rear. Most, too, allow interchangeable bellows, either long ones for extra-long extension with long lenses, or bag bellows for very short extensions with extreme wide-angle lenses.

Most monorails offer extensive movements both front and rear, and of course indirect movements (page 69) are normally easy to obtain. Prices span an immense range, even new: the cheapest monorails are comparable in price with a decent zoom compact, while the most expensive cost as much as a second-hand car. When you pay more, you generally get more durability; more convenience of use; more movements (the cheapest models may omit direct rear rise/fall and cross); and geared or micrometer movements, which some photographers cannot live without but we regard as a zero-sum game, being equally happy with smaller, lighter cameras.

Although the monorail offers all the advantages listed above, it also suffers from the significant drawback that it is usually very bulky. Our 8x10in monorail seldom leaves the studio: for location 8x10in photography, we normally use a wooden field camera, the Gandolfi Precision, instead.

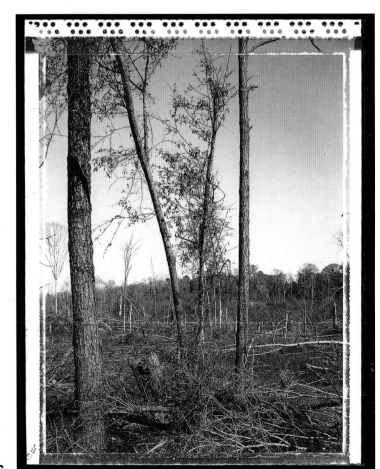

TORNADO DAMAGE, SELMA, ALABAMA

Frances shot this on Polaroid Type 55 P/N using a Cadet and a 203/7.7 Kodak Ektar – hardly an expensive combination. This is a contact print on Kentmere Roomlight Contact Paper, but even as a 16x20in/40x50cm enlargement, tonality is gorgeous and the detail goes on and on.

TOYO VX125

The VX125 is one of the most expensive monorails on the market – but it is also very compact, thanks to the telescoping rail (a feature shared with the Toho FC45X and the Linhof Technikardan) and the unstiffened bellows allows extreme rise, even with ultra-wides.

LINHOF KARDAN COLOR

The movements of the Kardan Color are somewhat limited, especially at the back, but these vintage Linhofs, based on the Technika field camera, are a pleasure to use and can sometimes be found surprisingly cheaply.

DE MPP

Monorails are so modular that it is sometimes possible to meld two "scrappers" of entirely separate makes. This is mostly De Vere, but with an MPP rear standard.

There are, however, a few monorails that are designed to pack up much more compactly, and we own two of them, the Toho FC45X (page 98) and the Linhof Technikardan. The Toho is by far the smaller and lighter; packs up and unpacks faster; offers full movements front and rear (as does the Linhof); and is more than strong enough for careful use. We travel abroad with it far more than we do with the Linhof. The Linhof, on the other hand, has more convenient movements; is significantly more robust; accepts interchangeable bellows (the Toho's are fixed); has built-in levels; and is easier to use with the 6x12cm back. The Linhof, therefore, tends to be used more at home or when we are travelling by car.

▼ **LINHOF L-BRACKET MONORAIL**

L-bracket construction, shared with the (very much cheaper) Cadet, is often reckoned to be the best way to build a monorail.

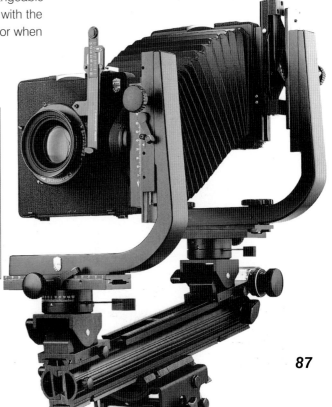

"ON-AXIS" AND "YAW-FREE" MOVEMENTS

Almost all monorails have "on-axis" movements. In other words, the swings and tilts are on an axis that goes through the middle of the lens panel or film holder. When you use the swing or tilt, the middle of the image stays in much the same focus, with only the top and bottom (or left and right) changing focus. The on-axis rear swing and tilt are particularly easy to see on the Cadet (left). Compare this with the "off-axis" movements found on some field cameras (page 89).

"Yaw-free" is a refinement of "on-axis," but it seems to excite advertisers more than photographers, few of whom understand it, and even fewer of whom care.

Field cameras

Most of the wooden field cameras available today would not be particularly unfamiliar to a photographer of the late nineteenth century, and they would not be too surprised at the metal versions, which derive from the "hand and stand" models of a hundred years ago. Both wooden and metal field cameras fold away very small, and wooden cameras can also be admirably light, so the appeal of both kinds is easy to see. Because any reasonably competent woodworker can build a wooden field camera, there are numerous manufacturers, many of whom make only a handful of cameras a year, embodying their personal priorities. Indeed, you can even buy kits (from Bender) to build your own wooden camera. When it comes to formats larger than 8x10in, wooden field cameras are the only design available: there are no monorails, and no metal field cameras.

On the downside, most field cameras have very limited movements compared with most monorails. Wooden field cameras can often muster good indirect rise and fall, but rear rise is almost unheard of, rear cross is rare, and rear swing is normally modest. Front cross and swing may or may not be provided, and if either is provided, it is again likely to be modest. Where movements are provided, some lock a good deal better than others, too. Some are double extension, not triple extension (page 71), and bellows are often fixed, so that bag bellows are unobtainable: a disadvantage if you want to use movements with extreme wide-angles, or roll-film backs on a 4x5in camera.

GANDOLFI VARIANT

The Variant can accept interchangeable bellows (above) and rear standards of different formats: the 8x10in, set up and folded, is shown below, left and middle. The 4x5in is blocky when folded (below, far right). A 5x7in is shown on page 80.

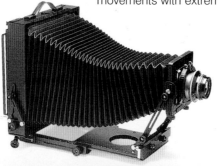

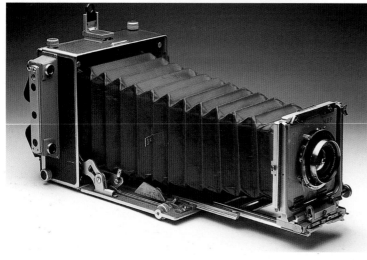

◀ RED MPP

Micro Precision Products borrowed ideas from both Linhof and Graflex: their cameras are in some ways superior to either. Four articulated rods allow the back to be swung or tilted (off axis – see panel) by about 15 degrees: the locking knobs are at the corners. At the front, there is rise, cross, swing and (off axis) backward tilt only, though a side-mounted tripod boss allows swing to become tilt, cross to become rise and fall, and so forth. Some Linhofs have a second tripod socket in the roof to allow the camera to be mounted upside-down for similar reasons.

WOOD, METAL OR ABS?

Unless you plan on working exclusively in the studio (in which case a monorail is likely to prove a better choice), field cameras are probably the most useful compromise for most people. Wooden field cameras are normally lighter; metal ones, often known as "technical cameras," are stronger and more rigid, and may even have coupled rangefinders; and there is one line of field camera, the Walker Titan range, that is made of injection-moulded ABS and stainless steel. There is a picture of a Titan on page 32.

PRESS CAMERAS

The typical 4x5in press camera is a simplified field camera, with fewer movements, a fixed double-extension bellows, and a built-in coupled rangefinder. Its heyday was the late 1930s to the late 1950s. Press cameras are sometimes encountered in 6x9cm and quarter-plate (page 83).

IMPERIAL 11x14in

The Imperial, made to Roger's design in India in the 1980s, featured removable top locking rods for extra rigidity – a significant concern with a light 11x14in camera.

HORSEMAN WOODMAN

The Woodman is one of the smallest, lightest 4x5in field cameras available, weighing just 1.35kg (3lb) without lens.

"OFF-AXIS" MOVEMENTS

Often, the front and back of a field camera are hinged at the bottom, so tilt is "off-axis." In other words, if you use the tilt, the whole standard moves forward or backward – a little at the bottom, a lot at the top – so you have to refocus the whole image. Although "on-axis" movements are more convenient (page 87), many photographers find that the savings in weight and cost outweigh the loss of convenience. Some grow so used to off-axis movements that they even prefer them.

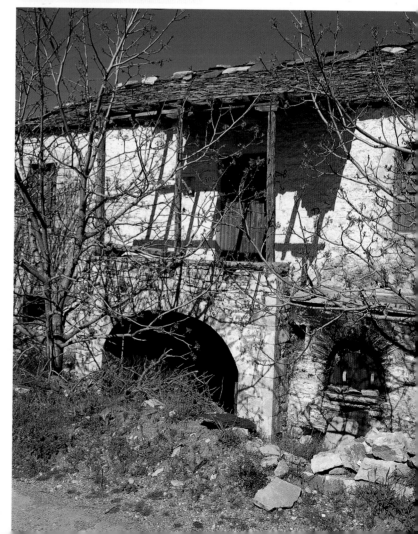

RUIN IN THE PELOPPONESE

Technical cameras are heavier than most field cameras, but they are stronger than most, too, so they are good for knockabout photography, whether landscape, travel (as here) or industrial. If they have a rangefinder, they can even be used hand-held, though this camera was tripod-mounted.

MPP Mk VII, 150/4.5 Voigtländer Apo-Lanthar, Fuji Provia 2. (RWH)

Other LF cameras

CAMBO WIDE 150
The Cambo Wide accepts a range of lens cones for different focal lengths: this one stretches the definition of "wide" somewhat, with a 150/5.6 Apo-Symmar.
(COURTESY CAMBO)

As well as monorails, wooden and metal field cameras, and press cameras, there are at least six other options: wide-angle cameras, reflexes, *doppel-klapp* cameras, tailboard cameras, aerial cameras and other rigid-bodied cameras. If you go back far enough into the past, there are also sliding-box cameras, where one box slides inside another for the focusing movement, but these really are early: few were made after the 1850s.

WIDE-ANGLE CAMERAS

Some manufacturers make wide-angle variants of their standard field cameras, with short bellows and reduced movements: the Walker XL is one such. Others make all-rigid cameras, typically with front rise/fall/cross only: these are often known as "pancake" cameras, and come from Cambo and others. Because of the shallow depth of focus of wide-angle lenses, front/rear parallelism is very important. If you plan on using 58mm or shorter lenses on 4x5in, a wide-angle camera, or one with interchangeable bag bellows, is all but essential, and with focal lengths up to about 121mm they can be a good idea.

REFLEXES

The most common size for LF SLRs is quarter-plate (3¼x4¼in/83x108mm), but 4x5in and even half-plate (4¾x6½in/121x165mm) and whole plate (6½x8½in/165x216mm) reflexes are encountered: the largest models resemble tea chests with a focusing hood. They were last made in any quantity in the 1950s or (possibly) the very early 1960s, but they remain excellent for portraiture by continuous light, though huge, slow-moving focal-plane shutters synchronize slowly, if at all, with flash. There have been one or two LF reflex cameras since, including the Noblex.

The only remotely common LF TLR is the Gowlandflex, still available at the time of writing, to special order, in a variety of formats.

DOPPEL-KLAPP CAMERAS

These resemble two book-sized blocks, typically joined by a pair of X-shaped brackets: the 6x9cm Plaubel Makina, illustrated on page 64, is a typical example, though most 4x5in or (more usually) 9x12cm versions did not have a rangefinder. They were popular as press cameras until the early 1950s.

GRAFLEX SUPER D
We have adapted this Graflex, inherited from Frances's late father, to accept a quarter-plate Polaroid back: Type 665 makes an excellent portrait film, and the 150/4.5 Ektar is an ideal focal length for portraits on quarter-plate.

TAILBOARD CAMERAS

These take their name from the way they were built: a Gandolfi tailboard is illustrated on page 92. For transport, the rear standard is racked all the way forward, and the focusing track behind it – the tailboard – folds up and protects the ground glass. They were introduced in about 1860 and remained in production for around a century, from a wild profusion of manufacturers,

and in numerous formats. They have rather more limited movements than most field cameras, and do not pack up quite as small, but they are very strong and the covering of the ground glass for transport is a major attraction. They remain usable today.

AERIAL CAMERAS

As well as big aerial survey and reconnaissance cameras that are built into aircraft, there have been a number of aerial cameras for hand-held use. Some use 4x5in film, and a few use roll film, typically 5in. Most have lenses fixed at infinity, and some have vacuum backs or glass pressure plates to hold the film flat. Rigid bodies are the norm: bellows react badly to slipstreams. They are likely to be of limited interest to most people.

OTHER RIGID-BODIED CAMERAS

From time to time, rigid-bodied LF cameras are introduced with helical lens mounts. They are useful for applications such as group portraits, or in locations where strength is at a premium, but they are highly specialized. The Gran View, illustrated, is an example: there is also an 8x10in version.

GRAN VIEW
The Gran View is a simple camera: a back of unique design (which nevertheless accepts standard film holders, though not Grafmatics) and a lens cone with focusing mount.

BEACH, MINNIS BAY
The Gran View is ideal for hand-held shots, being a good deal lighter than most hand-holdable 4x5in cameras. With Polaroid sepia, as here, it makes for excellent pastiches of ancient snaps (even down to the tilting horizon), though deckle-edge trimmers are increasingly hard to find.
90MM ANGULON. (RWH)

Using very old cameras

It is often possible to use cameras that date back well into the nineteenth century, never mind the twentieth. There is a certain fascination, and sometimes something of a challenge, in being able to do so. Taking each of the obvious considerations in turn:

ROGER

This portrait was taken with the Graflex on page 90, using conventional film (Ilford HP5 Plus), before we converted the camera to Polaroid film – an option that may be worth considering with other quarter-plate cameras, though getting the ground glass in the right place could be demanding.
PRINTED ON ILFORD WARMTONE, SEPIA TONED IN SULPHIDE. (FES)

REASONABLE WORKING ORDER

Few cameras are so hopelessly rickety that they cannot be restored to adequate working order via a thorough cleaning, a replacement of washers on locking screws, and (where necessary) lubrication. Use fine machine oil on the point of a toothpick for metal parts, and a soft pencil or a wax candle for sliding wooden surfaces. Missing screws can often be replaced temporarily, albeit unaesthetically, with modern screws, and in most towns there is a jobbing engineer who will make up parts, to pattern, surprisingly cheaply, though this is only worthwhile for a really nice camera.

LIGHT-TIGHT BELLOWS

Patch bellows with two tiny pieces of leather, one on the outside, one on the inside, glued in place. Camera Bellows, a 100-year-old British company, can make new bellows for almost any camera, and this is certainly an option – it may well cost less than you expect.

GANDOLFI UNIVERSAL
This tailboard camera was in production from the 1890s to the 1960s: Gandolfi will still make them today, to special order. They will also make new standard-fitting backs, for older models built for book-form holders.

LENS AND SHUTTER

If there is a lens on the camera, and it can be cleaned adequately, try it. If there is no lens, but a lens panel, you may have to indulge in some creative tinkering, or make a new panel. Good materials are thin ply; light alloy sheet; and (for temporary use only) cardboard.

Very old lenses may well be in a "barrel" (nonshuttered) mount, but trawling a few camera fairs will often turn up various patterns of front-of-lens shutter that can be clamped onto the lens.

FILM

If the film size is still available, you are home and dry. If it is not, you may have to cut film to size, in the darkroom. Remember that Ilford Ortho Plus can be handled under deep red safelighting. Just for testing, you can even try photographic paper: assume an ISO speed of around 2.

With conventional (block-form) plate holders, you may be able to find a film-to-plate adaptor at a camera fair. Alternatively, you may be able to wedge the film in using a rigid stiffener as backing, which works surprisingly often: an old glass plate, or a sheet of Formica or similar thin laminate facing, is ideal.

Book-form plate holders (page 73) are much easier. With the "book" open in front of you, place the film face down on the open side: put a sheet of Formica, or an old glass plate, or anything similar, in behind it; swing over the center "door," and lock it; then repeat the operation for the other side.

If you can find a modern, standardized back second-hand at a camera fair, this may be the easiest approach: with a reversing back, you can simply remove the old back and set it aside, so you do not have to make any irreversible modifications.

TP ROLLER-BLIND SHUTTER
Pulling the string half-way down opens the shutter for focusing; pulling it all the way down draws the second blind over the lens. Speeds (1/10–1/40 second) are set by adjusting the shutter tension, winding a little knob on the side. Releasing the spring beneath the setting knob releases the tension, back to 1/10 second.

LESS ANCIENT CAMERAS

One of our working cameras is an 8x10in De Vere, complete with 5x7in and 4x5in reducing backs. It came with just the 8x10in back, and a 24in (60cm) bellows and rail. The local metal stockholder supplied a metre of 25mm square tube for the rail; Camera Bellows built us a one-meter bellows on the original bellows frames; and we found the two reducing backs a few years after we got the camera. We use it with our 21in f/7.5 Ross lens for Hollywood-style portraits. The whole thing, including the lens, shutter, rail, new bellows and reducing backs, cost us very little more than the price of a new, mid-range 35mm SLR body, or a good (but not top-end) compact.

8x10in DE VERE
This is the camera described in the text. When we had the new bellows made, we specified red – it's prettier.

Choose your compromise

Any camera designer must compromise between weight, size, price, durability, rigidity, convenience and versatility. The buyer has to consider all this; and whether to buy new or old; and the "personality" of the camera, which is often far more apparent with LF than with MF or 35mm.

At one extreme, the Peckham-Wray 4x5in aerial camera is massively strong, utterly rigid, and very easy to use for its intended purpose, but very heavy. It has no movements, helical focusing (no bellows), and no ground glass.

At the other extreme, the Toho FC45A is a full-featured 4x5in monorail camera that weighs little more than a kilo (about 2½lb). But a ham-fisted assistant could probably write it off in ten minutes, and the wildly off-axis base tilts are so inconvenient that most people prefer the slightly heavier (by about 350g/14oz) but much more rigid FC45X, with considerably cleverer camera movements.

These are extremes, but they well illustrate the point. If you buy a small, light camera, you will have to treat it with more respect than a big, heavy one. One reason why big, heavy old Cambo monorails are so popular in rental studios is that they are next to assistant-proof: photographers' assistants are legendary for the damage they can innocently do to defenseless cameras.

In general, too, if you want more movements, you will need either a heavier camera, or a more expensive one (sometimes both). For maximum movements, you need either a monorail, which is generally a lot less convenient to carry around and set up than a field camera, or a Gandolfi Variant, which is one of the biggest and heaviest 4x5in field cameras made.

The danger, always, is being sold more camera than you need – and worse still, a camera that doesn't suit your personality. One of the greatest mistakes you can make is buying all the extra features and movements you can possibly find, "just in case." In fact, you may even be better off to buy two cheap second-hand cameras, each optimized for a particular application, rather than one super-deluxe new model that promises to do it all. In the studio, a monorail is wonderful, so buy an old, beat-up Cambo or even De Vere or MPP: just don't try to carry it very far. For landscapes or architecture, buy a light wooden field camera, or maybe an MPP Micro-Technical, which is a bit heavier but which you can more or less throw in the trunk of a car without putting it in a case.

NORTH-EAST MALTA

Our Toho FC45X is our standard 4x5in camera for travel because it is very light, packs away to almost nothing, and offers a very wide range of movements.
We normally load the film into Grafmatics (page 77).
110/5.6 SUPER SYMMAR XL, KODAK E100S. (RWH)

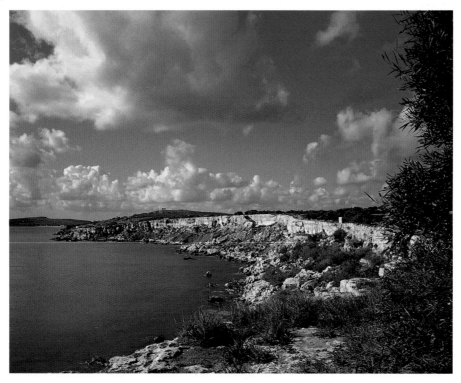

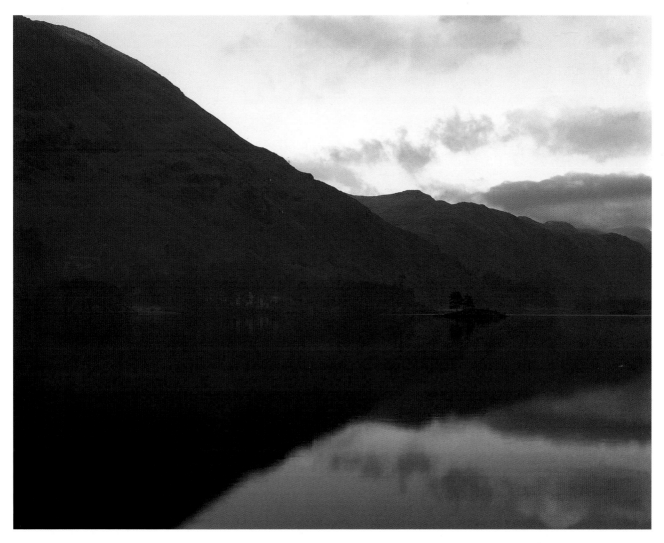

Whenever the opportunity arises to handle another LF camera, old and new, you should take it, as it may surprise you which cameras you take to, and which you don't. We love our Gandolfi 8x10in Precision, which on paper has very limited specifications but which has always turned out, since we first tried it, to have all the movements we have ever needed, as well as being very light and compact and very rigid.

LAKE DISTRICT
Our MPP Mk VII is a much more robust camera than the FC45X, but it is also heavier and has more limited movements – not that one normally needs extreme movements for travel.
203/7.7 Ektar, Fuji Provia 2. (RWH)

RIGIDITY

Newcomers to LF often dismiss field cameras (and some others, too) because they can flex the front and rear standards relative to one another: "Insufficiently rigid," they cry, after locking all the movements as tight as they can, and then hauling like King Kong on the hapless apparatus.

They are quite wrong. You can flex any camera if you exert enough force. The critical questions are, first, are you exerting a realistic force, or are you emulating the action of an assistant (see text, opposite); and second, do the various parts go back to the same relative positions when you let go?

The former is a question of judgment, while the latter is a matter of simple observation. Set up the camera, focused on any handy subject. Set the movements square, or as needed. If, after being subjected to any reasonable force, the camera does not require re-alignment, refocusing, and re-setting of movements, it is rigid enough.

Chapter

4

LENSES AND THE OUTFIT

The typical MF or LF outfit is significantly smaller than the typical 35mm outfit, simply because it is asked to do less. Very long and very fast lenses are extremely rare; zooms are only a little more common; shift lenses are rare in MF, and unnecessary with the vast majority of LF cameras (where all lenses are potentially shift lenses); and there is generally less choice of accessories, though some MF systems are surprisingly extensive. Furthermore, because LF cameras, lenses and backs can be mixed and matched almost without limit, accessories often come from third party manufacturers.

Users of MF and LF cameras also have a much easier time than the 35mm photographer if they are in the market for used lenses. The larger the format, after all, the less the need for very high definition. Although there are still plenty of cheap, nasty lenses being made for 35mm today, you need to go back to the 1960s or even 1950s to find lenses for MF and LF that are flatly unacceptable, at least for monochrome.

Of course, it would be foolish to deny the advantages of modern lenses. They generally perform better at wider apertures; render color more attractively, because of lower flare; and (for LF) have larger circles of coverage. The shutters are often more ergonomically designed, too. But for monochrome, at f/8 and below (for MF) or at f/16 and below (for LF), there is likely to be no discernible difference in performance between a good, old lens, and a good, modern lens in any reasonable focal length.

Coverage for all LF lenses varies with aperture, and is normally specified at f/22. For example, a 300mm lens may only just cover 8x10in at f/8, with no movements; but at f/64, it may well cover 11x14in, possibly with some room for movement. The diffraction-limited resolution at f/64 (page 18) will be between 16 and 25lp/mm, but with a contact print, who cares?

▶ **ROSSETTI WINDOW**
Dante Gabriel Rossetti is buried in the churchyard of our parish church: his mother paid for this window. We shot it on 4x5in Fuji Astia (for relatively low contrast) using a Linhof Technikardan and an old 14in (356mm) f/9 Cooke Apotal process lens, roughly the equivalent of 105mm on 35mm. The lens probably dates from the 1960s or early 1970s. *(RWH)*

EXODVS CHAP XII VER 5 · 5

CHRIST OVR PASSOVER IS SACRIFICED FOR VS

To the glory of God & in memory of my dear Son Gabriel Chas Dante Rossetti

SAINT MARK CHAP VIII VER 22 · 23

THE LIGHT SHINETH IN THE DARKNESS

Born in London May 12 1828 Died at Birchington Easter Day 1882

Equivalent focal lengths

Because most photographers today start out with 35mm, it is usual to compare focal lengths on other formats with those for 35mm, so that, for example, 180mm on 4x5in is described as being "about like" 55mm on 35mm. The normal basis for comparison is the diagonal coverage of the lens: 55mm on 24x36mm covers 43 degrees, and 180mm on 4x5in covers 45 degrees. A lens equal in focal length to the negative diagonal is referred to as "standard."

While these comparisons are useful, and are given in the two tables below right (one for MF, one for LF), they have to be regarded with some suspicion, for three reasons. First, only some focal lengths are actually available: you can't easily find (say) 53mm for 35mm and 170mm for 4x5in. Second, it is flatly impossible to make truly meaningful comparisons if the formats are different shapes. Third, the bigger the format, the greater the working distance with an "equivalent" lens.

The different shapes of the various formats mean that while diagonal coverages may be similar, vertical and horizontal coverages may diverge rather more. The 55mm lens on 35mm (43 degrees diagonal) covers 36 degrees on

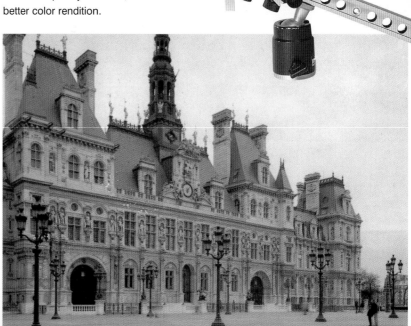

ANGULON AND SUPER ANGULON

The 120/6.8 Schneider Angulon is so much smaller and lighter (and cheaper) than the later 121/8 and 120/8 Super Angulons that many photographers gladly put up with the inferior coverage and smaller working aperture of the older lens: f/6.8 is for focusing only, and the lens is normally used at f/16 or below, while the Super Angulon can be used wide open.

▶ TOHO FC45A WITH 120/6.8 ANGULON

This outfit was used for many of the pictures in this book, including the Paris shot below, though we have since added a heavier monorail (thereby converting the camera to an FC45X) and switched to the 110/5.6 Super Symmar XL, for better color rendition.

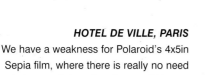

HOTEL DE VILLE, PARIS

We have a weakness for Polaroid's 4x5in Sepia film, where there is really no need whatsoever for modern lenses. This was taken with our 120/6.8 Schneider Angulon, a little flat and blue for color but perfect for monochrome.
Toho FC45X. (FES)

one axis and 24 degrees on the other, while the 180mm lens on 4x5in (45 degrees diagonal) covers 38 degrees on the one axis and 30 degrees on the other. Formats of the same shape can, however, be compared absolutely: 28mm on 35mm (75.3 degrees diagonal) is effectively identical to 65mm on 6x9cm (75.7 degrees diagonal), because both formats are 1:1.5 in shape.

As for working distances, a good example is afforded by portraiture. In 35mm, it is quite usual to use 85mm or even 105mm lenses, to give more pleasing apparent perspective than the "standard" 50mm, which is itself longer than a "standard" 43mm. With 4x5in, this would mean switching to 300mm lenses or longer, and with 8x10in to 600mm or longer. This is not what people do. Generally, 210mm is reckoned adequate for portraiture on 4x5in (roughly equating to 60mm on 35mm), and on 8x10in many people use 360mm (roughly 50mm on 35mm) or even 300mm (under 45mm on 35mm).

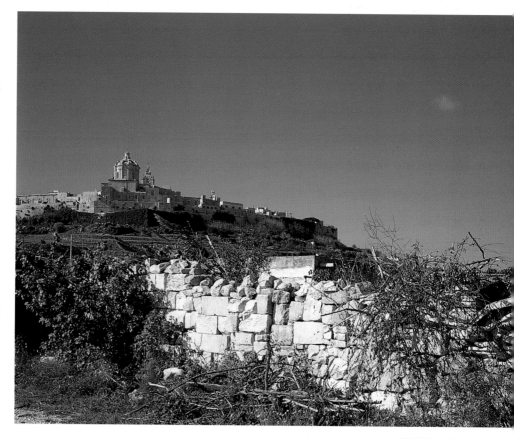

▲ *MDINA, MALTA*
For color, newer lenses are generally more desirable. This was taken with a 100/5.6 Apo-Symmar on a "baby" Linhof (page 62): our former lens for this camera, the 105/3.5 Xenar, was less contrasty and slightly blue by comparison. *(RWH)*

▼ In both tables, the first figure is the calculated equivalent, and the second is the nearest likely focal length, though it may not actually be available for a particular camera system.

EQUIVALENT FOCAL LENGTHS FOR CUT FILM

On 35mm	4x5	5x7	8x10	11x14
"Standard" 43/50	150	210	300	450
14mm	49/47	68/72	98/110	147/?
21mm	73/72	103/110	147/150	220/?
28mm	98/90	137/150	195/165	293/300
35mm	122/120	171/165	244/240	366/360
50mm	174/180	244/240	349/360	523/600
90mm	314/300	440/450	628/600	942/1000
135mm	471/450	659/600	942/1000	1413/1200
200mm	698/600	977/1000	1395/1200	2093/–
300mm	1047/1000	1465/1200	2093/–	3140/–
500mm	1744/–	2442/–	3488/–	5233/–

EQUIVALENT FOCAL LENGTHS FOR ROLL FILM

On 35mm	645	6x6	6x7	6x9
"Standard" 43/50	71/80	80/80	90/90	100/100
14mm	23/–	26/–	29/35	33/35
21mm	35/35	39/38	44/45	49/47
28mm	46/45	52/50	59/55	65/65
35mm	58/55	65/65	73/72	81/80
50mm	83/80	93/90	105/105	116/110
90mm	149/150	167/180	188/180	209/210
135mm	223/200	351/250	283/300	314/300
200mm	330/350	372/350	419/400	465/450
300mm	495/500	558/500	628/600	698/800
500mm	826/800	930/1000	1047/1000	1163/1200

Lens speeds and designs

To anyone brought up on 35mm, MF and LF lenses seem very slow. For MF, the fastest available are around f/2; f/2.8 is a common speed for standard lenses; and on 6x7cm and above, even f/3.5 is quite fast. Move up to LF, and probably the most popular maximum aperture is f/5.6.

There are two and a half simple reasons for this. The first is that if the lenses were any faster, they would be too bulky, heavy and expensive. An 85/1.4 for 35mm is big enough: an 85/1.4 to cover roll film would be even worse. The second is that depth of field and depth of focus with big, fast lenses are tiny. Although there have been such monsters as a 150mm f/2.8 for 4x5in, they are all but unusable. The film is not located accurately enough (or held flat enough) for good resolution, and even if it were, depth of field, wide open, at anything closer than a few meters, is ridiculously shallow. The half reason is that with leaf shutters, the designer has the choice of a huge and expensive shutter and a fast lens, or a smaller, less expensive and less unwieldy shutter and a slower lens, though lenses for focal-plane shuttered cameras are exempt from this consideration.

IF YOU NEED SPEED, USE 35MM

If 35mm didn't exist, there would probably be more fast lenses for roll film – but as 35mm does exist, there is very little need. There would probably be more fast films, too. After all, when Speed Graphics were popular as press cameras, you could buy 1250 ASA Royal-X Pan from Kodak. Today, although there is no technical reason why Ilford could not coat Delta 3200 on sheet film, there is not enough demand to make it worth their while.

To a very large extent, MF and LF are used for different kinds of photography to 35mm: more studied, more careful. If you really want, you can use Ilford Delta 3200 roll film, and push Ilford HP5 Plus to EI 1600 and beyond. If your personal vision demands this, then do it; and you may well get some very fine pictures.

But the truth is that if you want the maximum in quality from 35mm, you have to work at moderate apertures, and use a tripod. In other words, you are going to be working at much the same apertures as you would use with roll film. Looked at in this light, slow lenses are less of a problem.

It is also true that the main reason for using a tripod is to avoid camera shake: subject movement is more rarely a problem.

Then again, the extra area of roll-film formats means that you can use faster films than you could with 35mm, without worrying so much about grain and loss of sharpness. In particular, Ilford Delta 400 delivers astonishing quality, and since late 2000 it has actually delivered the speed it promises.

CRAFTSMAN, NORBULINGKA

With roll-film formats – this is 66x44mm on an Alpa 12 WA – the grain of even the fastest films is not obtrusive: this is Ilford Delta 3200 at EI 3200. Even so, the 38/4.5 Biogon had to be used at about f/8 for depth of field, and camera shake has taken the ultimate edge off definition. *Printed on Ilford Multigrade Warmtone, untoned. (RWH)*

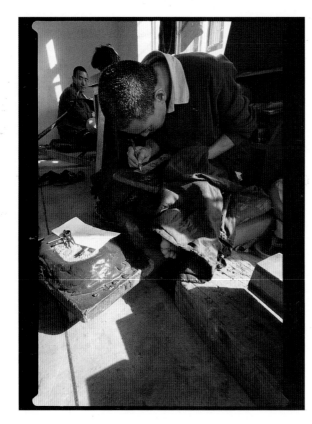

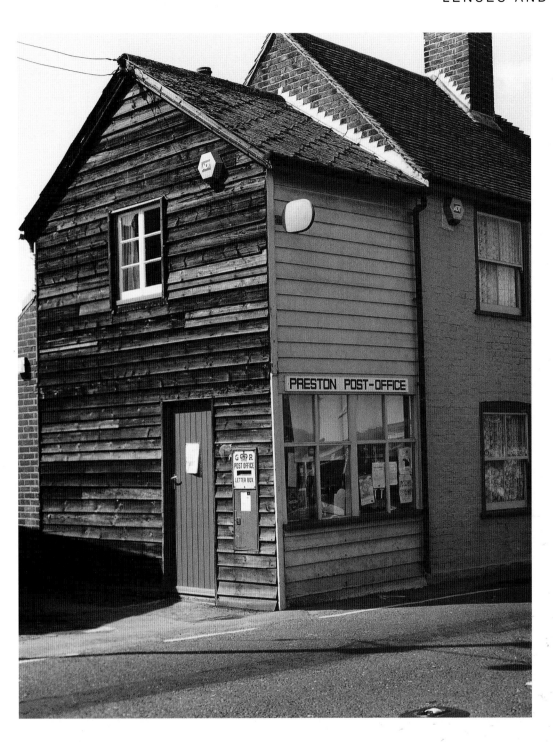

MINIMUM APERTURES

Few lenses deliver their best performance at maximum aperture. Most lenses for 35mm and MF improve steadily as they are stopped down to f/5.6 or f/8, after which the performance starts to deteriorate again. With LF, peak performance may be reached a little later, at f/11 or even f/16, because of the larger area they are required to cover.

The deterioration is principally due to diffraction, which limits the performance of the lens (page 16), and if you want the best performance possible, you should always work at the first aperture that is diffraction limited.

PRESTON POST OFFICE

A fast MF lens (here, the superb 80/2 Planar of the Contax 645) and a good ISO 400 film (here, Ilford HP5 Plus) can give better sharpness and grain than 35mm and ISO 100 or slower. The close-up of the letterbox is reproduced same size from a 14x17in enlargement; the other picture is "all in." *(FES)*

INTERIOR, RUINED HOTEL, MALTA
When we use extreme wide-angles on MF, we prefer whenever possible to use our scale-focusing Alpas rather than cameras with ground-glass focus: intelligent use of the depth-of-field scale gives a much better idea of what will be in focus, and what will not. We sometimes use the ground glass on the Alpas for extremely precise composition, however. *35/4.5 Apo Grandagon on 6x9cm Ilford HP5 plus, printed on Ilford Multigrade Warmtone, untoned. (FES)*

FOCUSING, SPEED AND FOCAL LENGTH

With LF cameras in particular, wide-angles can be difficult to focus, almost regardless of speed. This is because of the acute angle at which the light rays hit the ground glass, and "extra bright" focusing screens only make matters worse, with brighter hot-spots and dimmer outer areas. When rise and cross are employed (page 68), some such screens are completely useless.

On the other hand, even very slow lenses can be surprisingly easy to focus if the focal length is great enough: it is as easy, for example, to focus a 300/9 lens on 4x5in or 5x7in as it is to focus a 110/5.6, despite the fact that the 110 is 1⅓ stops faster.

WIDE-ANGLES AND TELEPHOTOS

With LF, and nonreflex MF cameras, extreme wide-angles are easier to design than they are for 35mm and MF SLRs, because there is no need to use a Retrofocus (reverse-telephoto) design to clear the flipping mirror. Many do incorporate a degree of reverse-telephoto design, not least to improve evenness of illumination, but this still imposes fewer constraints on the designer than with reflexes.

Telephotos are nearly as common in MF as in 35mm, but they are little used in LF. Although they can be useful, allowing the use of significantly greater effective focal lengths than would normally be allowed by the bellows draw, they can be extremely confusing if you want to use front swings and tilts, as the nodal point (the point about which the swing should act) is some way in front of the front standard.

TELECONVERTERS

Teleconverters are very convenient, but they have two principal disadvantages. One is that the faults of the lens with which they are used are magnified along with the image size, and the other is that they reduce the maximum aperture by a factor equal to the magnification. The importance of the former is less with both MF and LF than with 35mm, for the usual reason that the image is magnified less, but the latter is more important, as MF and LF lenses are slower to begin with: when a 150mm f/5.6 is transformed to a 300mm f/11, and f/22 is a sensible working aperture, the drawbacks are clear.

For this reason, although most manufacturers of MF cameras offer teleconverters, they are not popular, and the market is not big enough to support many independent converters: very few are available, in even fewer fittings. When it comes to LF converters, we have only encountered one, though of course it is pretty much universal in applicability.

GRAVEYARD, SELMA, ALABAMA
The old 121/6.8 Angulon (not Super Angulon) that was used to take this picture is wonderfully compact and works superbly with monochrome (including, as here, Polaroid Sepia), but in color, the newer 110/5.6 Super Symmar XL Aspheric is a much better lens. *Toho FC45A. (RWH)*

SOFT FOCUS

If you like soft focus, use the biggest format that you conveniently can, and a purpose-made soft-focus lens. The results are much more predictable: if you use 8x10in and make contact prints, you can judge what is going to happen just by looking at the ground glass. Although we have used soft focus on both 35mm and 6x7cm, we no longer consider it below 4x5in and we prefer to use it only on 5x7in and 8x10in. We would love to find a 1920s soft-focus lens, an 18in or above, to use with 8x10in.

JAGUAR XJ-S
A drawback to "tea-strainer" (perforated) diaphragms is that they can lead to oddly shaped highlights. This is from a 6x7cm Ektachrome 64 transparency shot with a 150mm soft-focus lens on a Mamiya RB67. *(RWH)*

Ancient and modern

BAY, THE PELOPPONESE
The old Voigtländer Apo-Lanthar was probably the finest lens of its day – it appeared in about 1950 as 105/4.5, 150/4.5, 210/4.5 and 300/4.5 – and it is unlikely to be taxed by any mono work, or most color, though under adverse conditions the multi-coating of newer lenses will give them an edge.
MPP Mk VII, 150/4.5 Apo-Lanthar, Polaroid Polapan 100. (RWH)

In an ideal world, we would all use the latest and finest lenses – or would we? In fact, there is a good deal to be said for both ancient and modern lenses.

The first question is, are you shooting black and white or color? In color, newer lenses will almost always be contrastier and brighter: older lenses – before the 1970s, say – can be flat and (out of doors) rather blue, as a result of higher flare levels. But in black and white, flare can be greatly reduced with an efficient lens shade, then compensated for by increasing the development time. The effect will not be quite the same as with a contrastier lens and decreased development, but many prefer the effect of older lenses.

The next question is, what sort of lenses are we talking about? Some designs are so good that they have hardly changed at all over several decades. Many old standard and long lenses can scarcely be bettered, provided they are undamaged and clean: that is, they have no scratches on the outside, the result of overenthusiastic cleaning, nor hazing on the inside, usually the result of the distillation of lubricants from inside the lens onto the glass. The latter can be remedied; repolishing to cure the former is rarely worth the candle.

Wide-angles are another matter. There are a few noble exceptions, such as the deservedly legendary Zeiss Biogon, but in general, modern wide-angles are sharper, faster, contrastier and all-round better than older lenses.

MF LENSES

In black and white, just about any MF lens made since the 1950s will be adequate, and many will be excellent. The best MF lenses from the 1950s are still very impressive today, in color or monochrome, and by the 1970s or so almost all MF lenses were good for all film stocks, with the exceptions of a few

MARGATE FRONT
The 150mm and 210mm three-glass Rodenstock Geronars, also available as Calumet Caltars, deliver extremely good quality, very high contrast (the flare factor is negligible, as you would expect from a multi-coated triplet), and surprisingly large coverage (especially when stopped well down). They deserve to be better known, but they are often discounted as "too simple."
Cadet, 150/6.3 Geronar, Polaroid Type 55 P/N. (RWH)

ultra-wides and maybe the occasional "dog."

Although multi-coating is often more of a sales tool than a decisive optical advantage, it does serve as a useful marker. If a lens is new enough to be multi-coated, it is almost certainly equal in quality to just about anything being made today. The advantages of multi-coating itself will normally be apparent only in adverse conditions, as when shooting under a white sky without a lens shade, or directly into the light. We would never willingly use uncoated lenses.

LF LENSES

Some ancient LF lenses have cult status: there are those who will declare that they are better than anything made today. Examples include Goertz Dagors, the 203/7.7 Kodak Ektar, and Voigtländer's Apo-Lanthars. While it is true that newer lenses will always be sharper and contrastier, with a wider circle of coverage at f/16 or f/22, this may not matter in black and white: almost any LF lens ever made should be usable, and some (like the cult lenses) are very good, even uncoated.

The bigger the format, the more this is true, especially in contact prints, where the extra sharpness of a newer lens is unlikely to be visible: our (uncoated) 1905 Ross is astonishingly sharp at f/16 or so.

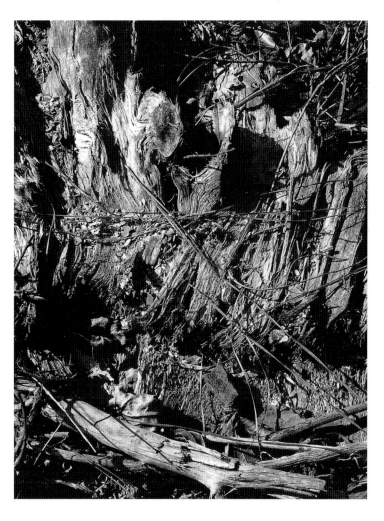

TREE ROOTS, SELMA, ALABAMA
It is not hard to see from this picture how the Dagor earned its reputation. The 168/6.8 Dagor used for this shot, taken in 1999, was probably 70–80 years old at the time.
CADET, POLAROID TYPE 55 P/N. (FES)

COVERAGE

The coverage of newer lenses tends to deteriorate quite smartly outside their circle of sharp resolution, even when well stopped down, while older lenses seem to go on picking up more coverage for much longer. In particular, the old Goertz Dagor covers absurdly large angles of view at f/64, and the Schneider G-Claron, designed as a process lens, has considerably more than its nominal angle of coverage even at f/32.

SIZE AND WEIGHT

The vast majority of old lenses are a great deal smaller and lighter than the vast majority of new ones, which can be a decisive point if you are out walking with your camera, or if you have a camera with a small lens panel or a narrow "throat": some of the bigger modern lenses simply will not fit onto some older cameras.

Shutters

Among medium format SLRs, there is a great divide between leaf-shuttered (LS) and focal-plane shuttered (FP) cameras. Historically, the advantage of leaf shutters was flash synch at all speeds, but the latest and fastest FP shutters, as fitted to the Contax 645, offer higher top speeds and faster flash synch. On the other hand, they are also more highly stressed and more fragile than some of the leisurely cloth FP shutters of old, and should be treated with the utmost care and respect. Really, really old FP shutters, where speeds were controlled by independently set slit-width and tension, may still be astonishingly reliable today.

Focal-plane shutters are all but unheard of today for large format, but enough varieties of leaf shutters are encountered that they warrant a fair amount of description.

HOTEL DE FRANCE, MONTREUIL
Until we bought the 110/5.6 Schneider Super Symmar XL, the 120/6.8 Angulon in an old Synchro-Compur was our standard travel lens on the Toho FC45A/FC45X; and that shutter never even required cleaning in a decade and a half.
POLAROID SEPIA. (RWH)

LARGE FORMAT SHUTTERS

Over the years, there have been several standard sizes for leaf shutters: 00, 0, 1, 2, 3, 4 and 5. The tiny 00 size is rarely encountered for view camera lenses – it was mostly for amateur snapshot cameras – but it is sometimes found with 65mm and similar lenses. It suffers from the infuriating drawback of having neither a "T" setting nor any means of keeping the shutter open, other than "B" and a locking cable release. Sizes 0 and 1 are the most usual nowadays; size 2 is no longer made, and repairs can be problematic (the easiest option is often reshuttering in a size 3); size 3 is the largest normally encountered; size 4 is rare; and size 5 is vanishingly rare.

It is often possible to put a new lens straight into an old shutter, but if you do, it is essential to keep the same separation of front and rear lens cells: just because a lens will go into a shutter, it doesn't mean that the separation is right, and wrong separation can undoubtedly wreck performance. Some use shims, while other shutters have an adjustable separation.

Modern shutters are more convenient, for several reasons.

OASTS

Fast FP shutters can come into their own for hand-held shots with long lenses. This was shot with a Contax 645 using the 210mm Sonnar, where $\frac{1}{250}$ second would be marginal and $\frac{1}{500}$ second the minimum one would really want – except that, as noted in the text, very few leaf shutters can manage a true $\frac{1}{500}$. This was shot on Ilford HP5 Plus at $\frac{1}{1000}$ second. (RWH)

First, they have a simple sliding lever to open and close the lens for focusing, which works whether the shutter is cocked or not. Second, shutter speed and aperture scales are normally duplicated above and below, making them easier to see and to set, even when the camera is awkwardly placed. Third, they have only X-synchronization: most earlier shutters have a lever to select M-synch (for bulbs) as well, and accidentally knocking the lever to M means no flash synch for electronic flash. A dab of glue to secure the lever is not a bad idea.

On the other hand, many old shutters, especially Compurs, are astonishingly reliable, and most can be cleaned and repaired quite cheaply. An old professional trick is to set the shutter "sideways" (turned through 90 degrees) so that the scales are easier to read. The generation before the present one was opened and closed for focusing via a little push lever beside the cocking lever: push in to open and pull out with a fingernail to close. The shutter must be cocked before this will work, but it does not need to be recocked to take the picture.

Still earlier shutters were opened and closed by the (somewhat circuitous) process of cocking; pulling back the interrupter button, at the end of the travel for the cocking lever; and releasing the shutter. The cocking lever will hang up on the interrupter. Pull the cocking lever back a fraction to release the interrupter, and allow the shutter to close. Recock for use.

The interrupter also allows engagement of the self-timer in many shutters. When the shutter is fully cocked, pull the interrupter back, and push the cocking lever past the interrupter. Often, the self-timer is sticky on old shutters,

DRILLINGS

Figures for 0, 1 and 3 are official; figures for sizes 00, 2 and 4 are as measured from shutters in our possession (we think the big one is a 4). We have never even seen a 5.

00	25mm approx (1in)
0	34.8mm (1.40in)
1	41.8mm (1.65in)
2	49mm approx (1.95in)
3	65.3mm (2.57in)
4	78mm (3.07in)

but it can be helped with a gentle push: listen for the buzz that says it is working. On a few shutters, delayed action ("V") is selected with the same lever as M/X synch: the MXV lever.

Speeds on the very earliest Compurs were set on a small dial at the top of the shutter, so these are called "dial-set" shutters to distinguish them from "rim-set." "Compound" shutters look like dial-sets, but speeds are governed pneumatically (and far more accurately than this might lead you to expect) instead of mechanically. On dial-set Compurs and Compounds, there is an additional control, marked M-B-Z or I-B-T. For Instantaneous or Moment timed exposures, the lever is set to I or M and the shutter must be cocked. The shutter need not be cocked for B or TZ, and indeed, attempting to do so will damage it. The former is Bulb or Brief, where the shutter stays open as long as pressure is exerted on the release, and the latter is Zeit or Time, where the shutter opens on the first pressure and closes on the second.

PRESS SHUTTERS

"Press" or "everset" shutters do not require cocking. This limits the maximum speed, but they can be extremely convenient if you want to make multiple "pops" with electronic flash, or if you are photographing a poorly lit scene where people wander in and out of shot. Instead of (say) one exposure of 1 second, you can give eight exposures of ⅛ second, shooting when the coast is clear. In windy weather, too, you can make use of the fact that foliage normally comes back very close to its original position when the wind dies down, and make (say) four exposures of ¹⁄₁₂₅ second instead of one at ¹⁄₃₀ second.

SINAR SHUTTERS

Sinar shutters, which fit behind the lens, are essentially updated (and more accurate and reliable) versions of the kind of front-of-lens or behind-lens shutter described on page 93.

LOCATING SLOTS

Most shutters are supplied, when new, with a locating pin which fits into a slot filed at the side of the circular panel drilling. This pin has often been removed on older shutters, because it makes it quicker and easier to swap panels

MARIE AT HIPPO'S
A great advantage of leaf shutters is that they synchronize at all speeds, so that it is possible to use synchro-sunlight (fill flash) across a much wider range of shutter speeds, or as here to balance internal lighting (2400W-s of flash) with external daylight. *"BABY" LINHOF WITH 105/3.5 XENAR, CONVERSION FROM FUJI ASTIA 100. (RWH)*

without using a lens spanner: the shutter can just be screwed into the panel. Normally, panels are supplied without a locating slot, but whenever possible, retaining the pin is a good idea.

TRUE SPEEDS, FLASH SYNCH AND EFFICIENCY

With the exception of very recent Rolleiflexes, the high speeds on leaf shutters are rarely all that accurate: a marked ⅟₅₀₀ is rarely even ¼₀₀, and may be as little as ⅟₃₀₀. But then, ⅟₂₅₀ may only be ⅟₂₀₀. Even so, some flash guns do have a long enough flash duration that the flash is "clipped" at the highest speed.

In available light, too, it is worth remembering that shutter efficiency is affected by aperture. At small apertures, the entire aperture is uncovered sooner, and covered later. As a result, the effective exposure at (say) ⅟₁₂₅ second at f/22 will be slightly more than 4 stops greater than at ⅟₁₂₅ second and f/5.6. This rarely matters, but is worth knowing about; it is most significant at the highest shutter speeds.

THE ROMAN GALLEY
The exposure needed here was about 10 seconds – more than enough time for ghostly blurs to wander in and out of shot. Chopping the exposure into ten 1-second exposures is safer, but with a conventional shutter, this would risk moving the camera each time that the shutter was cocked. A press shutter solves such problems.
TOHO FC45X, 90/6.8 SCHNEIDER ANGULON, POLAROID SEPIA. (RWH)

Pinholes and pinhole cameras

Before we go on to look at the other accessories that make up the MF and LF outfit, it is worth taking a look at pinholes. The fascinating thing about pinhole images is that depth of field is infinite (everything is equally sharp, or unsharp); that there is zero distortion; and that "focal length" depends solely on how far the pinhole is from the film. It is therefore possible, for minimal expenditure, to take extreme wide-angle shots, such as the equivalents of 35mm on 6x9cm or 50mm on 4x5in, both of which equate roughly to 14mm on 35mm. And the advantage of MF and LF is that the larger the format, the less it needs to be enlarged, so (as a general rule) the more successful a pinhole image will be.

We have to admit that we regard pinhole photography as more of a curiosity than a matter of great interest, partly because of the difficulty of aiming the camera, partly because of the drawbacks of very long exposure times – a pinhole typically has an effective aperture of f/180 or smaller – and partly because we do not find the softness particularly attractive. We have had some very attractive results with Rigby pinhole cameras, but we have never exerted ourselves greatly in this field.

Although there is an optimum pinhole size for every format, working distance and pinhole/film separation, a hole of around 0.5mm is fine for separations of 150mm and above, with perhaps 0.4mm for wide-angle shots, and 0.3mm or even 0.2mm for copying or extreme close-ups.

RIGBY 4x5in PINHOLE CAMERA
Far and away the easiest route into pinhole photography is via a ready-made pinhole camera. This one is aimed by lining up studs on the top and side – they should just about be visible in reproduction – and there is even a shutter which doubles as a lens cap.

AIMING THE CAMERA

The easiest way to make a finder is to bend a piece of wire – a coat-hanger is ideal – to the shape and size of the format, and mount that on the front panel. A rear peep-sight is then fixed above the film plane. If the separation of the two standards is varied, this automatically adjusts the field of view.

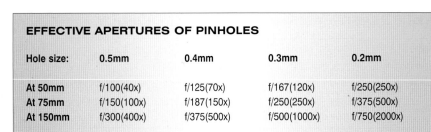

EFFECTIVE APERTURES OF PINHOLES

Hole size:	0.5mm	0.4mm	0.3mm	0.2mm
At 50mm	f/100(40x)	f/125(70x)	f/167(120x)	f/250(250x)
At 75mm	f/150(100x)	f/187(150x)	f/250(250x)	f/375(500x)
At 150mm	f/300(400x)	f/375(500x)	f/500(1000x)	f/750(2000x)

The figures in brackets are the (very) approximate multiplication factors for the exposure time, as compared with f/16. Depending on the film, these exposure times may in turn need to be doubled or quadrupled for very long exposure times (10 seconds or above) in order to compensate for reciprocity failure.

MAKING THE PINHOLE

Several suppliers sell pinholes "off the shelf" and this is the easiest way to get a well blacked, round hole. For those who are determined to do it themselves, the classic approach is to punch a small dimple in a piece of thin metal; rub the dimple down with a very fine file, to create a thin spot; then punch through the thin spot with a sewing needle, working from the hollow side. Remove the burr with a fine carborundum stone; pass the needle through the hole again to clean it up; examine it with a magnifier, to make sure it is clean and round; and blacken the hole, preferably chemically (gun-black works well). Blacking the hole is one of the most difficult parts of the whole undertaking: an unblacked hole, or burrs, will reduce definition.

NO 3 ALFRED ROAD
The distance from the pillars in the foreground to the house in the background is probably about 7m (20ft), yet everything is equally sharp (or unsharp).
RIGBY 4X5IN, POLAPAN 100. (RWH)

THE TUDOR HOUSE, MARGATE
Polaroid Sepia film is curiously well matched to pinhole cameras: the lack of definition of the pinhole combines with the sepia to create an illusion of something from the dawn of photography.
RIGBY 4X5IN. (RWH)

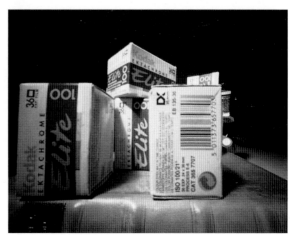

CLOSE-UP
It is hard to believe that pinhole cameras really do have infinite depth of field, until you try it. The smallest print on the film boxes is not legible, but there is plenty that is.
RIGBY 4X5IN, POLAPAN 100. (RWH)

Tripods

Many MF and LF users buy tripods that are heavier than they need. The heaviest tripod that we normally use on location weighs about 4kg, well under 9lb. That will support a 6kg (13lb) 8x10in camera, almost 2m (about 6ft) above the ground. The lightest tripod we use with 4x5in weighs well under 2kg, about 3½lb, again complete with head.

The important thing is rarely whether the tripod can support the camera. Rather, the trick lies in avoiding vibration. Some tripod/camera combinations are notorious for high-frequency vibration: you may literally hear them ring or buzz. Others wobble, so that if you put a spirit level on the camera, you will see the bubble constantly moving. The camera is, in effect, acting like a pendulum-bob.

The extra mass of an MF or LF camera means that "ringing" is far less of a problem than it is with 35mm – and the smaller degrees of enlargement mean that even where it is present, it will degrade image quality less. To a large extent, therefore, this is a self-solving problem. The pendulum effect is another matter. It can normally be traced to a completely undersized tripod (very rare); a poor tripod head (fairly common – see box below); or a center column (the biggest single culprit).

LINHOF TRIPOD

Our biggest tripod can hold our heaviest 8x10in camera (the De Vere monorail) perfectly securely some 2.5m (8–9ft) above the ground, even with the center column at full extension. On the other hand, look at the size of the thing, and consider that even if Frances were standing on the wall, she still wouldn't be high enough to use the camera.

QUICK-RELEASE PLATE

The NPC Pro-Head is available with and without QR plates, the semistandardized Arca dovetail pattern. We rarely use QR plates with MF cameras, but we habitually use them with LF. If a QR plate does not add unacceptably to the weight and bulk of an MF camera, then either the plate isn't substantial enough, or the MF camera is too big and heavy to carry about much.

TRIPOD HEADS

Anywhere that a tripod head has a small cross-section, there is the potential for vibration. Anywhere there is a small mating surface, there is the potential for slippage. Look too for realistic-sized locking knobs. Some pan-and-tilt heads rely for each movement on a single 6mm (¼in) bolt, secured by a 25mm (1in) butterfly nut compressing a thin, flat 12mm (½in) washer. This is hopelessly inadequate.

On the other hand, good design does not necessarily rely on sheer bulk. A well designed pan-and-tilt head might rely on that same 6mm bolt, but use high-tensile steel so that it will not strip; a longer locking lever, to exert more force; and conical mating surfaces that will not rotate relative to one another once tightened.

BEWARE THE CENTER COLUMN

After decades of experience, we have come to the simple conclusion that for MF and LF cameras, a center column is rarely worth the weight, expense and (above all) reduced stability that it entails. Although we have one tripod with a totally reliable center column that will hold our 10kg (22lb) 8x10in monorail 2.5m (8ft) in the air, it weighs well over 9kg (call it 20lb) in its own right, complete with head. Several of our favorite tripods don't even have center columns: with the ones that do, we either don't use the center columns, or we use them at only very short extensions, and then only with the lighter cameras. Tripods without center columns are undoubtedly less convenient, but in our experience, the savings in weight and money alone are worth the sacrifice, and the increased sharpness is a bonus.

4x5in OUTFIT
It does not make much sense to buy an ultra-light 4x5in camera like the Toho FC45X, and then anchor it to a tripod that weighs a ton. The MPP tripod illustrated weighs a mere 1350g (3lb), without head, and is more than stable enough.

WAR MEMORIAL, THE PELOPPONESE
The MPP tripod can actually hold a considerably heavier camera than the Toho illustrated (above), including (unsurprisingly) an MPP Mk VII, which was used to take this picture. The MPP weighs rather over 4kg (9lb) complete with its 150/4.5 Apo-Lanthar.
FUJI PROVIA 2. (RWH)

113

PHOENICIAN APIARY, MALTA

In the studio, we often shoot two 4x5in sheets, one for "insurance" in case of incorrect exposure or damage. When traveling, we don't always do this. Inevitably, unique images are always the ones that get damaged: look at the processing scratch in the tree on the right. *Toho FC45X, 110/5.6 Schneider Super Symmar XL, Kodak E100S. (RWH)*

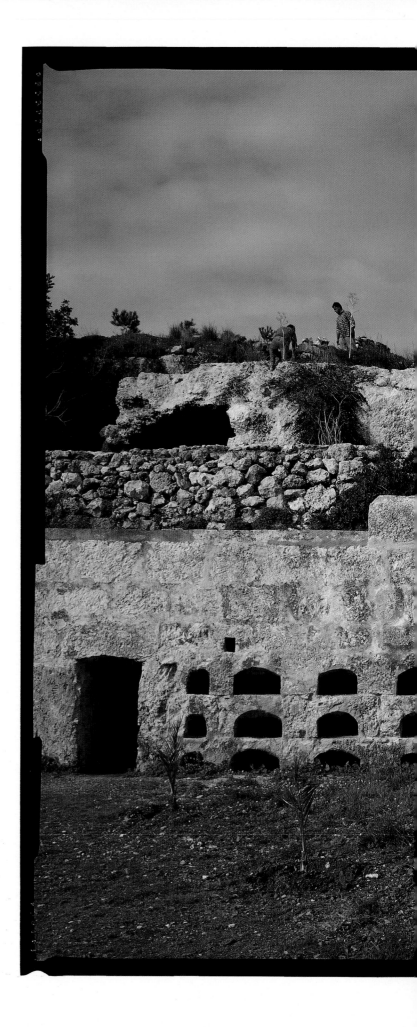

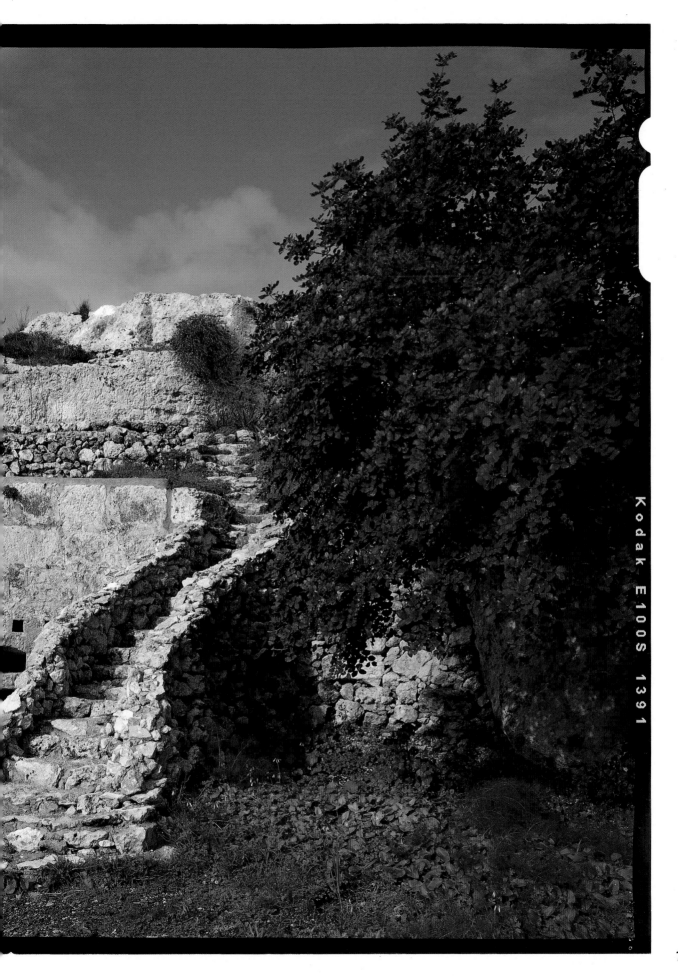

Kodak E100S 1391

115

Meters and metering

If you want the ultimate in quality, in any format, you have to understand that exposures for color slides are pegged to the highlights, while exposures for negative films (color or mono) are pegged to the shadows.

Understandably, most in-camera meters in both 35mm and MF cameras are designed to give the best possible results with slides, where departures from the optimum exposure are most obvious. They do not, however, give the best possible results with negative materials. In order to get good shadow detail when using most in-camera meters, you have to rate these films slower than the ISO speed, which leads to the entirely erroneous belief that black-and-white films, in particular, are not really as fast as their ISO speeds indicate. They are, of course; but you have to use a metering technique that is appropriate for negative films, not a metering technique that is appropriate for transparency films.

◄ PENTAX SPOT METER

Roger uses mostly the Gossen Spot Master 2, while Frances uses mostly Pentax spot meters. The Pentax meters are not as sophisticated, and are arguably slower to use, but they are easier to understand and a great deal easier to illustrate: the Gossen gives a direct exposure reading in the viewfinder, while the two Pentaxes give a number from 1 to 19 in the viewfinder (one reads out on a moving-needle scale, the other via an LED) and this number is transferred to the calculator scales.

▲ IRE SCALE

A particularly useful feature of the Pentax is the IRE (Institute of Radio Engineers) scale, in which 1 is 2⅔ stops below a mid-tone and 10 is 2⅓ stops above. As shown here, the darkest shadow area in which texture is required was indicated in the viewfinder as 8; this is set to 1 on the IRE scale. A highlight reading of 13 would give the same reading.

WORKSHOP, TIBETAN INSTITUTE FOR PERFORMING ARTS

Frances based her exposure on spot readings of the floor (lower right) and cupboard (right), using the IRE scale. This allowed a tiny bit of texture and tone in the darkest areas, even in a fairly straight print.
ALPA 12 S/WA, 35/4.5 APO-GRANDAGON, 6x9CM KODAK PORTRA 400 VC.

METERING FOR NEGATIVES

The easiest way to ensure optimum quality on negative materials is to take a limited-area reading of the darkest shadow area in which you want texture, and give about 2 stops less exposure. If you used the meter reading "straight," the shadow would be rendered as a mid-tone: you want it darker, so you give less exposure. You can make this limited-area reading with the "spot" mode in your camera (if it has one); by going in close and taking a reading with a conventional hand-held meter, taking care not to shade the area you are reading; or with a spot meter (see illustrations). With any of these techniques, you should be able to use the manufacturer's ISO speed, or something very close to it: no more than ⅓ stop slower, EI 100 for Ilford FP4 Plus, for example (true ISO 125).

If you don't want to take limited-area readings, then the best you can hope for is an approximation. Use your in-camera meter, or a conventional reflected-light meter, but set a film speed that is up to a stop lower than the ISO speed: EI 200–250 for Ilford HP5 Plus, for example (true ISO 400), or EI 50–80 for Ilford Delta 100. Increased exposure will inevitably mean more grain and reduced sharpness, but with the larger formats this is nothing like as important as with 35mm, so you get a lot m ore gain with a lot less pain.

METERING FOR TRANSPARENCIES

Easily the best way to meter for transparencies, even if you have a through-lens meter in your camera, is to take an incident-light reading, that is, a reading of the light falling on the subject. Although the strangely shaped invercone of the old Weston meter is probably the best incident-light receptor ever designed, a simple dome like that on the Gossen is very nearly as good and a lot more convenient. Hold the meter as close to the subject as possible, with the subject/camera axis in line with the axis of the receptor.

Alternatives include using the in-camera meter (of course), or using the spot meter to take a highlight reading and setting that against 10 on the IRE scale, as described in the caption on page 116.

HERO SANDWICHES
For this shot, Roger used a Gossen Variosix F held just above the sandwiches, with the incident-light dome pointing straight at the camera. The color is because he used tungsten lighting (3200 K) with daylight-balance film (Fuji Provia) to re-create the light of the setting sun.
LINHOF TECHNIKARDAN, 210/5.6 SYMMAR.

Filters and shades

SKELETONIZING FILTER ADAPTOR RINGS

If an adaptor ring obscures the lens controls too much, "skeletonize" it. You can use a drill, a hacksaw and a file, though a Dremel tool is much easier.

Most of our filters are made of optical resin, or "organic glass," or (to be blunt) "plastic." Many people throw themselves around like a pig in a fit when anyone suggests this, saying, "I'm not gonna ruin the definition of my $1000 lens with a $15 filter." Well, we cheerfully use $15 filters on lenses that cost a good deal more than $1000; and we know, because we have tested it, that the loss of definition that they entail is imperceptible.

Once again, we get a lot of flack over this. "Well, maybe *you* can't see it," people say, "but *I* can." Invariably they haven't actually tested it at all; they are relying on good, solid prejudice and on what "everyone knows." But we are not the only ones who cannot detect meaningful degradation: Ctein, who tried the same experiments, found exactly the same results.

WHAT SIZE "SYSTEM" FILTER DO YOU NEED?

For modern LF lenses, and for big lenses on MF cameras, the 100mm size is probably the most convenient. Although the 84mm size is often described as "professional," it can prove limiting on LF when extreme movements are employed, or with ultra-wides on MF. We also use the 67mm "amateur" size on the "baby" Linhof, where anything bigger fouls the base-board.

To be sure, if you want to buy B+W or similar top-of-the-line multi-coated glass filters, do not let us discourage you. They are a pleasure to use, a good deal more compact than "system" filters, more resistant to scratching, and (because they are coated) very slightly more contrasty under extreme conditions; but the low refractive index of CR39 resin means that "plastic" filters have far less need of coating than glass anyway. Many LF lenses have

REAR FILTER ADAPTOR

Some lenses (such as our 110/5.6 Super Symmar) are specifically designed to take rear-mounted filters, but before we bought that lens, we had an adaptor made by SRB of Luton to enable us to use 52mm filters behind our 120mm Angulon, here seen mounted in a Gandolfi Variant.

FILTERS AND SHADES

The MPP on the left has a Kodak universal shade, held by three plastic set-screws, which accepts 3in (75mm) square gels in frames. On top of it is a Pro 4 hood, which allows any of four filters to be put in place or removed in a second – a boon for a wedding photographer – and lower center is a Cromatek rail-type bellows shade/filter holder on a 35mm Pentax. Upper center, the Toho FC45X wears a Cromatek self-supporting bellows, while on the right, a Gandolfi Variant has a Cromatek wide-angle filter holder, designed to obviate cut-off with lenses like the 121mm Super Angulon in use.

▶ LINHOF CLAMP-ON HOODS

The old clamp-on Linhof hoods are crude (they are also astonishingly expensive, even second-hand), and the filters that go with them are uncoated, but as a system, they are tough and very quick and easy to use. Much the same is true of bayonet-fitting hoods for Hasselblads, Rolleis and others. In general, go for rectangular or square hoods whenever possible, as they can be made deeper than round hoods for a given focal length.

smaller rear glasses than front glasses, so rear, screw-in filters can certainly be a worthwhile option.

Gel filters are admirably small and light, though easily marred, and are easy enough (though a little time-consuming) to use in conjunction with a simple spring-clip holder; modern acetate filters are cheaper and a lot less delicate.

LENS SHADES

Wherever possible, we use self-supporting bellows shades (from Lee and Lastolite) that can be adapted to precisely the right length for a particular lens. In the past, we used the "bellows plus rail" variety, but self-supporting shades are much quicker to use; are smaller when collapsed; and can be "bent" for use with shift lenses or when lens movements are employed. The only real risk is pulling them out too far, so that they are in shot: check this carefully, with the lens at minimum aperture.

FLARE BUSTER

The real jokers in the lens-shade pack are the Flare Buster (illustrated) and the similar Wiggly Worm, which are both ideal for flagging off light sources when a conventional hood is not feasible, usually because extensive movements have been employed or because the lens is an extreme wide-angle. They cannot offer the overall protection against veiling flare that is available from a proper hood, so they are of limited use on an overcast day or in a white "coved" studio, but for individual windows or lights, they can be invaluable. They can also be used to hold filters when (for some reason) "system" holders are not feasible.

Nonphotographic accessories

It is never a good idea to compartmentalize photography too far. From a Swiss Army knife to a compass to a cellular phone, there are all kinds of "nonphotographic" and "semi-photographic" accessories that can improve your photography regardless of the format you use; but with MF and LF, where there is more incentive to think about what you are doing, rather than relying on point-and-shoot cameras and the manufacturers' accessories, the case is even stronger. In alphabetical order:

Business cards Essential if you want to look professional. May get you into places that are otherwise inaccessible. Properly printed cards are more impressive than the ones you get out of machines.

Compass The sun rises in the east and sets in the west. A compass can help you determine the time of day that is most likely to produce the best pictures. As a rule, smaller is better: you don't need extreme accuracy, just a general indication. For map reading, though, a hand-bearing compass is more useful.

Leatherman The original multi-tool, and still probably the best, with first-class needle-nose pliers, a couple of usefully small screwdriver blades, and more. Now available in a surprising range of models.

Lens wrench Not something you normally need to carry with you, except on extended trips, but useful for changing LF lenses into different panels. Illustrated on page 121.

GARLIC SELLER, FOURCALQUIER
Even if you are half-way competent in a language, as we are in French, a dictionary is a good idea – or a phrase book, if you are not half-way competent. *ALPA 12 S/WA, 35/4.5 RODENSTOCK APO-GRANDAGON ON 6x9CM KODAK PORTRA, CROPPED TO APPROXIMATELY 6x8CM. (FES)*

Maps A good map – the larger the scale, the better – can make it easier to find interesting places; gives a good idea of when to shoot (see Compass); and helps you find places faster without getting lost.

Mini portfolio We first saw this a few years ago: a tiny photo album of your best work, to explain to people what you do. Again, can open doors in the same way as Business Cards, above.

Cellular phone A basic model can be used for all the obvious applications such as telling hotels you are going to be late, or checking the availability of filters or film at the nearest camera store, but a more sophisticated model allows internet access for weather news, traffic news, tourist attraction websites, etc.

Pencil Essential for marking films and dark slides with subjects and "push/pull" notes, and for noting anything important in a notebook. A soft lead requires less pressure and is more easily erased.

Ruler A small (15cm/6in) steel ruler is not just useful for checking filter sizes, etc: it

can also be used to determine reproduction ratios, and as a straight-edge in map reading.

Screwdrivers For tightening screws that come loose in the field. Philips-head and other cross-heads are often more useful than plain.

Spirit level Accessory shoe-mounted models are good, but some cameras don't have accessory shoes. A small, plain, block-type level takes up very little space in a pocket, and can also be used for levelling enlargers, processors, balances and more.

String An easy way to stop tripod legs skittering on a shiny floor (tie a triangle, one foot at each corner). Also handy for *ad hoc* lanyards and all kinds of other things. Brightly colored nylon string is the easiest to see.

Swiss Army knife Arguably less essential if you have a Leatherman already, but still mightily useful.

Tape measure To check focusing distances, dimensions of subjects and more. A very small 2m (6ft) measure is normally all that is needed and again fits in a pocket.

Thermometer Essential if you shoot Polaroids; useful for checking temperatures for film storage.

Timer Extremely useful for Polaroids and for long exposures, though a watch is nearly as handy. Most people can count with adequate accuracy (to the nearest 10 percent) by counting "a thousand and one, a thousand and two..." and so forth, but this gets tiresome for 2-minute developing times.

Tourist office information This not only tells you what's where: the illustrations can also give some idea of what to shoot and how to shoot it (or sometimes, what not to shoot and how not to shoot it).

Vernier calliper Again, not something you need to carry with you, but ideal for measuring filter and cap sizes, lens panel holes, and (very important) lens dimensions on LF lenses when reshuttered (page 106).

BEDROOM, CHONOR HOUSE

Luxury hotels are surprisingly often willing to let you take pictures, but a business card makes you look more professional.

ALPA 12 S/WA, 35/4.5 RODENSTOCK APO-GRANDAGON ON 6x9CM KODAK PORTRA, CROPPED TO APPROXIMATELY 6x8CM. (FES)

TOOLS

Lens spanners are not strictly photographic – you don't take pictures with them – but they are useful tools, whether you go for the lightweight version beside the lens, or the heavier one beside the camera. And small screwdrivers are always useful.

Putting it all together

BLIND MATCH SELLER, NEW YORK
Do not despise the humble standard lens, though in this case it was the not-so-humble 80/1.9 for the Mamiya 645. The bigger formats and longer focal lengths somehow perform differently from 35mm.
KODAK EPR. (FES)

By the time you move up to MF or LF, the chances are that you should have a pretty good idea of the sort of photography that interests you – and as intimated throughout the book, one of the pleasures of formats larger than 35mm is that the cameras are refreshingly nongeneric, so you can get the outfit that suits you, rather than "one size fits all."

The very simplest outfit – one camera, one lens – has its place, and can be all you need for many forms of photography: portraiture, or reportage, or even landscape. But most people are used to the choice of lenses they get with 35mm, so the lens outfit is a good place to start.

THE MF OUTFIT

Although a number of excellent long lenses are available for MF, especially from Pentax, it is not unfair to say that once you go beyond about a 135mm lens in 35mm terms, you are looking at huge, unwieldy and expensive objectives. The equivalent of 135mm on 35mm would be 210mm on 645, 250mm on 6x6cm, and 300mm on 6x7cm.

In the other direction, some excellent wide-angles are available, but they are rarely wider than the equivalent of 21–24mm on 35mm: 35mm on 645, 40mm on 6x6cm, 50mm on 6x7cm, unless you go for a nonreflex.

Within this relatively narrow range, there is no need to own a vast number of lenses, and often a three-lens outfit will do all that one would normally need. You may have to walk about a bit more than you would with 35mm, but as the old saying goes, "Your legs are your best zoom lens." In fact, we found that with an RB67, just two lenses did all that we needed: a 50mm ultra-wide and a 127mm "long standard."

Increasingly, we find that we can work with a single lens, and that the discipline of doing so gives us better pictures. This is true whether the focal length is the "wide standard" 80/2.8 on our Graflex XL, the 100/5.6 on the "baby" Linhof, or even the ultra-wides on our Alpas: typically 35/4.5 on 6x9cm for Frances, the equivalent of 14mm on 35mm; and 38mm on 44x66mm for

FORT, SAN PEDRO
At first sight, 38mm on 66x44mm is a fairly specialized combination; it is almost exactly the same as 21mm on 35mm. But if that is all that you carry with you, you soon learn to compose pictures that suit the focal length.
ALPA 12 WA, FUJI ASTIA. (RWH)

Roger, the equivalent of 21mm on 35mm. We use these last two so much that we had to make a conscious effort to go and shoot some new material for this book with more conventional focal lengths.

BACK GATE, MONTREUIL S/MER
A "standard" lens on a view camera seems to behave more like a wide-angle, presumably because of the visual clues (including true wide-angle distortion) when you use the movements, and because you can use movements and get in close, rather than not using movements and stepping back. This is true even of "baby view" cameras, such as the Linhof Super Technika IV used for this picture.
105/3.5 XENAR, FUJI ASTIA 100. (RWH)

THE LF OUTFIT

The availability of very long lenses for LF is even more limited than it is for MF: twice the length of a "standard" lens, the equivalent of 85mm on 35mm, is the longest that is normally practicable. In the other direction, although numerous extreme wide-angles are available – the equivalent of 14mm on 35mm – they are less use than you might expect, because they are so hard to focus on a ground glass. Once again, about half the "standard" focal length – the equivalent of 21mm on 35mm – is really the widest that you can use quickly and conveniently.

We find that the vast majority of our needs in 4x5in are met by a modest wide-angle and a somewhat longer-than-standard lens: 110mm and 210mm, equivalent to 32mm and 60mm in 35mm terms. At 5x7in, we use almost exclusively a "standard" 210mm lens (43mm in 35mm terms), and for 8x10in, the "standard" 300mm is again all we normally need, though our 21in Ross for portraiture has been mentioned elsewhere.

Something which is very hard to explain, however, is that these lenses do not seem to behave in quite the same way as their 35mm equivalents. Because of the availability of camera movements, they feel more like wide-angles, and because of the bigger format and greater working distances, you do not need such long lenses – proportionately – as you do with 35mm, in order to create pleasing perspective effects.

INTERIOR OF THE INQUISITOR'S PALACE, BIRGU, MALTA

The 110/5.6 Super Symmar XL Aspheric is roughly equivalent to a 32mm lens on 35mm. Although Roger preferred the 120/121mm focal length (35mm on 35mm), the XL is smaller, lighter and faster than the Super Angulon and delivers better quality, so it is now his standard lens for travel: he rarely feels the need for anything else. In the studio, the 210mm Apo-Sironar-N fulfils much the same "universal" role.

LF CHECKLIST

ESSENTIALS

Camera	Pencil
Film	Tripod
Lens(es)	Focusing cloth
Cable release	Lupe
Film holders	Exposure meter

OPTIONS

Spirit level	Thermometer
Lens shade	Timer
Filters	Empty film boxes
Roll-film back	Changing bag
Polaroid back	Tape measure
Polaroid film	

Whereas a 50mm lens on 35mm is quite rightly regarded as rather too wide for most sorts of portraiture, a 360mm lens on 8x10in works fine, despite having almost identical diagonal coverage, and even a 300mm is normally adequate.

CAMERA BAGS

We are firm believers in backpacks for carrying things, and as we grow older, we are more and more convinced of this. Ever-tighter airline restrictions on carry-on baggage meant that Roger had to step down from his original full-size Tenba backpack to a smaller one, but both of us believe that a comfortable, well designed backpack is the easiest way to carry any camera outfit for any distance.

If we do not have to carry the equipment any great distance, on the other hand, we will quite often use two bags for LF: one for the camera, lenses, etc,

and the other for film holders. Not only is this a better balanced arrangement for carrying, it is also much quicker for working.

LF OUTFITS – AND CHECKLISTS

Much the same considerations apply to the size of the LF outfit as to that of the MF outfit: better to have a small, reasonably portable outfit, rather than a massive, all-encompassing outfit which weighs a ton and means that you spend half your time changing lenses.

Because an LF outfit consists of so many bits from so many different sources, we find it all but essential to use checklists (page 124) to make sure that we have everything. This is divided into two parts, essentials and options, which makes it much more difficult to miss an essential (such as a focusing loupe) when omitting options (such as a Polaroid back). Our all-time record was a motorcycle trip with LF when we realized, 200 miles from home and on the wrong side of the English Channel, that we didn't have a tripod.

◀ *AVOCADOS*
Some decent professional lighting – in this case, Courtenay Solaflash – is often a more useful investment than new cameras or lenses.
LINHOF TECHNIKARDAN, 210/5.6 RODENSTOCK APO-SIRONAR-N, FUJI RDPII. (RWH)

ALL SAINTS, BIRCHINGTON
As far as we recall, this was shot with a 6x12cm Horseman back on a 4x5in camera, probably the Linhof Technikardan. The back was very expensive, and we have never found it as useful as we had hoped. We should have borrowed one before buying it!
LENS FORGOTTEN, BUT LOOKS LIKE 47/5.6 SUPER ANGULON, KODAK EKTACHROME 100. (RWH)

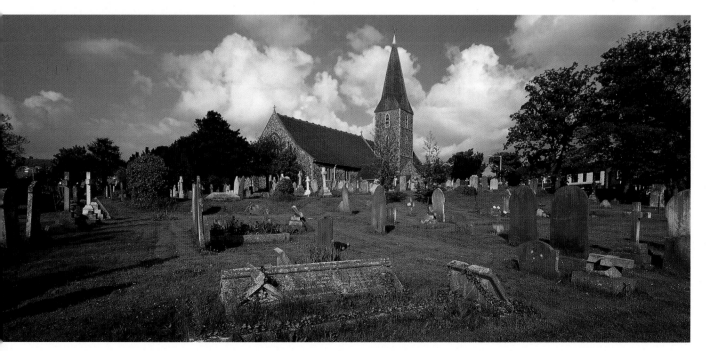

Chapter

5

THE DARKROOM

The MF and LF darkroom is surprisingly similar to the 35mm darkroom. The enlarger is bigger, of course, as are the spirals for developing 120 and 220 film. With LF, you have the choice of developing film in trays, or (with 4x5in) of buying some sort of developing tank. Everything else is the same: the same chemistry, the same print-processing arrangements. Apart from the actual physical film handling, everything about the MF and LF darkroom is in fact easier than 35mm.

Why is it, then, that most people actually take more care with their MF and LF darkroom work than most 35mm users? There are two reasons for this, one good, one bad. The good reason is that by the time you move up to MF and LF, you understand (and care) rather more about technical quality, so you are prepared to put in the extra effort. The bad reason is that too many people still think in 35mm terms.

One of the least understood truths about MF and LF is that you can afford to be rather less careful, at least when using pos/neg processes, at every stage of the process. As we have already seen, a bit of extra exposure at the taking stage will give you more shadow detail and extra richness, without having to worry about the increased grain and loss of sharpness that this would entail with 35mm. The same is true at the development stage: ultimate fineness of grain, and maximum sharpness, are no longer so important. And when you come to print, dust is not enlarged as much as it is with 35mm – and you can afford to use a more diffused light source, because (once again) you aren't striving for the last iota of sharpness.

For many people, though, one of the great attractions of LF, in particular, is that it allows each sheet to be processed for the optimum time, to suit the subject and the photographer's visualization. This is why we have devoted a spread to the Zone System, before going on to development times for *all* formats larger than 35mm, and why they may differ from the manufacturers' recommendations.

We have to reiterate, though, that the only real problems with MF and LF, as compared with 35mm, are the physical film handling, and that with practice, this becomes very much easier.

▶ *TORNADO DAMAGE, SELMA, ALABAMA*
This picture is curiously reminiscent of the nineteenth century, though Frances took it toward the end of the twentieth, in about 1997. Part of its vintage quality is its uncompromising factuality: this is, above all else, a record shot. Then there is the tonality, with detail in every shadow, every highlight. The large format (4x5in Polaroid Type 55 P/N) and the image tone (Ilford Multigrade Cooltone RC, toned in gold) also help. And there is something vintage about the edge processing artefacts. But processing the negative could not have been a lot easier...
CADET, 168/6.8 GOERTZ DAGOR

The Zone System

The Zone System, devised by the late Ansel Adams for black-and-white photography, is a wonderful servant and a very dangerous master. Essentially it is a simplification of basic sensitometry, and the reduction of sensitometric theory to a set of rules.

Even those who actively dislike the Zone system have to admit that the naming of Zones is extremely useful, so we'll begin with this. With large formats, the 11 Zone system can be used, though originally there were just 9 Zones, with I as maximum black and IX as paper-base white: Zones II/III and VII/VIII were effectively combined. In the print, the Zones for the 11 Zone system are:

0 The maximum black of which the paper is capable.
I The deepest tone distinguishable from maximum black.
II The deepest tone with distinguishable texture, 1 stop darker than Zone III.
III Very dark mid-tones, 1 stop darker than Zone IV.
IV Dark mid-tones, 1 stop darker than a mid-tone.
V The mid-tone.
VI Light mid-tones, 1 stop lighter than the mid-tone.
VII Very light mid-tones, 1 stop lighter than Zone VI.
VIII The lightest tone with distinguishable texture, 1 stop lighter than Zone VII.
IX The lightest tone distinguishable from paper-base white.
X Pure paper-base white.

Thereafter, the Zone System is a means of assessing the brightness range of a scene, preferably with a spot meter; determining the exposure; and adapting the development regime to the measured brightness range. The aim is to produce a negative that will print perfectly on grade 2 paper.

The development time that will achieve this for a "normal" subject is understandably called "N," for "normal." Subjects with an unusually long brightness range are then developed for less than the normal time ("N–"), and those with an unusually short brightness range are developed for more ("N+"). Unfortunately, this seductive-sounding system has several drawbacks, one absolute, the rest potential.

The absolute drawback is that it presumes a higher degree of precision and predictability than exists in the real world. All exposure and development is a compromise, and treating the Zone System as a set of scientific rules, rather than a set of aesthetic guidelines, won't even give the best compromise in all circumstances.

Among the potential drawbacks, the first is that it encourages people to do things because they can, rather than in response to the needs of the subject and the picture. In particular, extreme "N–" development will indeed allow the retention of a very long tonal range, but all too often at the expense of a flat, dull, unnatural looking print.

The second potential drawback is that the Zone System takes little account of the extent to which a print from a generously exposed negative may be dodged and burned during exposure. Skill in dodging and burning is often a great deal more important than skill at N, N+ and N– development.

CHURCH, NEW ROMNEY
The tonal range here is enormous, from the sky through the windows, through the reflection on the font cover, the sunlit, whitewashed walls to the dark chest in the background and the shadows under the font: the shadows, of course, determined the exposure. Seriously reducing the development time would have retained tone in the sky seen through the window, and possibly even texture in the reflection of the font lid, but the result would have been flat and unnatural: Roger deemed it better to have a few small areas of burned-out highlight, and a natural effect.
Gandolfi Variant 5x7in, 210/5.6 Rodenstock Apo-Sironar-N, Ilford FP4 Plus developed in Paterson FX39 and printed on Ilford Multigrade Warmtone, toned in selenium.

The third potential drawback is that one may fall into an all too common trap, that of devising extraordinarily tedious and mechanistic tests for determining personal film speeds and development times, without stopping to ask what theoretical basis (if any) these tests can claim, or whether they bear much relationship to the real world.

With modern variable-contrast (VC) papers, there is little or no need even for those modest levels of precision that the Zone System genuinely can achieve. The sort of negatives that anyone can get with reasonable diligence – that is, negatives that are neither grossly under- nor overexposed, nor grossly under- nor overdeveloped – should be printable to exactly the same standard as a Zone opus.

If it seems that we protest too much, the answer lies in Roger's history. Like many people, he tried to embrace the Zone System when he bought his first LF camera. As a result, again like many people, he wasted an immense amount of time, and produced some truly awful pictures. Only when he abandoned the Zone System, and went back to first principles, did his pictures begin to improve. The next few pages are about these first principles, as they apply to MF and LF.

Exposure and development

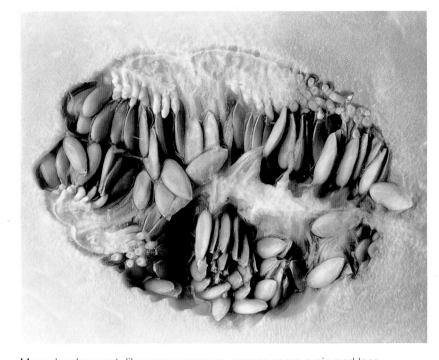

MELON SEEDS
The brightness range of this cut melon is very low, so increasing the development time by 50 percent gave more "sparkle" and modeling, allowing the negative to be printed on Ilford Multigrade Warmtone paper at grade 2½. The print was subsequently toned in sepia, then gold.
LINHOF TECHNIKARDAN, 210/5.6 RODENSTOCK APO-SIRONAR-N, ILFORD FP4 PLUS. (FES)

More development, like more exposure, means more grain and less sharpness. Minimum development is therefore more important with 35mm than with MF or LF. But development times are based on "average" subjects and "average" metering techniques and "average" flare levels and "average" enlargers and enlarger lenses. When you move up to MF or LF, you may decide to go behind these "averages," and see whether "average" development times suit your needs. Flat, low-contrast subjects often benefit from extra development, while very contrasty subjects can be "tamed" by cutting development. The Zone system is a very elaborate formalization of

POLYETHYLENE TENT
If you shoot a mixed bag of subjects using an MF camera – this was taken with a Contax 645 – you have to choose a development time that is reasonably suitable for all the subjects, then adjust final print contrast via your choice of paper grade.
210MM SONNAR, ILFORD HP5 PLUS. (RWH)

these simple facts: too elaborate, for our taste. We prefer to use a rough rule of thumb, giving 15 percent less development for very contrasty subjects, and 50 percent more for very flat ones.

Less and more than what, though? Than our standard time. This may again differ from the film or developer manufacturers' recommendation, but it is arrived at by a simple iterative process. We begin with a "normal" subject, which is defined as "the sort of subject we normally shoot." In other words, our "normal" subject may not be the same as yours.

If this "normal" subject, with "normal" development, prints on a "normal" paper grade – which we regard as 2½ – then the development is right. Otherwise, we change the development time, as described on page 133 under Determining Development Times.

With our usual films and developers, as a result of long practice and a darkroom notebook in which development regimes are carefully noted for each film, we have a very good idea of the best development times for "normal" subjects. That is it, really. But the question is, why should our development times not be the same as yours? Well, here we give you some of the answers.

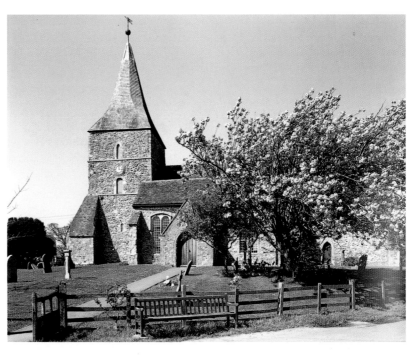

CHURCH, ROMNEY MARSH
This is an admirably "average" sort of subject – green grass, blue sky, gray stone – so "average" development is fine. Note, though, the unfortunate light-strike on the right, the result of a worn light-trap on the 4x5in holder.
WALKER XL, 110/5.6 SUPER SYMMAR XL, ILFORD FP4 PLUS, PRINTED ON ILFORD MULTIGRADE WARMTONE, TONED IN SELENIUM. (FES)

Choice of subject Softly lit portraits have a very short brightness range and often benefit from extended development; bright, sunny deserts at mid-morning have a very long tonal range and often benefit from curtailed development. Other subjects tend to be somewhere in between. If you normally shoot a particular type of subject, you may find that it departs sufficiently from "average" for you to give it rather more or less development than "average."

Geographical location The original Kodak research on film speeds and development recommendations was based on landscapes within 100 miles or so of Rochester, New York. Further south – in Los Angeles or Tokyo or Greece, for example – the light is contrastier, and less development is generally needed; further north, in (for example) London, which is level with Edmonton, Alberta, the light is less contrasty and more development is often a good idea.

Camera/lens flare When an image is focused on the film by the lens, there is a certain amount of stray light that bounces around inside the lens, and a certain amount that is reflected from the inside of the camera. This lightens the

FIREPLACE

Frances shot this with her Alpa 12 S/WA, with the 58/5.6 Super Angulon XL, on 6x9cm Ilford FP4 Plus. The same subject, shot with our old 65/6.8 Angulon, would have required about ⅓ stop less exposure and 25 percent more development to achieve similar tonality, because of the higher flare levels of the older lens.

Ilford Multigrade Warmtone, toned in selenium.

shadows on the film, and reduces overall contrast. Most current MF camera/lens systems, and almost all current LF camera/lens systems, exhibit significantly lower flare levels than many 35mm camera/lens systems, especially 35mm cameras with zoom lenses. The image is therefore inherently contrastier, and should be developed for less time. Of course if you are using a flary old uncoated lens, you may need to increase development time.

Development conditions Everyone has slightly different agitation techniques; different thermometers; different ways of timing (from when they start to fill or empty the tank; from half-way through filling or emptying; from when it is full or empty); different water supplies; the list goes on. Some of these variations are significant on their own; others are trivial on their own, but can be significant cumulatively. For some people they cancel out; for others they add up. As long as you are consistent, the variations won't matter – but they may mean that your times are a minute or more different from what another person would require to get sensitometrically identical negatives of the very same subject, identically exposed.

Enlarger light source Historically, many 35mm enlargers used a condenser system, which gave inherently more contrast with conventional films because

HARMONIUM AND CREED

The contrasty, sharp 110/5.6 Super Symmar XL has held the glazing bars in the window, which a flarier lens might easily have lost, especially given the generous exposure that was needed to hold texture under the harmonium. The reflection at the bottom of the creed might have been removable with a polarizer, but the exposure would then have been a good deal longer.

Walker XL, Ilford FP4 Plus, Ilford Multigrade Warmtone, toned in selenium.

of the Callier effect. As well as simply blocking the light, the silver grains in the image also scatter it, and because the light from a condenser system is more nearly parallel than it is from a diffuser system, it is scattered more. This translates directly into higher print contrast. Diffused light, more common with LF enlargers, meant that a negative developed to exactly the same contrast would result in a print with lower contrast. It was therefore the custom to develop negatives that were to be printed in a diffuser enlarger for longer. Of course, many people (including us) use diffuser enlargers for 35mm nowadays.

Enlarger/lens flare A good MF or LF enlarger/lens system may well exhibit less flare than a 35mm enlarger/lens system, which implies a higher print contrast; again, this would argue in favour of less development time.

Paper choice and developer choice One manufacturer's grade 2 may have the same sort of contrast range as another's grade 3, so a lot will depend on what paper you choose. Then, a contrasty developer such as Tetenal Dokulith is worth about half a grade of extra contrast, while a soft developer such as Tetenal Centrobrom can wipe off a grade. What price "normal" at this point?

Personal preference Last but not least, some people just like contrastier prints than others, and there is nothing wrong with this.

DETERMINING DEVELOPMENT TIMES

With so many conflicting factors pulling in different directions, the only way to find the right development time for you is by experiment. Start out with the manufacturer's development time. If this gives you negatives that print easily on grade 2 or 3 paper, that is all you need. If you find that you consistently need soft paper (grades 0 and 1) as well as 2, even for "average" subjects, then you are probably overdeveloping and you should cut your development time by about 10 or 20 percent. If you find that you consistently need hard paper (grades 4 and 5) as well as 3, then you are probably under-developing and you should increase your development time by up to 25 percent.

Of course, variable-contrast (VC) papers can conceal a multitude of sins, and are at least as good as graded papers nowadays. As a result, it simply isn't as important to get your development absolutely right as it was in the days of graded papers. It's still nice to get it as right as possible, though.

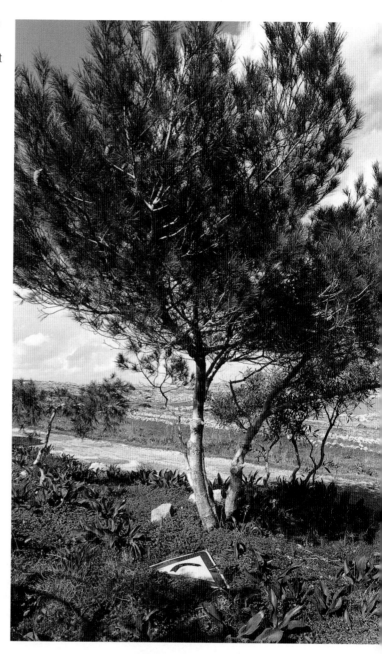

TREE AND SIGN
Filtration is a double-edged sword. Certainly, there are pictures it can improve; but there are others where it can exaggerate tonal relationships excessively. Good exposure technique, as here, can surprisingly often substitute for filtration.
ALPA 12 S/WA, 58/5.6 SUPER ANGULON XL ON 6X9CM, ILFORD HP5 PLUS. (FES)

133

Choosing developers

There is absolutely no reason why you should not use exactly the same black-and-white developers for MF and LF as you use for 35mm, and indeed, we habitually process most of our roll films and our Ilford 100 Delta cut film in Paterson FX39.

On the other hand, when you move to LF, you are no longer nearly as concerned about grain and sharpness, and you can use developers which would not be acceptable for 35mm or MF. In particular, we use Paterson Universal for Ilford FP4 Plus and Ortho Plus when we want extra contrast for printing on POP (page 143). Aggressive "universal" developers like Paterson Universal or Ilford's PQU give high contrast and a long tonal range, which is exactly what you need for most "alternative" processes.

Because you are less concerned about grain and sharpness, you can also agitate your films more enthusiastically during processing. This reduces processing times by 10–15 percent, and gives fractionally more film speed, both of which can be welcome. With 35mm, you can actually see the reduction in sharpness that you get with continuous agitation, but with MF you are unlikely to see it and with LF you simply will not see it.

Contrary to widespread belief, the actual amount of developer you need for a 120 film or an 8x10in sheet is tiny, maybe a tablespoon. The main function of the rest of the developer is to wet the whole of the film quickly and evenly, though it also washes away developer by-products. People who use two litres of developer to process five sheets of 8x10in film are popular with developer manufacturers, but they are wasting their money.

If you don't believe us, try a simple thought experiment. Imagine a sheet of 8x10in film in a two-bath developer. When it is removed from the first bath, the only developing agent that is present is what has soaked into the emulsion, plus whatever is wetting the film: maybe 10ml at the outside. In the second bath, there is no more developing agent. The film still develops...

Two-bath and water-bath development are popular with LF users, but there is little if any scientific evidence that they are any better than using a weaker developer. Staining developers (especially PMK, Pyro-Metol-Kodalk) genuinely do give you something for nothing, in that the stain gives more printing density without decreased sharpness or extra grain – but how much do you care about this in MF, let alone LF?

Reusing developers – putting several batches of film through something like D-76, preferably with replenishment – is economical, but results in a steady drop in

WHITSTABLE DOCKS
Remember that Polaroid Type 55 P/N (as used for this picture) develops just like any other film, so higher temperatures or longer development times will mean more contrast.
TOHO FC45X, 120/6.8 SCHNEIDER ANGULON. (RWH)

film speeds (because of the build-up of bromide and other developer by-products in the developer) until the developer is fully "seasoned," at which point the speed remains constant at maybe ½ stop below the ISO speed in fresh developer. Because of this, and because reusing developers is inherently less predictable than single-shot development, we unreservedly recommend the latter. This is all the more true because replenishment is normally done by rule of thumb rather than by titration of the developer. It is also an interesting fact that the pH of D-76/ID-11 cycles up and down as it sits on the shelf: the variation corresponds to about 30 seconds' variation in development time, and you need a pH meter if you want to compensate for this.

Some of the above assertions will precipitate apoplectic fits among those whose pet theories they contravene. Our answer to this is simple: tough. Those photographers who have Pet Theories (with capital P and T) are not, on average, any better darkroom technicians than those who do not. Indeed, one of the best printers we know, George Gardner, reckons that the only way to get first-class results is to follow the manufacturers' instructions implicitly – advice that even we would say was a little too restrictive.

CANALS AND RAILWAYS, MANCHESTER

Just as the very best 35mm cameras, lenses and film, carefully used, can rival MF for quality, so can the very best MF cameras, lenses and film rival LF. Roger took this on 66x44mm Ilford 100 Delta using his Alpa 12 WA and 38mm Biogon, developing the negative in Paterson FX39, and printing on Ilford Multigrade Warmtone toned in selenium. The black border not only screams "I've got an Alpa" but is also essential to the composition: without it, the edges of the picture just "leak away."

Processing MF film

To a considerable extent, the procedure for processing film is the same, regardless of format. Subject to the observations already made on the previous pages, similar considerations apply to time, temperature, agitation, and the speed with which you get the film into and out of the developer. The biggest difference is actual film handling.

Although we prefer stainless reels for 35mm, we normally use plastic reels for 120, for three reasons. First, we find them much easier to load: it is all too easy to get stress marks when loading wide, thin-base 120 into a stainless spiral. Second, we can easily load two films onto one spiral, end to end, which we cannot do with stainless spirals: this means we can process two or four films at a time, instead of one or two. Third, we normally process our 120 films in a Jobo CPE-2 with lift, which allows us to do six films (three spirals) at once, in less than 600ml of chemistry, with fill and drain times of 10 seconds or so.

In a conventional daylight tank with inversion agitation, we do not care to process more than one spiral at a time, because of the slow fill time. There is, however, a way around this. If the tank is already filled with developer, with the lid alongside, you can load the spirals in the dark; put them onto the central post; then drop them in and put the lid on, after which all subsequent processing can be carried out in the light. Better still, have two tanks ready, one with developer and one with fixer, and transfer the film from one to the other. Astonishingly, you can safely do this by room light: the few seconds' exposure as you pull the film out of the developer and drop it into the fixer tank will not cause detectable fogging, because the induction period of the second development is longer than the time available.

70MM AND 35MM
The way in which 70mm is very much like giant 35mm is shown clearly here. The problem is that no one makes daylight tanks for 70mm!

◄ TANKS
The various sorts of spiral, and the way in which one 120 or 220 spiral fits into the same tank as holds two 35mm spirals, should be clear here. With stainless steel, it is usual to have different spirals for 120 and 220, and of course the spirals themselves are nonadjustable. With plastic – these are Paterson – the spirals can be adjusted for 35mm and 120/220; in fact, it is possible to load two 120 films end to end on the big spiral.

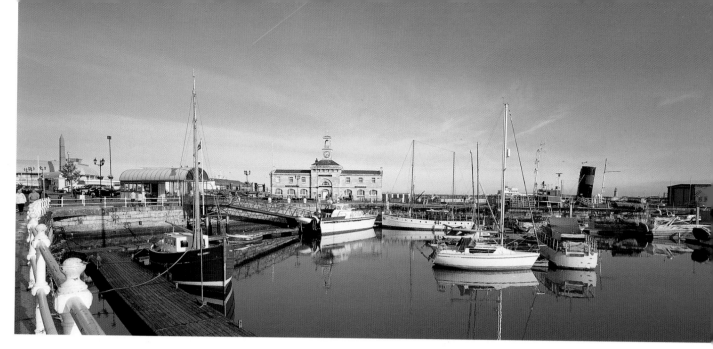

▲ *RAMSGATE HARBOUR*
(see caption below)

Nova's FP series of developing lines allows you to process even E6 this way, provided you work in the dark for the first development step and initial wash. They consist of a row of open tanks in a water bath, which gives very accurate temperature control. The easiest way to time agitation steps (every 30 seconds) is with a tape recorder on which you have recorded "one minute... FORTY seconds... one minute... FIFTY seconds... TWO MINUTES..." and so forth.

For film sizes other than 120, you will have to try harder. Some old Paterson spirals can be adjusted for 127, and stainless spirals for a number of sizes (including 127 and 70mm) are available from Hewes of Erith. Although the 127 film will fit in a tank, the only way we have found to process 70mm is in two buckets, one each for developer and fixer, working in the dark. For obsolete film sizes where no spiral is available, the easiest approach is probably a bowl full of developer in which you "see-saw" the film. Wearing rubber gloves, hold each end of the film and loop it in a U-shape through the developer, lowering and raising the ends alternately (hence "see-saw").

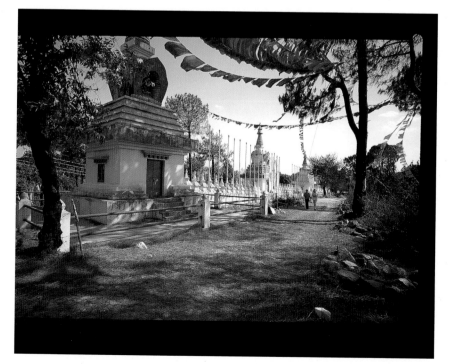

◄ *SHERAB LING*

Regardless of format, of course, all 120 films can be processed in the same reels, so changing formats implies no new investment at this stage. Here we have 66x44mm (Alpa, with 38/4.5 Biogon, left) and 6x12cm (Linhof 612, lens forgotten, above). Processing one's own E6 in a hand line or with a CPE-2 with lift (in effect, a tank with automatic rolling agitation and rapid fill/empty) can save quite a lot of money and, if you live as far as we do from a pro lab, a good deal of time as well.

Processing LF film

The traditional way to process LF film is in a tray, the same way that you process paper. Unless you use ortho film, which can be processed under a red light, you have to work in complete darkness. If you process more than a single sheet at a time, you have to shuffle the film in the tray, drawing out the bottom sheet and placing it on top, throughout the processing sequence. Many photographers manage this without any problems, but others find it difficult to avoid scratches. The trays don't cost much, and for very large formats (over 8x10in) this may be the only option.

Another possibility, only with 4x5in, is to use a developing tank. There are several kinds, some of which fill and empty much faster than others. Most take six sheets, though a few take twelve – and some photographers load only four sheets into six-sheet holders to reduce the risk of films touching. Probably the best is the Jobo, used in conjunction with a CPE-2 or other rotary processor. It uses a relatively small amount of developer (just 270ml), allowing one-shot processing with rapid fill and empty times. Another popular one is the Combi-Plan, though it takes more developer and fills and drains more slowly. Once again, you can do the trick with the open tank, described above for roll film, or you can use a Nova hand line.

Then there are BTZS tubes. They are simply plastic tubes into which the film is loaded, curled into a C-shape or a near-O. The developer is added and the end-cap fitted in darkness (cunningly, the end-cap holds the right amount of developer) and subsequent processing is carried out by "log rolling" the tube in room light. At the end of the developing time, the end-cap is removed, the developer poured out, and the fixer poured in. The main disadvantage to BTZS tubes is that the backing of the film often does not clear properly, so a subsequent treatment in fresh fixer or sodium sulphite is required.

Single sheets can also be processed in Nova deep-slot tanks, but do not overagitate or the edges and center may develop at different rates. With 8x10in film in an 8x10in tank, for example, it is quite enough to raise the film once every 30

▼ TANKS

Yankee (left) and Doran (right) tanks can be used to process 4x5in in large batches, but it makes sense to fill and drain the tanks in the dark, with the lid off, to speed filling and emptying. They also take a lot of developer. The Polaroid PN-10 tank in the background is used for clearing Polaroid P/N film in the field, and storing it until it can be washed.

◄ ► PATERSON ORBITAL PROCESSOR

The power base for the Paterson Orbital provides motorized agitation (there is also a manual version) and the 8x10in tray can be divided to process four 4x5in or two 4x5in and one 5x7in or two 5x7in. The processor can also be used (as here) for its intended purpose of processing prints.

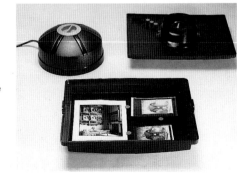

seconds; hold it at an angle so that one corner drains; replace it; and at the end of the next 30 seconds, hold it with the other corner up, so that the developer drains from the lower left instead of the lower right corner, or vice versa.

We process the majority of our LF film in Paterson Orbital tanks (below left). These were designed for processing color prints, up to 8x10in, and they have four "golf tees" that allow the interior to be divided up for two 5x7in (or 13x18cm or half-plate) or four 4x5in (or 9x12cm or quarter-plate). Whether you process one 8x10 or two 5x7 or four 4x5in, all you need is 100ml of developer. To make sure that the film backing clears adequately, we roughen the floor of the tank with a Dremel tool. Despite theoretical objections about evenness of development and temperature control, we find that we can get very satisfactory results by working at ambient temperature and making small time corrections to compensate for temperature variations. Orbitals are no longer made, but still appear frequently at camera shows, and besides, there may still be a few "new, old stock" in camera stores. The power base gives continuous agitation and is a lot more convenient than the manual base.

NOVA FP45 HAND LINE
This Nova hand line is built around the HP Combi-Plan six-sheet holder. Temperature control is more than accurate enough to allow reliable processing of E-6.

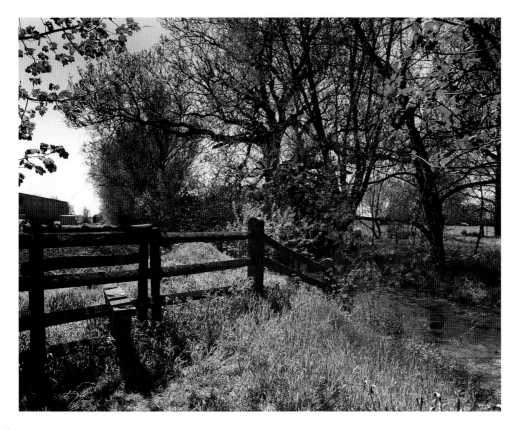

CHURCHYARD, ST AUGUSTINE'S CHURCH, SNAVE
Being able to process 4x5in in batches of four in only 100ml of developer in the Paterson Orbital is useful, and the fact that agitation is constant means that it is quite quick, too: 10–15 percent faster than with intermittent agitation. *WALKER XL, 110/5.6 SUPER SYMMAR XL, ILFORD FP4 PLUS, PRINTED ON ILFORD MULTIGRADE WARMTONE, LIGHTLY TONED IN SELENIUM. (FES)*

Enlargers and lenses

The main difference between MF/LF enlargers and 35mm enlargers is the obvious one: they are bigger. Up to 6x9cm, they are still (for the most part) reasonably portable, but by 4x5in they are becoming a bit unwieldy, and a 5x7in enlarger is not something you want to have to move too often, so unless you have (or can construct) a permanent darkroom, you may be well advised to stick to MF or, at the least, to seek out a reasonably light 4x5in enlarger. At 8x10in, vertical enlargers are rare and horizontal enlargers become the norm, so you will need a pretty big permanent darkroom. Suddenly it becomes clear why 5x7in and 8x10in enlargers can sometimes be found for the same sort of money as 4x5in.

The bigger the enlarger, the less likely it is to have a condenser head – though 4x5in condenser heads are by no means uncommon, and still larger condenser heads were apparently made, the condensers are pretty vast and expensive.

Diffuser heads are much the same as for 35mm enlargers, though some 4x5in heads and most 5x7in or larger heads will have two lamps instead of one, often with fan cooling, and the controller/stabilizer boxes are often large and complex. New, top-of-the-line enlargers have closed loop color control, monitoring light output and color (which vary with lamp age) and correcting them automatically. For a 4x5in enlarger with these features, you are looking at the price of a new, modest car.

Cold cathode heads are surrounded with an aura that is not, in our experience, entirely justified. It is true that a good cold cathode head gives the closest tonality to a contact print, but the difference between a cold cathode and a good diffuser head seems to lie more in the eye of the beholder than in actuality. We suspect that the aura grew up in the days when the only real alternative was a condenser.

Cold cathode heads can also have two significant drawbacks. To begin with, few if any respond well to Multigrade or similar filters, with uneven spacing of grades, normally bunched toward the contrasty end of the scale. Some are so blue that they hardly respond at all. In other words, with the exception of the (rare, expensive) twin-tube variable-contrast variety, where the output of the tubes is varied to control the contrast, they are suitable only for graded papers. This is a part of their mystique, of course.

They may change quite dramatically in light output (and light color) after they have been switched on for a few seconds, so it is a good idea to use a shutter or safelight filter to make the actual exposure.

It is, however, gratifyingly easy to change heads on most enlargers, even if you want to use another manufacturer's head. Our 5x7in MPP Micromatic came with a cold cathode (which we still have) but it has since been fitted first with a Durst 13x18cm head (destroyed during shipping by a cretinous removals company) and then with a De Vere 5x7in head. The smaller the enlarger, the more difficult it may be to fit another head on, but Meopta's 6x9cm color and Meograde heads are surprisingly inexpensive and can be adapted to a wide range of older enlargers – or you can do what we did, and put them on Meopta Magnifax enlargers.

LINHOF COLD CATHODE ENLARGER BACK

This long-discontinued accessory can be fitted onto the back of any 4x5in camera – here, a Cadet – to convert it into an enlarger. A copy-stand helps, of course; this one was made from the remains of an old MF enlarger.

When it comes to lenses, the perennial truth of larger formats resurfaces: you just do not need to worry as much about quality. With the much smaller enlargement ratios that are normal with MF and LF, pretty much any decent coated lens from the last third of a century or so will deliver far better results than it has any right to do. The only thing to beware of is old lenses that are slightly hazy. New enlarger lenses for 4x5in and above can be terrifyingly expensive, but you can generally buy used lenses with confidence from a professional dealer, who is likely to have more of the things than he knows what do do with.

SCHOOL, BIR

In color, Frances particularly likes 6x9cm negatives because they allow her to get very good color with maximum control at the enlarging stage and without undue effort at the taking stage: she uses the same shadow metering technique as she uses for monochrome negative. This was taken on 6x9cm Kodak Portra 400 VC ("Vivid Color") using her Alpa 12 S/WA and 35/4.5 Apo-Grandagon.

Contact printing

One of the delights of large format is the ability to make contact prints that are big enough to be considered as pictures in their own right. For our taste, 4x5in is marginal: a good 4x5in contact print in a mount that is not oversized can work very well, but it is all too easy for the small image to look pretentious, especially when printed in the middle of a huge sheet of paper. Our out-and-out favourite, as hinted elsewhere, is 5x7in/13x18cm/half-plate, while for 8x10in we often prefer to compose on a 7x10in area and then mask the negative correspondingly for printing. We find that the more pleasing proportions of 7x10in are more than compensation for the smaller image size.

There are three and a half choices when it comes to making contact prints. One is to use conventional enlarging papers, the second is to use "alternative" processes, and the third is to use POP, or printing out paper. The half choice is "gaslight" paper, a contact-speed developing-out paper which can be handled under subdued room light, like POP, then exposed to a UV-rich source – a sunray lamp is good – and then developed.

CONVENTIONAL ENLARGING PAPER

If you use the enlarger as a light source, you can even achieve variable contrast. Ilford Multigrade Warmtone is superb for this, and accepts a wide range of toners. The only thing to note is that you may need a slightly softer grade of paper than you would for making an enlargement, because there is no flare from the enlarger lens to reduce the contrast of the image.

ST AUGUSTINE'S CHURCH, SNAVE
Roger acquired his first 5x7in camera in June 1998, having long suspected that it was his "ideal format." He is convinced that he is right. The shape and size of the image are perfect for contact printing, and the ability of a contact print to capture texture and detail is beyond compare.
GANDOLFI VARIANT, 210/5.6 RODENSTOCK APO-SIRONAR-N, ILFORD FP4 PLUS, ILFORD MULTIGRADE WARMTONE, TONED IN SELENIUM.

"ALTERNATIVE" PROCESSES

We do not propose to go into "alternative" processes at any length here: we have treated them slightly more extensively in *The Black and White Handbook* (David & Charles, 1997) and others have written whole books on the subject. Suffice it to say, first, that most "alternative" printing processes (such as Argyrotype, salt paper, cyanotype, etc) are contact processes, so a big, original negative will always give better results than an enlarged negative; second, that reproductions of "alternative" prints almost invariably fail to do them justice, so they merely look like inferior versions of conventional prints; and third, that they generally involve a somewhat time-consuming rigmarole of kitchen-sink chemistry and do-it-yourself paper coating, though this can be greatly ameliorated by buying the appropriate kit from Fotospeed or other suppliers.

Most "alternative" processes demand a negative with a long density range, and often with fairly steep contrast. Exposure is normally in a split-back printing-out frame. Both of these points are covered below.

PRINTING OUT PAPER

POP is again a contact process, but it is much easier to use than any "alternative" process (unless you decide to make your own paper, which can be done), and the gorgeous quality of the results is normally visible even in reproduction. The paper is available off the shelf: we use Helios, from Silverprint in London, though Centennial, from the Chicago Albumen Company in Housatonic, Massachusetts, is also very good. Both are made in England by Kentmere.

TANKARD AND CHARGER
The black line that derives from the negative rebate of a contact print can be an essential part of the composition. Without it, the left-hand side of the tankard in this shot simply "leaks out" into the surroundings. Roger keeps meaning to shoot some more in his "pewter" series on 5x7in: this was made with the 4x5in Technikardan, before he got a 5x7in.
210/5.6 SYMMAR, ILFORD FP4 PLUS,

LOW TIDE, MINNIS BAY
The only current "gaslight" paper we know is Kentmere Room Light Contact Paper. It is a cold-tone paper that really requires a UV source for exposure: under sunlight, an exposure of 2–3 seconds suffices, and that is too brief to be easily controllable.
CADET, 168/6.8 DAGOR, POLAROID TYPE 55 P/N. (FES)

143

SPLIT-BACK FRAME

These two half-plate (4¾x6½in) frames are ideal for making 4x5in contact prints with a decent border. The red photo-opaque tape on the Mylar sheet provides a border; the Mylar isolates the negative from the POP.

As the name suggests, the paper is not developed: it simply "prints out" when exposed to light. The main points to note are as follows:

Negative The negative should have a long tonal range and a fairly high contrast. Not all materials can deliver this. We normally use Ilford FP4 Plus or Ilford Ortho Plus, developed aggressively in Paterson Universal developer (Ilford PQU developer is good too). Another popular film is Bergger BPF 200. Typically, you should give 50–100 percent more development than you would give a negative for enlarging. A negative that is suitable for printing on POP would require grade 0 or even grade 00 paper if enlarged.

Self masking Printing out paper is "self masking." In other words, as the shadows begin to print, they mask the emulsion below from further exposure and slow its darkening. In this way, the tonal range of a very contrasty negative can magically be compressed onto the maximum tonal range of which the paper is capable – which is typically very long.

Split-back frames Traditional printing frames in sizes up to about half-plate (suitable for 4x5in contact prints) are still commonly (and cheaply) encountered, but if you want a bigger frame, you may well have to buy something new. Prices vary widely: our favourite, the Gandolfi 11x14in frame, is similar in price to a fair-to-middling autofocus compact.

In use, the negative is inserted first; then a very thin sheet of Mylar, to protect the negative from the excess of silver nitrate in the emulsion of the POP (our ancestors used to varnish their plates, for the same reason); then the POP. Finally, the back is fitted. All of this can be done in subdued room lighting: anything more than a meter or two from a domestic lamp is likely to be OK.

Exposure This requires light with a high UV content. Daylight is traditional, though many people swear by Philips UV sunray lamps. Many prefer sky light to direct sunlight. From time to time, take the printing frame indoors (or away from the UV lamp); fold back one side of the frame, taking care not to move the paper relative to the negative; and inspect the print. The exposure is correct when there is plenty of tone in the lightest area of the print, which will lose density

GOLD TONER

Gold chloride	0.5g
Water	500ml
Ammonium thiocyanate	3.5g
Water	500ml

Pour the gold chloride into the thiocyanate solution in dribs and drabs, stirring all the time: momentary red flushes (probably of colloidal gold) will be seen. Leave the bath overnight to ripen before use. If you are in a hurry, use water that has just come off the boil; mix as above; and use when cold.

PLATINUM TONER

Potassium chloroplatinite	0.45g
Sodium chloride (common salt)	4.5g
Citric acid	5.7g
Water	1000ml

An easier approach may be to use 0.5g chloroplatinite, 5.0g salt, 6.3g citric acid, and make up to 1100ml – though the proportions are unlikely to matter to that degree of accuracy anyway.

An alternative formula (which we have not tried) uses the same quantity of potassium chloroplatinite, but instead of common salt and citric acid, 42ml of phosphoric acid (specific gravity 1.12). Then there is Haddon's Formula, which again we have not tried: platinum perchloride 0.2g, sodium formate 6.5g, formic acid 1.7ml, water to 1000ml.

when it is processed. This is known as "overprinting," and the degree of overprinting will depend on how the print is to be processed.

Processing After exposure, the print is first washed, to remove the excess silver nitrate. This will normally be seen as a milkiness coming off the surface of the paper. Half a dozen 30-second changes of water, or 3 minutes in running water, will normally be plenty.

The print may now be fixed, in which case it will lose a great deal of density and should therefore be overprinted even more than if it is to be toned, or it may be toned before fixing. Either way, the fixer should be 20 percent plain hypo – anything more aggressive is likely to bleach out the highlights – preferably applied as two 5-minute baths.

The classic toner is gold, though our favourite is platinum: formulae for both are given in the panel. Prints that are to be toned in platinum should be over-printed less than those to be toned in gold. Toning is a curious process, requiring a degree of experience to judge just when to stop, but even one's early failures can have a certain charm. All toners may be used repeatedly until the toning action either stops, or becomes intolerably slow. An old trick for making up gold toner is to use up to 50 percent exhausted toner instead of water. Remember, all toning is done *before* fixing.

COLPEPYR MEMORIAL (above left)
CRISPE MEMORIAL (above)
The picture of the Colpepyr memorial was gold toned, leading to the characteristic purple color, while the Crispe memorial was toned with platinum, giving a much more yellow color. Roger photographed both monuments, in the Parish Church of All Saints, Birchington, with a 4x5in Linhof Technikardan and 121/8 Super Angulon on Ilford FP4, and printed them on Centennial POP.

Electronic scanning

▼ PROOF PRINT

This was scanned from a 5x7in negative "all in." There is a reflection from the inadequately blacked edge of the film holder on the left, beside the window, which had to be cropped out. We find that scanning and printing out proofs is a lot quicker than making them the traditional "wet" way.

From one of the oldest photographic technologies – printing out – we jump to one of the newest – electronic scanning. The great thing about MF and (especially) LF negatives and transparencies is that all but the lowest quality scanners can normally deliver good to excellent quality, whereas with 35mm you need a much more expensive high-resolution scanner to get decent results.

As usual, this is a consequence of the reduced enlargement size. For an ink-jet printer, you normally need a resolution of around 200dpi (dots per in) on the final image; for photomechanical reproduction, the normal standard is 300dpi. Because a digital image can be enlarged or shrunk without loss, you can calculate directly what the requisite resolution is in the original scan.

Even the cheapest scanners normally have an optical resolution of 300x600dpi, allowing 600x600dpi with interpolation on one axis: this is as much interpolation as you would want for maximum resolution. Move up to 600x1200dpi, which is normal for a cheap mid-range scanner, and all these sizes are doubled. The two tables, one for ink-jets and one for photomechanical reproduction, make things clear: 35mm is very limited,

▶ ELECTRONIC GUIDE PRINT

Using the proof (above left), this was cropped and electronically "toned" (in Adobe Photoshop); this image is reproduced from the scanned-in file.
GANDOLFI VARIANT, 210/5.6 APO-SIRONAR-N, ILFORD FP4 PLUS. (RWH)

INK-JET PRINTS (200DPI)

	From 600dpi	From 1200dpi
35mm	72x108mm/3x4½in	144x216mm/6x9in
56x72mm	168x216mm/6½x9½in	336x432mm/13x17in
4x5in	285x360mm/11x14in	570x720mm/22x28in

PHOTOMECHANICAL REPRODUCTION (300DPI)

	From 600dpi	From 1200dpi
35mm	48x72mm/2x3in	96x144mm/4x6in
56x72mm	112x144mm/4½x6in	224x288mm/9x11½in
4x5in	190x240mm/7½x9½in	380x480mm/15x19in

6x7cm (here taken as the Linhof-sized 56x72mm format) is reasonably versatile, and 4x5in allows a good deal of flexibility, including double-page A4 spreads – bigger than this book – at less than 1200dpi.

We find that the main application for scanning is proofs, especially for POP, as it is quicker and easier to scan in a negative, "tone" it electronically, and print it out as an "enlarged contact," than it is to do the same thing "wet." Some things, such as spotting and even retouching, are much easier to do digitally, though operations such as dodging and burning are very much easier in the wet darkroom.

The only important point in exposing and developing black-and-white negatives for scanning is to avoid overdevelopment, as this may result in excessive density that will be beyond the dynamic range of the scanner – though even our modestly priced Agfa Snapscan, with transparency hood, seems able to handle negatives developed for POP without difficulty. We have generally found it better to scan the negative without reversing it, and to do the reversal stage (to a positive) in Adobe Photoshop, as this affords better control of contrast and dynamic range, though some negatives (especially Ilford FP4 Plus) respond beautifully when reversed at the scanning stage.

Move over to transparencies, and you will do best with low-contrast films with a low maximum density rather than contrasty ones with a high maximum density, for much the same reason: slight overexposure is preferable to any underexposure. You can also learn a great deal about color management by using outdated film and trying to remove color casts caused by crossed curves, where typically the shadows go magenta and the highlights go green. In conventional silver halide printing, you can correct one but not the other; in Adobe Photoshop or something similar, it is possible to correct individual channels.

◀ ARMAGEDDON
There is something faintly blasphemous about this print, electronically derived from the guide print (opposite), again in Adobe Photoshop. Scanning LF negatives may seem like doing things the hard way, but the great advantage is the sheer amount of detail that can be held even with a relatively low-resolution scanner: a 5x7in negative scanned at 600dpi can be photomechanically reproduced at 10x14in (26x36cm), or printed with an ink-jet printer at about 20x28in (50x70cm).

CHURCH OF ST THOMAS À BECKET, ROMNEY MARSH
A "pen and ink" derivative of an LF negative can hold details such as grass, trees and roof tiles that would be quite lost if you tried to scan in a smaller negative directly, or a print from a smaller negative.
GANDOLFI VARIANT 5x7IN, 300/9 NIKKOR, ILFORD FP4 PLUS. (RWH)

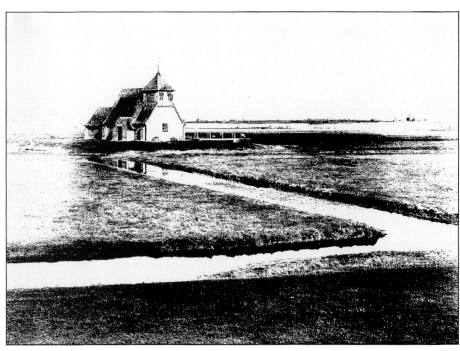

A PERSONAL STYLE: ROGER

Over the next four pages we have dropped the editorial "we" and reverted to the first person, with our own views on a personal style. Roger first:

A personal style is not something fixed and unchanging: it evolves with you. Even a year or two ago, I might have chosen one of my still lifes as a good example of my personal style, but as I wrote these words, this seemed to me to be more typical of what I like best about my work at the moment.

Frances described my Church series better than I could. She said, "Your church pictures are all glimpses, as though you're looking through a window, and can't see very much." As soon as she said it, I realized she was right: in this series, I want to imply a great deal more than is actually shown, which is why (somewhat to my surprise) I found myself using a "standard" 210/5.6 Apo-Sironar-N on 5x7in, roughly equivalent to 45mm on 35mm, far more than the ultra-wide 110/5.6 Super Symmar XL (similar to 24mm on 35mm) that I had expected to use. The 110 would be more literal: the 210 seems more mysterious.

I love the range of textures and tones. In the original print, there is texture and detail in both the lightest and the darkest areas, even a tiny bit in the beams inside the arch. I also like the rather obvious religious symbolism of the sunlight striking into the church. The actual paintwork in the church is unexpectedly vivid, and monochrome calms it down: this was Ilford FP4 Plus, developed normally and printed on Ilford Multigrade Warmtone with selenium toning.

In one sense, I care very little about technique. I am very interested in theory, principally to see what it will let me get away with; the easier it is to make the picture I want, the happier I am. This is one of the reasons I like transparencies: they require no further effort, other than taking them to the lab, after I have pressed the shutter release. I want to capture what's there, not interpret it. For me, seeing is everything, and I'll take the path of least resistance between the subject and the final image.

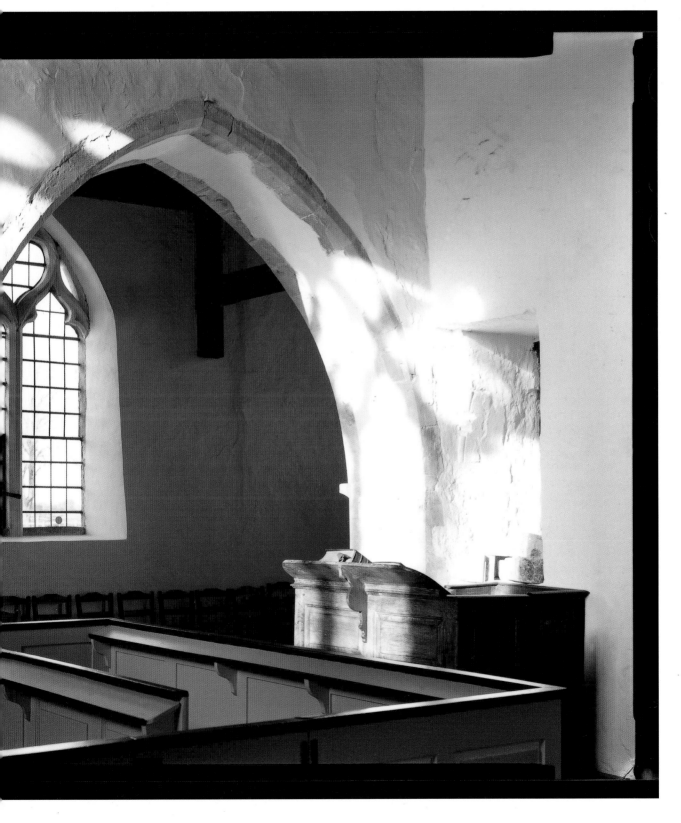

A PERSONAL STYLE: FRANCES

When I first started taking pictures, I was attracted by detail and couldn't see why Roger was so keen on wide-angles. In those days, my "standard" lens was a 90/2.5 Vivitar Series 1 macro (on 35mm, of course).

Strangely enough, it was a full-frame fish-eye – a 15/2.8 Sigma – that really began to broaden my horizons. I shot so much with that lens that I finally had to make a conscious effort to stop using it. Using conventional wide-angles, a 17/3.5 Tamron SP and a 14/3.5 Sigma, helped to wean me off the fish-eye but left me with a much stronger appreciation of wide views.

Then, when I got the Alpa, I found the perfect compromise. The 35/4.5 Apo Grandagon on 6x9cm is almost exactly the equivalent of 15mm on 35mm, and the 58/5.6 Super Angulon XL is almost exactly the equivalent of 25mm. Both allow a rising front. The big negative allows me to capture plenty of texture and detail, and to expose generously for shadow detail without worrying about grain (even with Ilford HP5 Plus, as here) or about sharpness.

What specifically attracted me to this shot was the repetition and rhythm of the arches, plus the detail, especially the graffiti including the somewhat enigmatic I DIED HERE, almost smack dab in the middle of the picture: the counterpoint of formality and decay. I also saw it as a technical challenge: I wanted to capture the whole tonal range in the print, without making a picture that was flat or dull. There is a tiny bit of detail and tone in the window in the middle of the nearest arch, and there is nowhere that the shadows block up entirely. Development was normal; the print was made on Ilford Multigrade Warmtone toned in selenium, at grade 2½.

For me, half of the photographic process is in the printing, so when I am shooting, I am also thinking about the final print, whether it is in color or in black and white; that is one of the reasons I don't shoot much transparency film. I like the idea that I can go back and reinterpret a negative. I find that I seldom make the same print twice, even where I have carefully noted all the details of exposure and burning and toning and so forth; it's all just a starting point for another interpretation.

Appendix I: Learning LF with Polaroids

FURNITURE STORE

If you want to practice shooting interiors, especially with tricky lighting, Polaroids are second to none.

TOHO FC45A, 120/6.8 ANGULON, POLAROID SEPIA. (RWH)

Polaroid film is horribly expensive: there's no doubt about it. On the other hand, so are residential and even non-residential courses, and for the price of a single course or workshop, you can buy an awful lot of Polaroid film. With it, you can learn just about all you need about movements, focus, lens coverage, and (if you use Type 55 P/N) exposure. You need Type 55 P/N to learn exposure because other Polaroid films, being direct-positive materials, are more akin to transparencies: the only way to see whether you have enough shadow detail on a negative is to make a negative. You may be able to get away with (slightly) outdated film if you are not too concerned with even development and clean edges, and outdated Polaroid is often very cheap.

If you don't already own a 4x5in camera, consider renting one, as described on page 138. You may of course be able to borrow one; many LF users are evangelical in their belief in LF, and remarkably generous, and if you explain that you want to learn by using Polaroids (and that you will pay for the Polaroids), they may even take time off to help you learn. Only you can decide what sort of subjects you want to practice on, but here are a few examples.

ROGER

Even an experienced photographer can learn a lot about a new camera, or a new way of lighting, or a new lens, with Polaroids. Frances shot these with her late father's Graflex after we had adapted it to take Polaroids. In the first shot (**A**), the lighting is all wrong and the exposure is too "hot"; in the second (**B**), the lighting and exposure over-compensated and the eyes are awful; in the third (**C**), the pose is a disaster and Roger looks like a hunchback; the fourth (**D**) is nearly there; and the fifth (**E**) is the final version in that series. The sixth and seventh shots (**F** and **G**) were experiments using the monocle as a prop.

150/4.5 EKTAR, POLAROID POLAPAN 100.

SPOTTING AND RETOUCHING

A simple "pack shot" such as this can teach you a lot about lighting and control of depth of field.
Linhof Technikardan, 210/5.6 Symmar, Polaroid Sepia. (FES)

POLAROID TYPE 55 P/N

The negative is not "instant"; it has to be cleared (in a saturated solution of sodium sulphite, which will rip your fingers up in an hour or two if you dabble them in it and don't wash them *immediately*), then washed, then dried. On the other hand, even an uncleared negative can show you whether or not you have adequate shadow detail, as can a cleared but unwashed negative. Negatives can be kept in the clearing bath, or even in water, until you have time to finish processing: the Polaroid clearing bucket, shown on page 138, is useful on location. Note that a negative that is ideal for printing, with plenty of shadow detail, will normally mean a positive that looks rather light and overexposed.

THEATRE ROYAL, MARGATE

This reveals two sad truths. First, 2400W-s was not enough to illuminate the interior of a theatre on ISO 100 film; and second, the composition was lousy anyway: it should have been higher, and "landscape."
Linhof Technikardan, 47/5.6 Super Angulon, Polaroid Type 54. (RWH)

◄ ◄ MARSHSIDE

Direct-positive materials (this is Polaroid Sepia) cannot teach you negative exposure, but they can tell you a lot about how you can vary mood by varying exposure.
Linhof Technikardan, 210/5.6 Symmar. (RWH)

Appendix II: Three custom cameras

LONGFELLOW

1 The two 6x9cm "donor" cameras are unremarkable roll-film folders from the 1950s. The big advantage of these Ensigns is their light-alloy chassis construction.

2 The two cameras are stripped down, and the left end is sawn off one camera, the right end off the other. The same is done for the top plate, base plate and back.

3 The two cut-down chassis are mounted on a "cone." The prototype cones were made of built-up plywood, but a short run of light alloy cones proved surprisingly affordable.

4 The chassis and top and bottom plates bolt to the cone; the two backs are fixed together with a fish-plate. Note the two pressure plates: not the ideal for film flatness, but surprisingly adequate.

5 A 90/8 Super Angulon in a Schneider focusing mount (the latter the most expensive component in the camera), plus a frame finder made from bent wire and a door viewer, complete the plot. Frame counting is via red window, counting 1-3-5-7, because the 6x9cm format is doubled up.

Very few have the technical skills needed to build a 35mm camera, but one of the great things about MF and LF is that adaptations, using scrap cameras or relatively inexpensive components, are entirely possible and allow experiments in fields which might otherwise be prohibitively expensive or (as in the case of the 4x5in fish-eye) completely unavailable.

We are indebted to Dr A. Neill Wright for details of both the 617 Longfellow and the 4x5 Fish; the Lubiloid was Roger's idea. We have deliberately not gone into too much detail, as every adaptation will have its own problems: the intention is to prompt some ideas of what can be done.

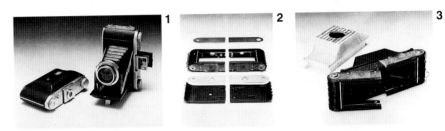
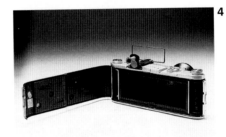

FISH

The 30mm Zodiak fish-eye lens is renowned for its performance, and (of course) it is full frame on 6x6cm. This led to the inevitable speculation that it should be able to function as a circular-image fish-eye on 4x5in, which indeed it can. The most nerve-wracking part of the procedure was sawing off the vestigial lens-shade lugs, which would have intruded into the area of the image, and it is not easy to find shutters big enough to accept a fish-eye lens on the front. The lens is, of course, in a barrel mount: well, you've heard of fish in a barrel, haven't you?

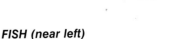

FISH (near left)
RECULVER TOWERS (far left)

Notice that the picture of Reculver Towers is complete with shadow of Roger and camera and tripod in shot. Also the remains of the lens-shade lugs are just visible.

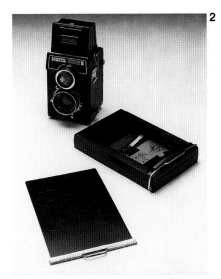

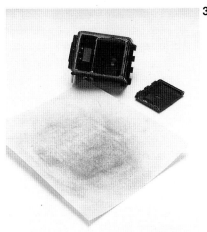

LUBILOID

1 The Lubiloid was made from a Lyubitel TLR bought at a boot fair (swap meet) for a couple of pounds ($3/€3); a scrap 4x5in film sheath from a broken dark slide; and a Polaroid back rescued from an ex-government CRT camera bought for £5 ($7.50/€7.50), though the same back can be found, new, in the Polaroid catalogue for about four or five times as much: it is the basic component in all manufacturers' Polaroid backs for MF cameras.

2 The components are clear here: the camera, the back and the film sheath.

3 The first stage was to remove the pin in the back hinge; saw down the back with a "baby" hacksaw; and grind the back of the camera flat on some glass paper.

4 In the interests of clarity, two Polaroid backs are shown here. The one at the back is as removed from the ex-government camera; the one at the front has been popped apart at the hinge, and the 4x5in dark slide (with hole for the film gate) has been glued to the front part.

5 Next, the Polaroid back is glued to the Lyubitel, and the base reattached. Mix a little black pigment with Araldite or a similar epoxy adhesive in the interests of light-tightness.

6 Use a homemade ground glass in an empty Polaroid film pack to check focus. Because of the way the Lyubitel focusing mount is made, it is possible to mesh the focusing and camera lenses in different positions to give the best possible focus both on the screen and in the film plane.

Appendix III: hints, tips and checklists

There are several things that didn't really fit in anywhere else much, some of which are useful to have at the back of the book as references anyway, so this last Appendix is something of a mish-mash of useful ideas picked up over the last third of a century or so, since Roger first took up photography. The pictures are things that didn't fit in elsewhere, either.

FILM DRYING (MF)

Pin films up diagonally, for example across a doorway in a dust-free part of the house, and they will dry faster and with less risk of drying marks.

NEGATIVE RETOUCHING (LF)

Much to our surprise, pencil retouching of LF portraits proved to be surprisingly easy. A soft pencil (2B or softer) is used with a very fine "scribbling" motion, in tiny circles or ticks or figures-of-eight, to darken wrinkles (which of course read as light lines on the negative). Use a very light touch, or you will wear off the "tooth" that is provided in most LF films to allow easy pencil retouching.

▼ ▲ NEGATIVE RETOUCHING
The two close-ups of Roger's eye (below), show the effect to which the ravages of age can be ameliorated by retouching; the original negative is 5x7in FP4 Plus, shot with our 21in f/7.5 Ross. This was Frances's first attempt at negative retouching!

To fix the retouching, hold the negative in the steam of a kettle for a few minutes, then leave it to dry fully: the retouching is then almost impossible to remove. The bigger the format, the less skilled a retoucher you need to be. Contact prints are best of all, though small degrees of enlargement (2x or 3x) are often acceptable.

GROUND GLASS (LF)

A quick-'n'-dirty way to replace a broken ground glass is with a piece of 2mm (1/16in) window glass, or (better still) thin picture-frame glass, with one side frosted with any one of a number of aerosols: hair spray in desperation, but Rust-Oleum Painter's Touch Frosted Glass is ideal. We are indebted to Tom Fuller in *Shutterbug* magazine for this trick.

CHECKLIST FOR SHOOTING
1 Zero all movements.
2 Open shutter; set full aperture.
3 Focus and compose.
4 Use movements as necessary.
5 Stop down to working aperture to check depth of field.
6 Close lens.
7 Insert film holder.
8 Pull dark slide (film sheath), protecting the dark-slide slot from direct light if need be.
9 Shoot.
10 Replace dark slide, black side out.

ANTEBELLUM HOUSES, SELMA, ALABAMA
We don't always remember to coat the positives that we get from Polaroid Type 55 P/N negatives, and the results, as they fade and oxidize, can be wonderfully unexpected.
TOHO FC45A, 120/6.8 ANGULON. (RWH)

NOTCHING (MF AND LF)

A common professional technique for both MF backs and LF film holders is "notching." This involves filing a small but distinctive pattern of notches at the side of the film gate, so that every transparency or negative reproduces the notching. This makes it easy to trace problems back to individual backs or film holders: things like light leaks, or uneven spacing on roll-film backs, or scratches. Linhof holders go one better: they are individually numbered.

CABLE RELEASE ADAPTORS (LF)

Linhof makes quick-fit cable release adaptors that screw onto the lens panel: you just push the release into a socket, where it locks until you release it with a button. These are much easier than fiddling around with the Compur/Prontor tapered thread, and are the only option if you have a lens in a 00 shutter and a sunk mount, so you can't fit a release conventionally.

AT THE TARAGARH PALACE HOTEL
Compare this with the picture of the café-bar, and you can see that the newer, contrastier lens (38/4.5 Zeiss Biogon on Alpa with 44x66mm back) makes colour exposures much easier under difficult conditions. *(RWH)*

CAFÉ-BAR, PELOPPONESE
Exposure is always a compromise. The sky and tree argue that this is correctly exposed; the excessively open shadows, and Frances's face on the edge of burning out, argue that it is anything up to 1 stop over.
MPP MK VII, 150/4.5 APO-LANTHAR, FUJI RDP 2. (RWH)

INDEX

INDEX

FILM FORMATS

◄ *HYPO AND SCOOP*